GARDENS
Maine Style

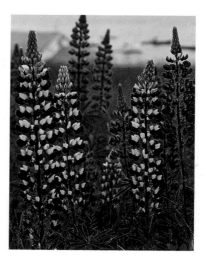

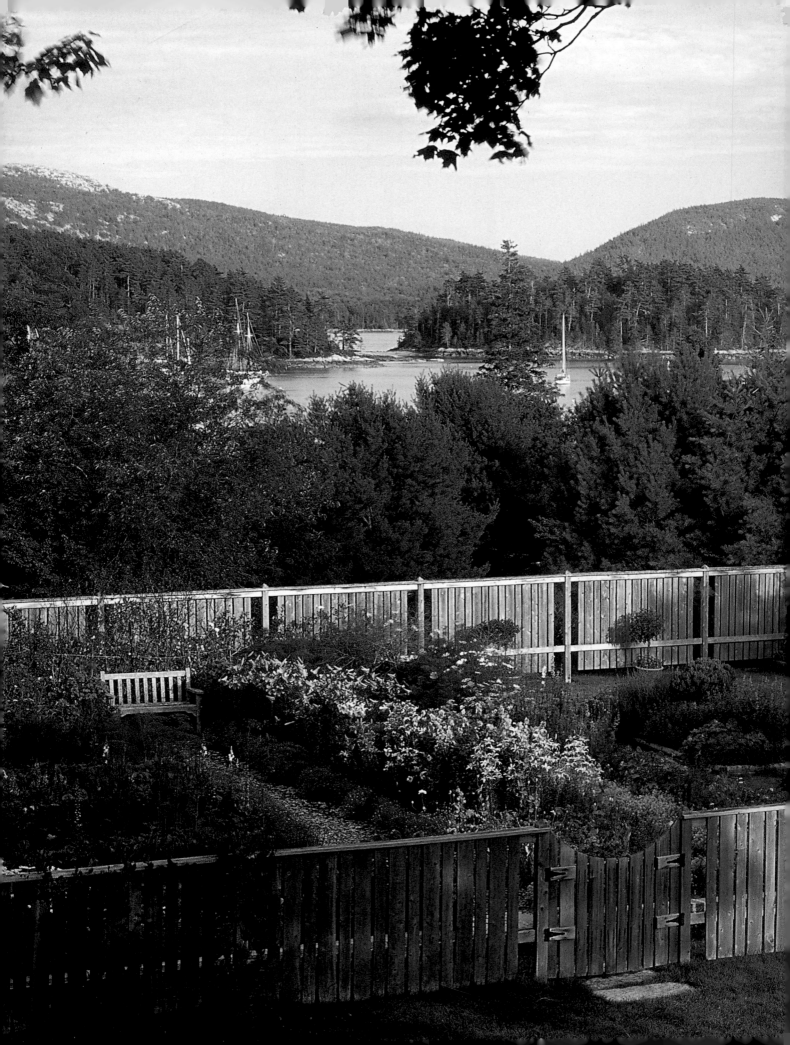

GARDENS
Maine Style

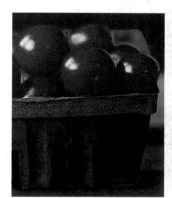

Rebecca Sawyer-Fay

Photographs by Lynn Karlin

Down East Books

Published by Down East Books

An imprint of Rowman & Littlefield

4501 Forbes Boulevard, Suite 200,

Lanham, Maryland 20706

www.rowman.com

10 Thornbury Road, Plymouth PL6 7PP,

United Kingdom

Distributed by National Book Network

Text copyright © 2001 by Rebecca Sawyer-Fay

Photographs © 2001 by Lynn Karlin

First paperback edition 2014

Photograph on page 75 reprint courtesy of *Country
Gardens* magazine; photographs on page 88 and 89 (top)
reprinted courtesy of *Country Home* magazine.

Quotation on p. 14 from *The Little Locksmith*, by
Katharine Butler Hathaway, © 1942, 1943 by Coward-
McCann, Inc., renewed 1974 by Warren H. Butler.
Reprinted by permission of The Feminist Press (www
.feministpress.org) at the City University of New York.

British Library Cataloguing in Publication
Information Available

Library of Congress Cataloging-in-Publication Data

The hardback edition of this book was previously
cataloged by the Library of Congress as follows:

Library of Congress Card Number: 00-110688

ISBN : 978-1-60893-293-1 (pbk : alk.paper)

ISBN : 978-1-60893-294-8 (electronic)

Book design by Faith Hague

∞™ The paper used in this publication meets the
minimum requirements of American National Standard
for Information Sciences—Permanence of Paper for
Printed Library Materials, ANSI/NISO Z39.48-1992.

Printed in China

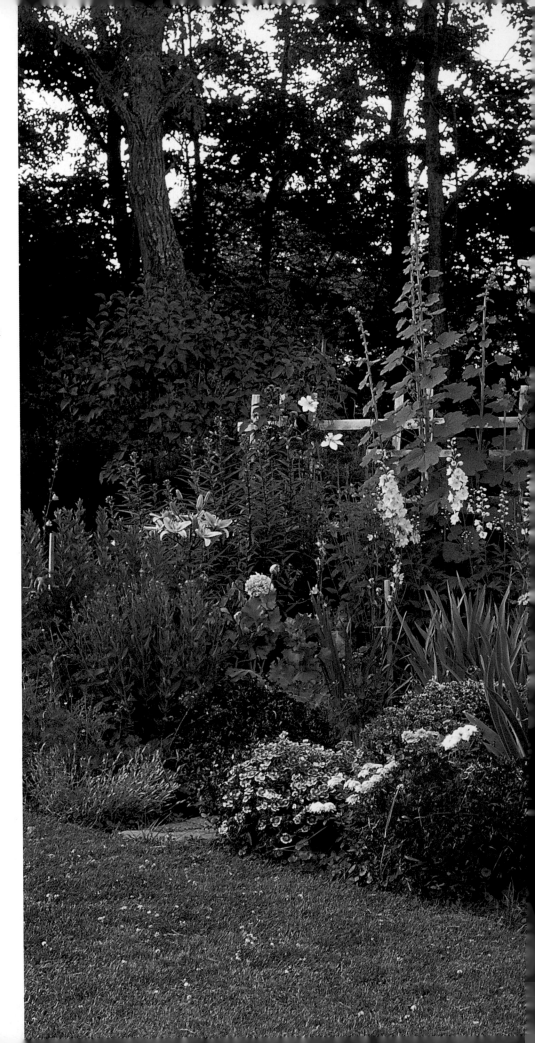

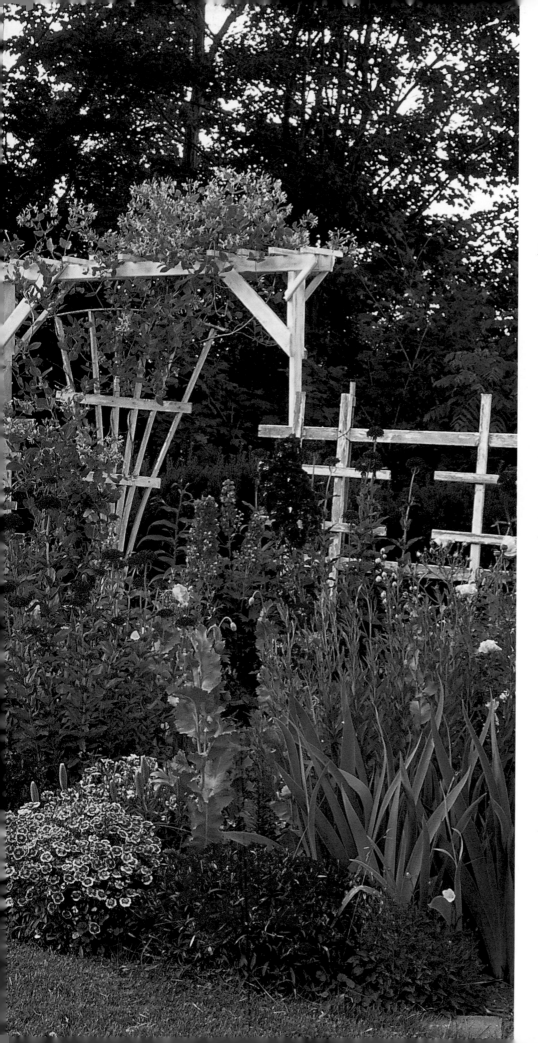

To our mothers,
Florence Theda Breakstone Karlin
and Nancy Mapes Sawyer Lynch

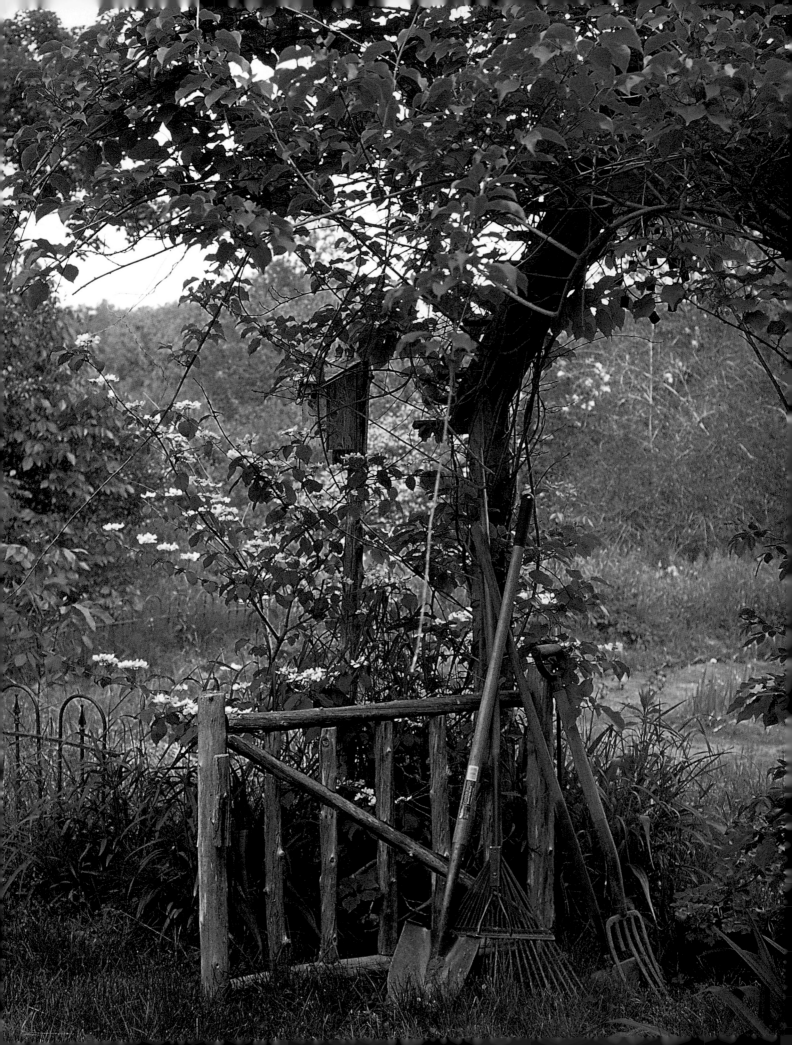

Contents

Robin Jarry's rustic arbor and hardy kiwi vine

Foreword

As an inquisitive Maine gardener, I always want to know how other gardeners in the state do things. I want to learn their cherished bits of wisdom and lore, and I yearn for a chance to peek over their fences and into their personal landscapes.

Since I couldn't attend every summer garden tour, and since peeking over fences is unacceptable behavior, I began to search for a book that would satisfy my curiosity. Though I found volumes that covered many gardening subjects, I longed for more. I wanted a book rich with photographs of contemporary Maine gardens, both grand and whimsical, and an intimate, conversational text akin to the friendly and understandable classics of the late nineteenth and early twentieth centuries.

Thanks to a ten-year quest by award-winning photographer Lynn Karlin, I need seek no further.

Lynn joined forces with garden writer Rebecca Sawyer-Fay, and together they managed to chronicle not only the diversity of our gardens but also the philosophies and indomitable spirits of their creators.

One of the things I most love about Maine gardeners is their indefatigable independence. No matter what is in vogue in the rest of the world, what counts for Mainers is what works for them. Their style is typically atypical—a vivid reflection of their passion, dedication, and vision—and the pages of *Gardens Maine Style* capture and illustrate these ephemeral qualities.

I believe that all knowledge is first rooted in wonder, then encouraged to grow by inspiration. Lynn and Becky's beautiful book demystifies the sometimes frightening prospect of trying to garden under difficult conditions and inspires and encourages us with the examples of others. Their book is a feast—soul food for the winter weary, the hopeful neophyte, Mainers in exile, and the optimists known as gardeners.

I wish you happy reading and joyous garden pleasures.

Sharon Lovejoy

Author and illustrator of *Roots, Shoots, Buckets & Boots*, *Sunflower Houses*, and *Hollyhock Days*, and contributing editor at *Country Living Gardener*

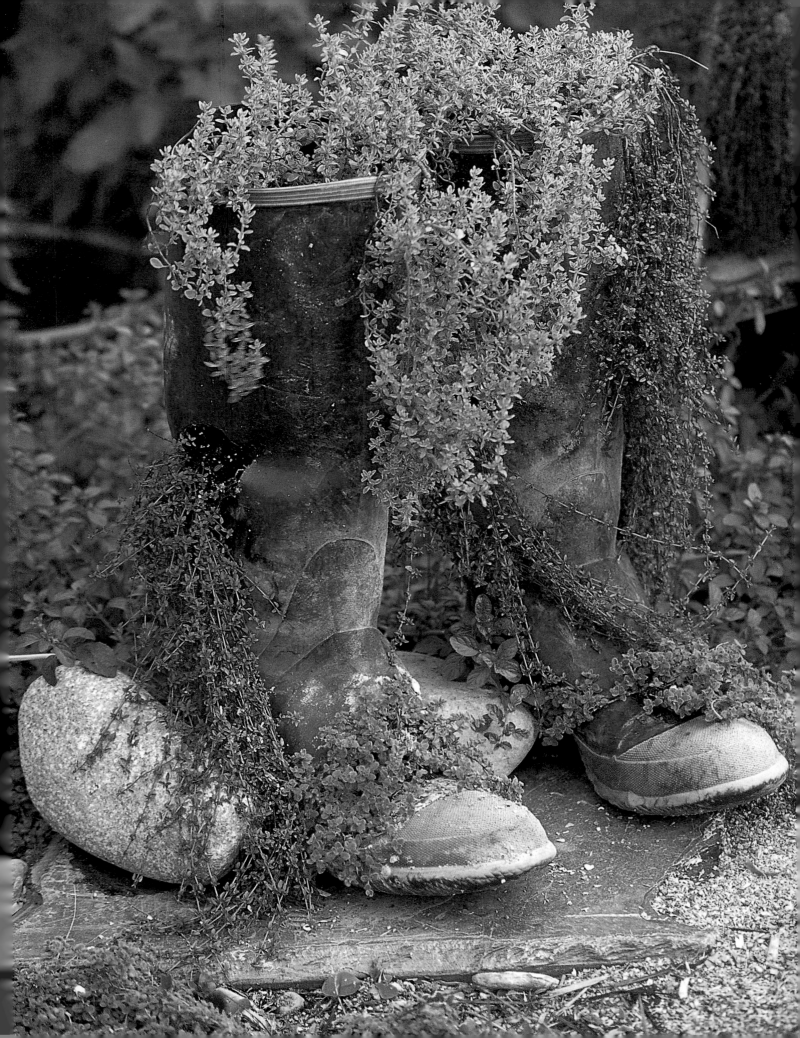

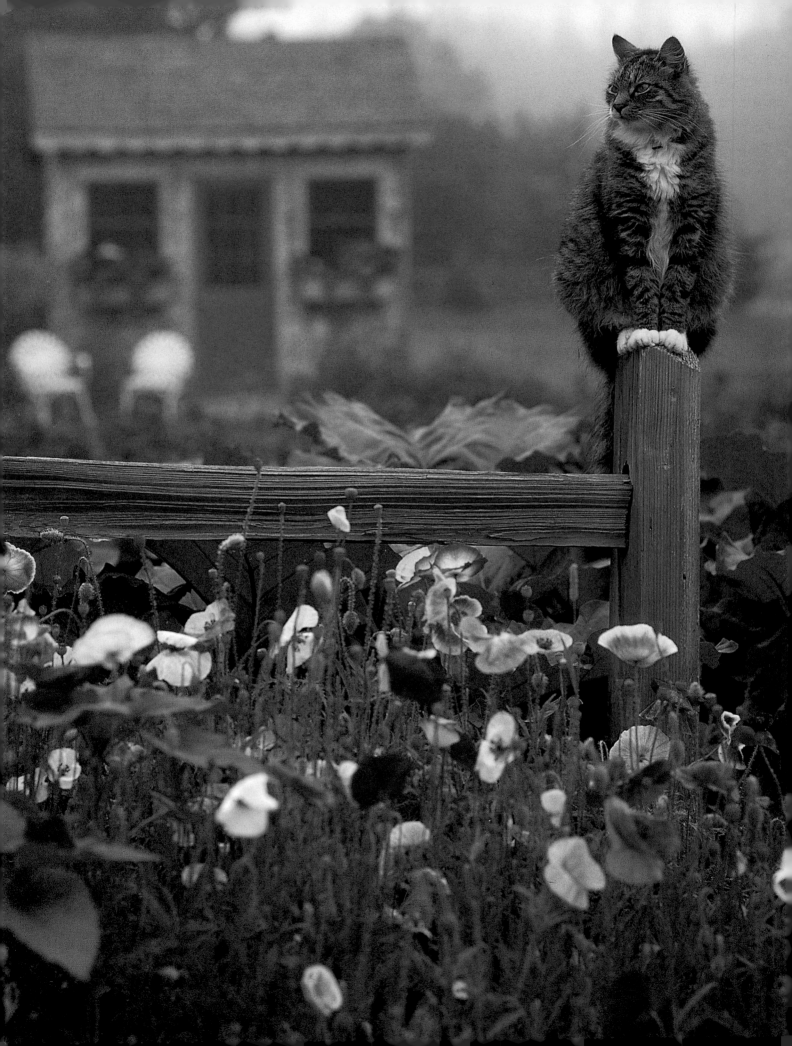

Acknowledgments

Any book years in the making, as this one was, involves scores of individuals who give their time, their support, and access to their gardens. Our one regret is that we could not include all the extraordinary gardens we saw over the years. Our gratitude goes to everyone who so generously allowed us to photograph and who answered our endless questions.

We are both most grateful to Diana Murphy, our gifted editor at *Country Living Gardener,* where some of the material included here first appeared. Our thanks go as well to Sharon Lovejoy and Jeff Prostovich for their support, friendship, and insight over the years; to our editor at Down East, Karin Womer, and publisher Neale Sweet, and to the book's talented designer, Faith Hague. Thanks, too, to Barbara Feller-Roth, our copy editor.

From Lynn, special thanks to the gardener friends who were there from the beginning: Muriel and John Krakar, Kate NaDeau, Morris Dorenfeld and Bob Davis, Stephen Huyler, Barbara Damrosch, Dora Galitzki and Jan Rosenbaum, Deb Soule, Jutta Graf, Leslie Clapp, Jean and Dud Hendrick, Audrey Muir, Robin Jarry, Judy Paine, Sharon and Paul Mrozinski, Sue Baillargeon, Alice Ann Madix, Cindy and Barry Porter, Beth Schuman, Karen Aveni and Dick Deforge, Bev Nolan, Blanche Bourdeau, Helen Tirone, Helene Lewand, and Jon and Margo Thurston. Thanks as well to Paul Tukey, editor and publisher of *People, Places, and Plants,* for his support and good spirit; to Jessica Brown and Brianne

Seekins at Maine Coast Photo for their happy and positive dispositions; and to Gail Priest and Julie Howard at Belfast's County Copy for their help and good cheer. Deserving special recognition are Lynn's friends at the Belfast and Camden farmers' markets, who allowed her to photograph their creative displays of fresh produce on Saturday mornings as customers arrived; these include Chase Farm, Peacemeal Farm, Fisher Farm, Rockbottom Farm, and Half Moon Farm.

From Becky, heartfelt thanks to past and present *Country Living* editors, most especially Rachael Newman, Mary Roby, and Niña Williams, for eighteen years of support and encouragement; to Rick Sawyer for his horticultural insight; to Tom Seymour for sharing his broad knowledge of edible wild plants; to Alicia Kellogg, David Bustin, and Judy and Bob Demos for introducing a newcomer to Maine's remarkable historic properties; to Nancy McGinnis and the knowledgeable staff at Hallowell's Hubbard Free Library; and to Howard Jones of the Maine Department of Agriculture.

Most important, our love and gratitude to Barry, Joe, and Sean for putting up with us through all this, and to other caring family members, as well: Sy, Donna, Bub, David, and Ann—we thank you all.

Leslie Clapp's garden in Blue Hill.

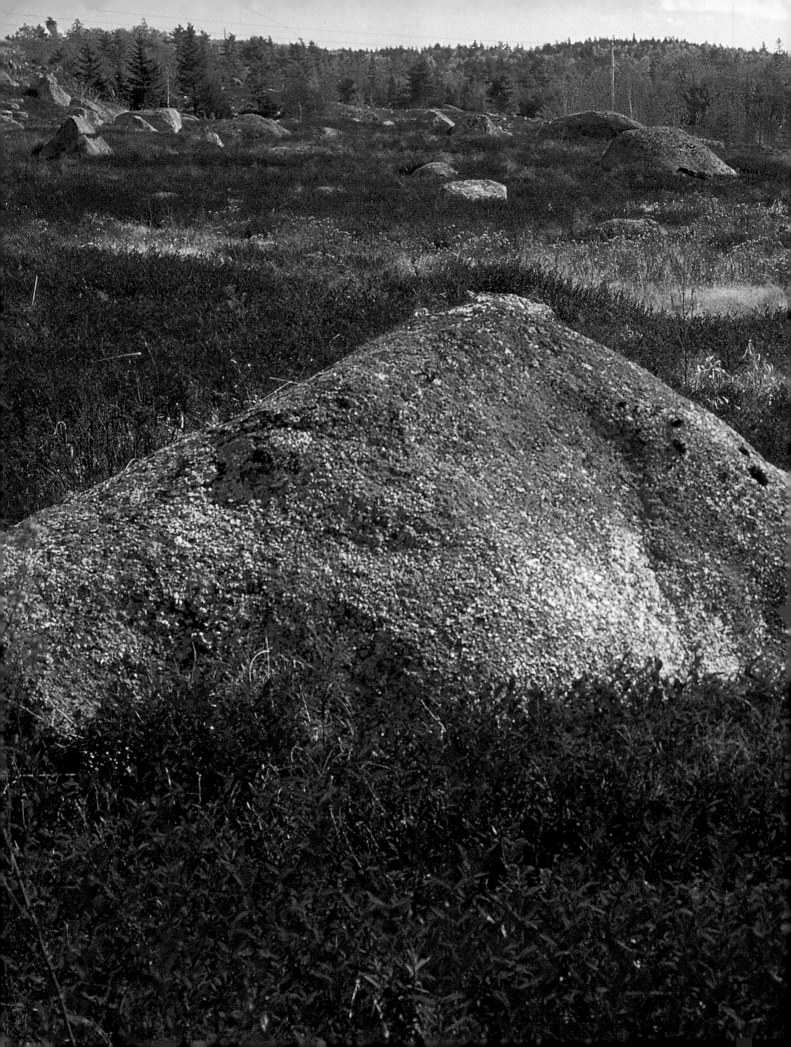

Local Color

They were so compelling, the divine air and the brilliant sun on my doorstep and all around me as far as I could see, that I stopped thinking. They made thinking seem ridiculous ... [What] would have been the most natural thing to do was to change into a plant or a fruit tree, and I almost felt myself changing. There was no other way to express my thanks for all this, except to burst into leaves and flowers."

To many who have known Maine on those days when the divine air and the brilliant sun perform their matchless duet, the notion of gazing at one's hands and suddenly finding petals instead of fingers is only slightly hyperbolic. Katharine Butler Hathaway's ode to coastal Castine in her 1942 memoir *The Little Locksmith* rings true throughout Maine, from the seaboard lowlands, west to the White Mountains, and north toward the Canadian border. For more than two centuries, residents in all regions have celebrated Maine's natural gifts by planting gardens—lots of them. Whereas the dooryard plots of early settlers were strictly practical, featuring comestibles and medicinal herbs, it wasn't

Previous page: Blueberry field, irresistible to artists

Right: Japanese iris

Opposite, clockwise from top left: 'Neon' eggplant; low-bush blueberries; lupine; 'Pacific Giant' delphiniums

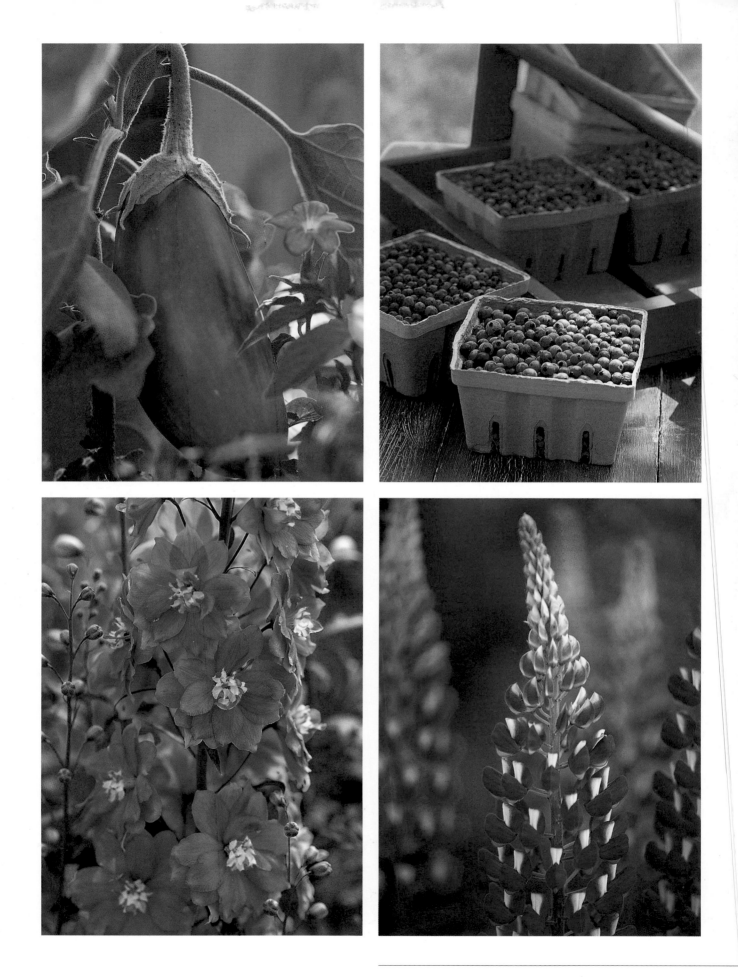

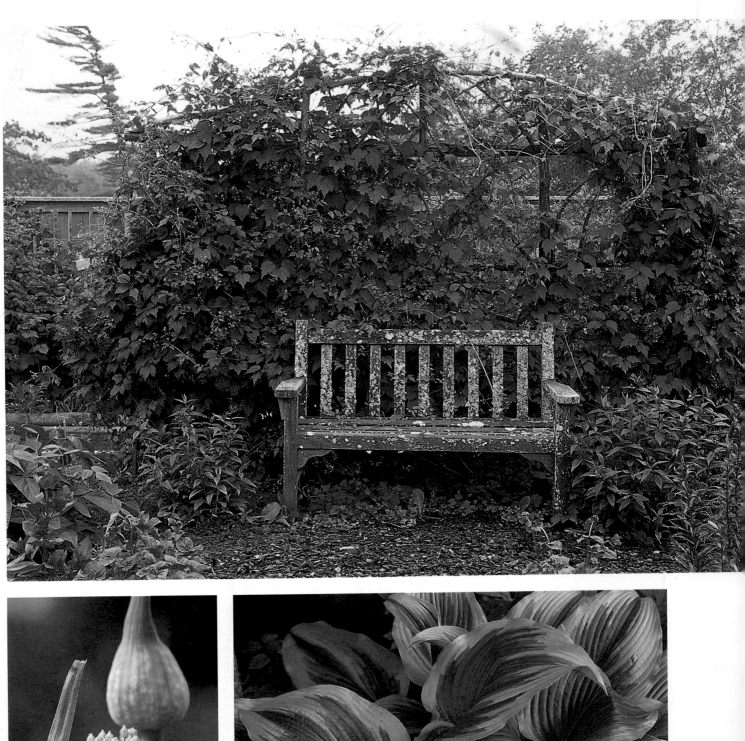

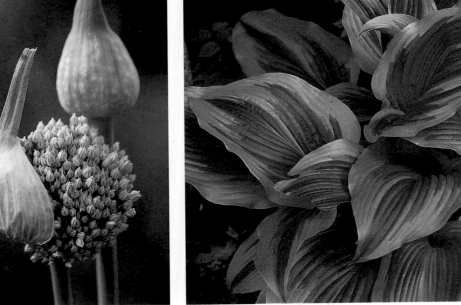

Clockwise from top left: Bench beneath a bower; Savoy cabbage; tomatillos; *Hosta montana* 'Aureomarginata'; 'Blue Solaise' leeks

long before more and more gardens were established just for the joy of it. Even in the northwest corner of Aroostook County, where the growing season lasts only ninety days, exuberant displays of delphiniums, poppies, and roses reveal an irresistible impulse to grow the broadest possible spectrum of ornamental plants.

What makes Maine's gardens so remarkable isn't just that they thrive despite long winters and sometimes painfully slow springs. It's the degree of pleasure they give. Through countless woodland gardens, cottage gardens, seaside gardens, formal and informal gardens, Maine's gardeners tell us, "The higher the hurdle, the greater the reward." Those hurdles include winter temperatures that can plunge to minus forty-eight degrees Fahrenheit, as happened in 1925 in Van Buren, on the St. John River. The snow cover that accompanies the cold is not a problem, acting as it does like a thick, insulating blanket. However, the freeze-thaw cycles that send the thermometer from one extreme to the other wreak havoc with herbaceous perennials. By the sea, especially on Maine's hundreds of islands, other

challenges include gale-force winds that slam the coast with regularity, delivering rains that flush important nutrients from the thin soil.

That's not all. When the last glacier melted ten thousand years ago, it left behind huge quantities of till. River and coastal currents have since redeposited some of those sediments to form fine, sandy beaches. But with the sand came immense deposits of gravel and clay that to this day affect Maine gardeners every time they dig a new bed or enlarge an old one. Some by-products of the melting glaciers are more than welcome: Maine's approximately six thousand lakes and ponds, for instance. Less congenial are the tons of rocks. Although they give character to the landscape, rocks—and boulders—give backaches to gardeners.

As for the soil itself, the state's magnificent coniferous forests, which once held pines two hundred feet tall and ten feet in diameter, contribute to its acidity—an average pH of 5.5 (7.0 is neutral). Generation upon generation of decomposed evergreens create a "sour" growing medium that's splendid for rhododendrons, heathers, and other ericaceous plants. However, what's good for such acid-loving members of the heath family is less than ideal for those previously mentioned far-northern delphiniums. (Parts of the midcoast, however, are blessed with sweeter soils because they are underlain by limestone bedrock, which industrious Mainers have quarried for two centuries. The Dragon Cement Company in Thomaston still produces ground limestone for agricultural use.)

What to do? On the coast, resourceful gardeners and farmers quickly found the solution right at their feet, in the form of nutrient-rich seaweed. Inland, they discovered that composted horse and cow manure were sufficient to make Maine loam rich—and pH balanced—enough to grow just about anything. Most important, though, they learned to convert liabilities into assets. Many of the boulders that challenged farmers became the building blocks of New England's famous stone walls and some of America's most beautiful rock gardens. As for the acid soil, in 1999 it yielded 66 million pounds of cultivated blueberries.

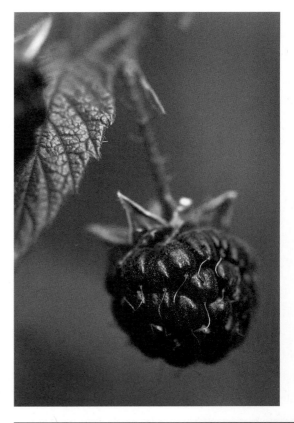

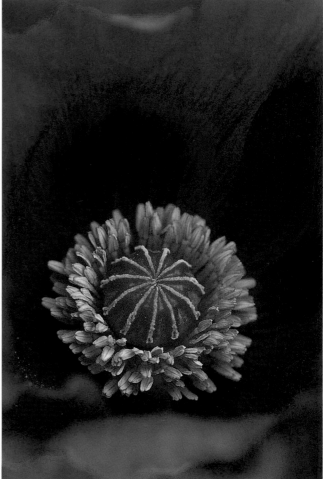

In short, Maine is a wonderful place in which to garden—so wonderful, in fact, that by the second half of the nineteenth century, gardeners "from away" began flocking to the state to buy summer homes and create the gardens of their dreams. The Civil War had ended, and the ensuing economic boom gave birth to America's summer-house period. "Rusticators" built "cottages" as big as hotels (which a few eventually became). With the summer people came many of America's most renowned landscape architects, including Frederick Law Olmsted, Sr., who in fact created the profession. With his two sons and many associates, including Warren Manning and Charles Eliot, Olmsted left a lasting impression in

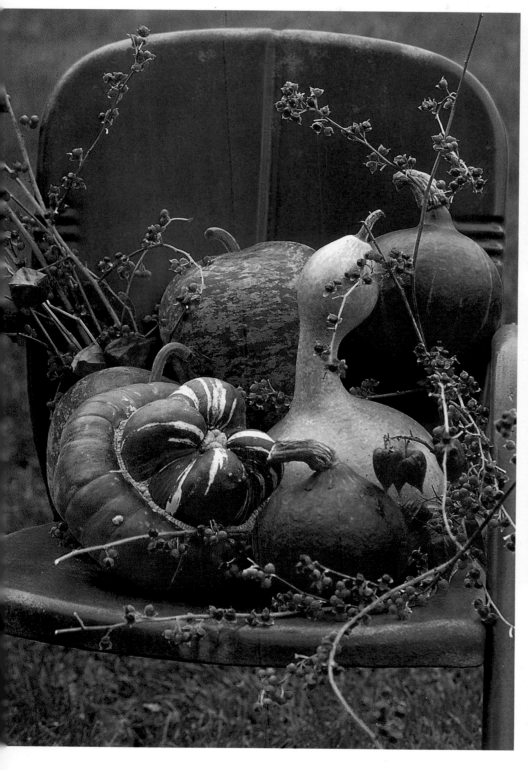

Opposite: Wild raspberries; poppy (*Papaver somniferum*)

Clockwise from top right: flamed tulips; 'Thai Dragon' hot peppers; gourds and bittersweet

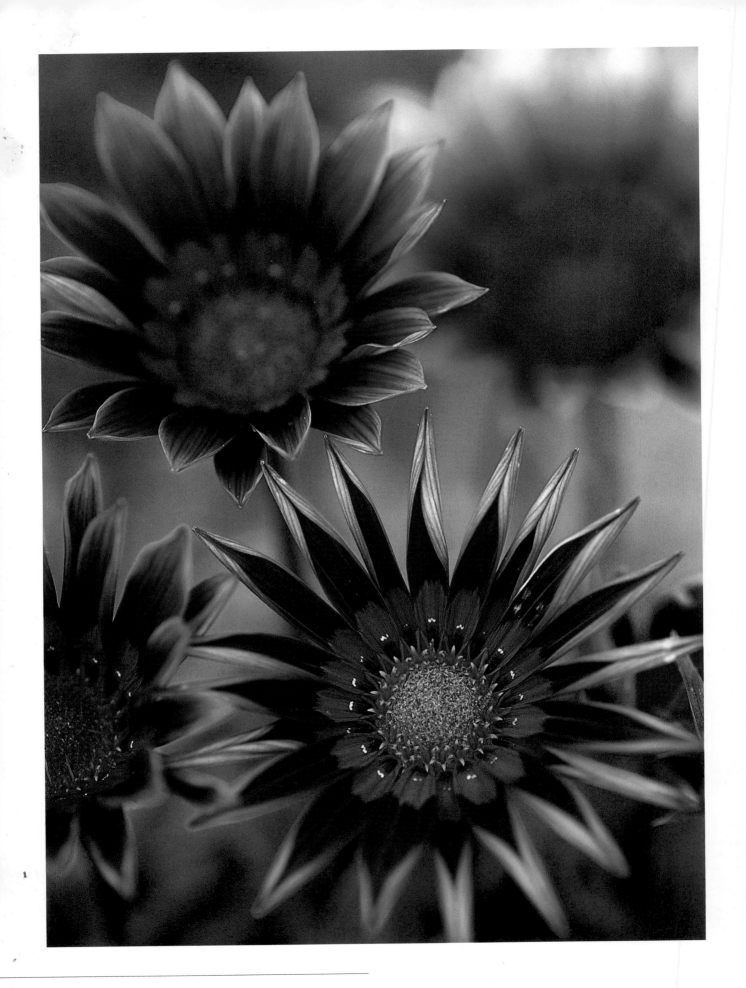

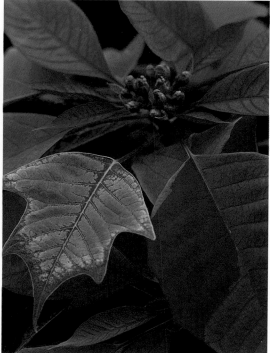

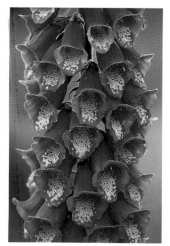

Opposite: Gazania
Clockwise from top left:
'Nicole' floribunda rose;
Poinsettia sport, 'Hot Pink';
Foxglove *(Digitalis purpurea);*
Magnolia x *soulangiana*
'Picture' ('Wada's Picture')

the form of public parks and college campuses. (Sadly, many of the private gardens that his firm designed for wealthy clients have vanished.)

Maine's most famous gardener, though, wasn't from away. Beatrix Farrand (1872–1959) lived here much of her life and used her Bar Harbor property, on the eastern shore of Mount Desert Island, as the canvas for one of her greatest works: Reef Point Gardens, an independent educational and philanthropic corporation. At Reef Point (dismantled in 1955), Mrs. Farrand tested countless species and cultivars for hardiness and adaptability to harsh climates, and instilled a love for native plants in Reef Point's many students and visitors. Her influence on the exquisite gardens that developed in other locations on Mount Desert cannot be overstated. "These were world-class gardens," says Patrick Chassé, an acclaimed landscape architect born and based in Maine and known for his naturalistic plantings. "Garden architecture at that time took a new direction, owing to greater cultural confidence."

Although the Olmsteds, Beatrix Farrand, and the many other talented designers who left their mark on Maine are gone, their legacy endures in the work of a new generation of landscape architects and renowned horticulturists, including Dr. Currier

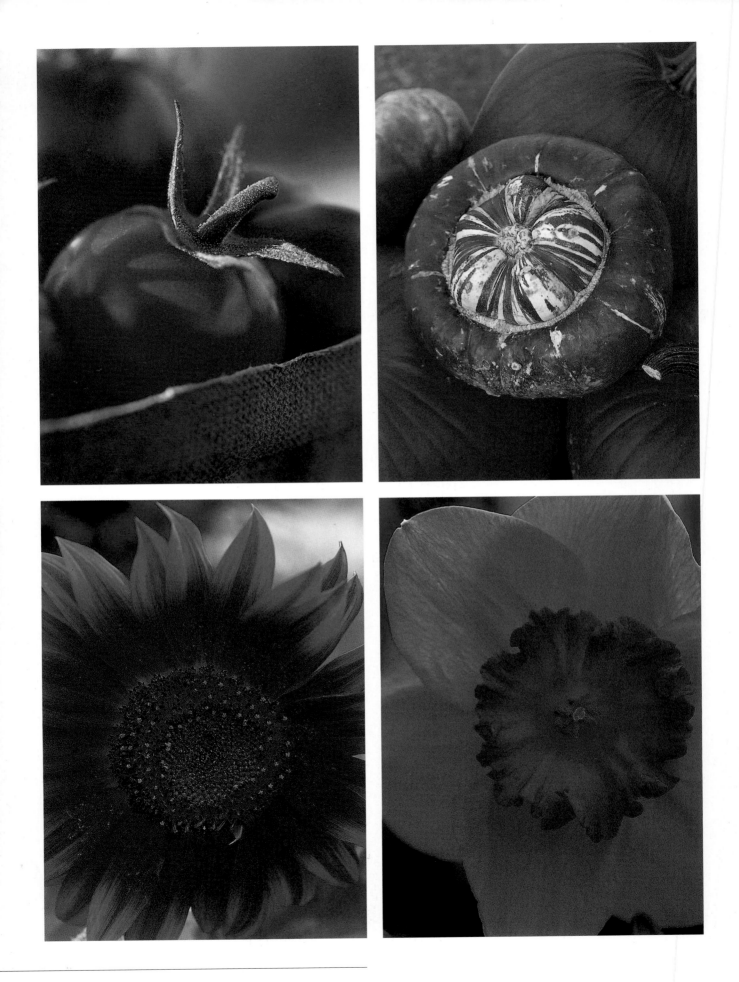

McEwen, of South Harpswell, and Roger Luce, of Newburgh. Throughout their lives, both men have shown that far more than evergreens can be made to feel at home in Maine. From Dr. McEwen's coastal "laboratory" have come hundreds of new Japanese and Siberian iris, many of them now common to gardens throughout the world. In 1970, Dr. McEwen started a revolution when he hybridized the first tetraploid Siberian iris; dubbed 'Orville Fay', the violet-blue beauty measured five and a half inches across, owing to double the number of chromosomes present in diploid varieties. Ten years

before that, up in Newburgh at the family farm where he was born prior to the Depression, Roger Luce began pushing the horticultural envelope when he raised Maine's first magnolia from seed. Named 'Elizabeth', the pale yellow specimen proved hardy to U.S. Department of Agriculture (USDA) Zone 4, confounding skeptics who had thought magnolias unsuited to the state. "I had seen a magnolia in Connecticut and thought, Why not?" Mr. Luce recalls. Other trees and shrubs hybridized and tested for hardiness by Mr. Luce throughout the years include hundreds of azaleas, lilacs, and primroses. Today, his

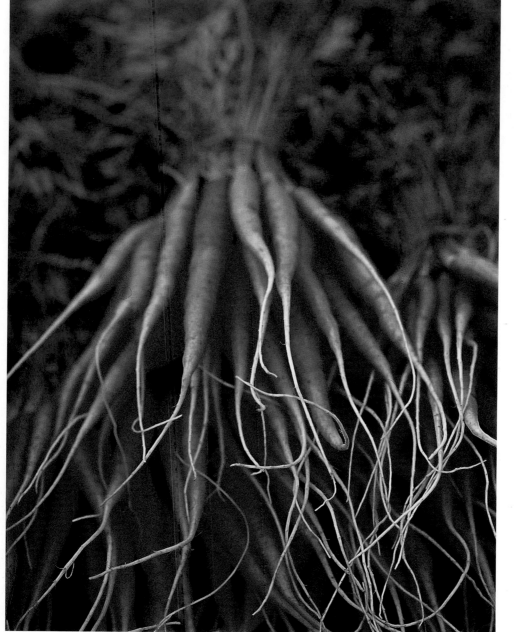

Opposite page, clockwise from top left: 'Sun Gold' and other cherry tomatoes; Turk's turban gourd; 'Ceylon' narcissus; 'Sundance Kid' sunflower

Left: 'Navajo' carrots

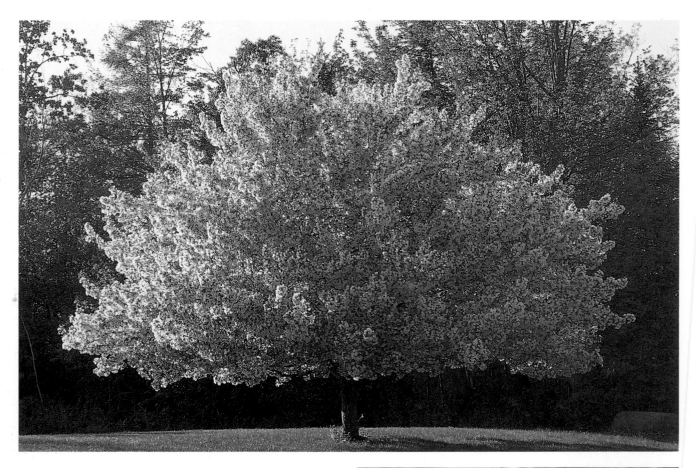

gifts to fellow gardeners span a plant palette far broader than ever thought possible in Maine.

Also helping gardeners in their quest for superior plants and innovative design are Maine's centers of horticultural learning. At the Roger Clapp Greenhouses and the Lyle E. Littlefield Ornamental Gardens, both at the University of Maine's Orono campus, trial gardens and Master Gardener programs promote superior design and sound gardening practices. Educational resources such as these have encouraged both year-round and summer residents in their experiments with new or unfamiliar species; they have also led to renewed appreciation for Maine's indigenous plants.

What follows is the merest glimpse at the wealth of gardens now flourishing around the state. For every garden seen on these pages, another dozen are equally noteworthy. Woodland gardens, cottage gardens, seaside gardens, camp gardens, in-town gardens: they're enough to make one positively exult in "the divine air and brilliant sun," and maybe even burst into bloom.

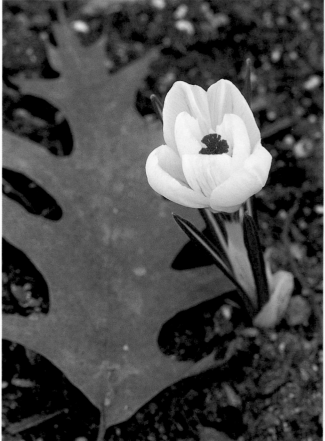

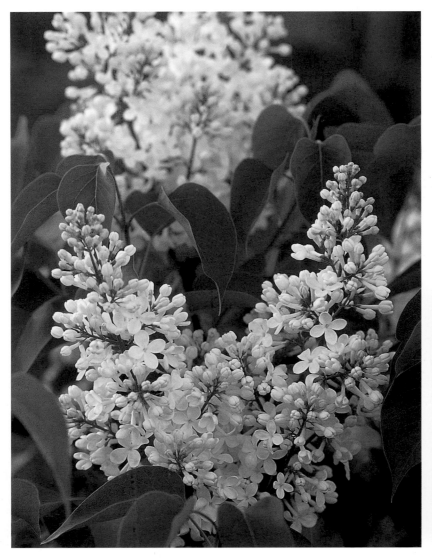

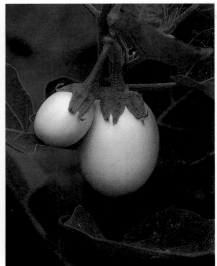

Opposite: White-flowering
crab apple; crocus

Clockwise from top left:
White lilac; 'Osterei' eggplant;
Lilium regale

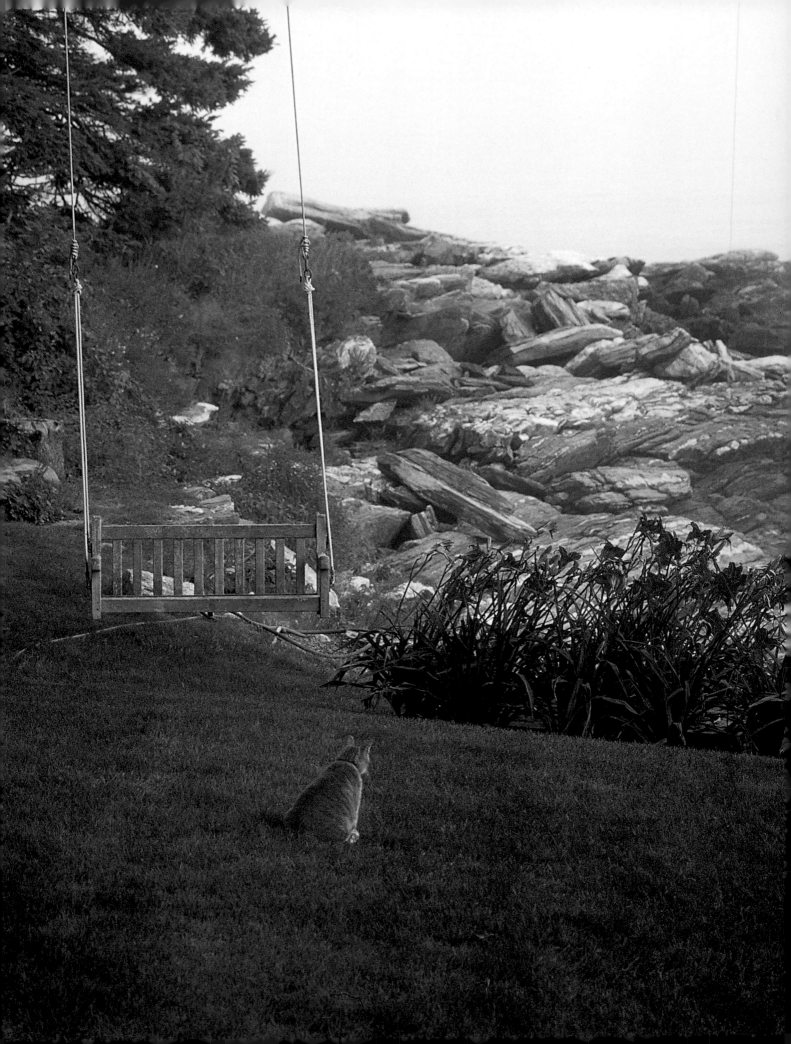

By the Sea

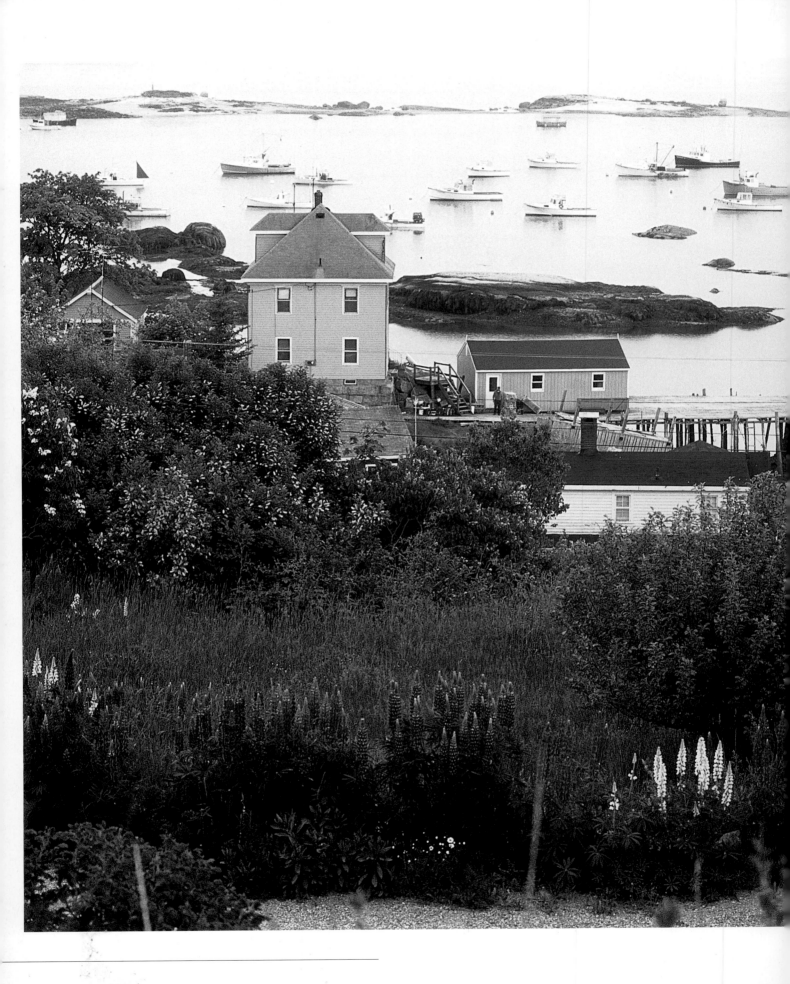

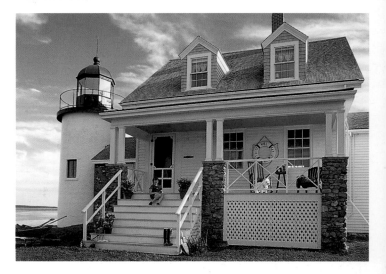

Previous page: Seymour the cat admires the early morning view of Boothbay Harbor. Peter and Karen Massaniso installed the swing so that humans can settle down and do the same.

Left: A Stonington "ungarden" features naturalized lupine, Maine's signature wildflower. In late May and early June, lupine colonies blanket hillsides all over the state. Legend has it that some of those drifts of deep blue, purple, pink, and white are the gift of Hilda Hamlin, a professor of English who broadcast many pounds of lupine seed in the 1950s and 1960s. In 1982, Maine author Barbara Cooney immortalized the story in her book *Miss Rumphius*.

Right: Now the private residence of the Madix family, Blue Hill Bay Lighthouse (built in 1856) sits proudly on a rocky island where soil is thin and fresh water scarce. In summer, pots of daisies, geraniums, and nasturtiums enliven the dwelling's white façade. To water her flowers, young Grace fills her watering can from a kitchen pump, which is connected to a rainwater cistern in the basement.

Rugosas spilling over a rocky cliff blanketed in daybreak fog, daylilies dancing in the noonday sun, beds of fragrant lavender reaching toward an endless twilight sky: Maine's seaside gardens are nothing short of spectacular. To linger even for a few days most anywhere along the deeply convoluted shoreline is to fall under an unbreakable spell. When we must leave, the memory is bittersweet, and it lasts a lifetime.

Why, exactly, are these coastal gardens so sublime? One explanation may lie in the contrast between the wild and the tamed. Sea and sky are vast and potentially dangerous, whereas gardens by definition celebrate nature subdued. From the safety of a man-made vantage point, we can be close to forces both powerful and awe inspiring. Other, more earthbound explanations emphasize the elements themselves. For instance, some island gardeners theorize that salt spray, although harsh and drying, paradoxically makes pinks look pinker and blues look bluer. The salt captures and reflects light, intensifying colors that already dazzle owing to their proximity to the mirrorlike sea. Moreover, moisture droplets in fog and morning dew act like minute prisms, filtering and softening the sun's rays, then bouncing them back in all directions. Delphiniums, poppies, sunflowers, heaths, and heathers conspire in the most radiant of rainbows.

As we stroll the scented paths of a seaside garden, all our senses come into play. The fragrance of such traditional herbs as thyme, pennyroyal, and

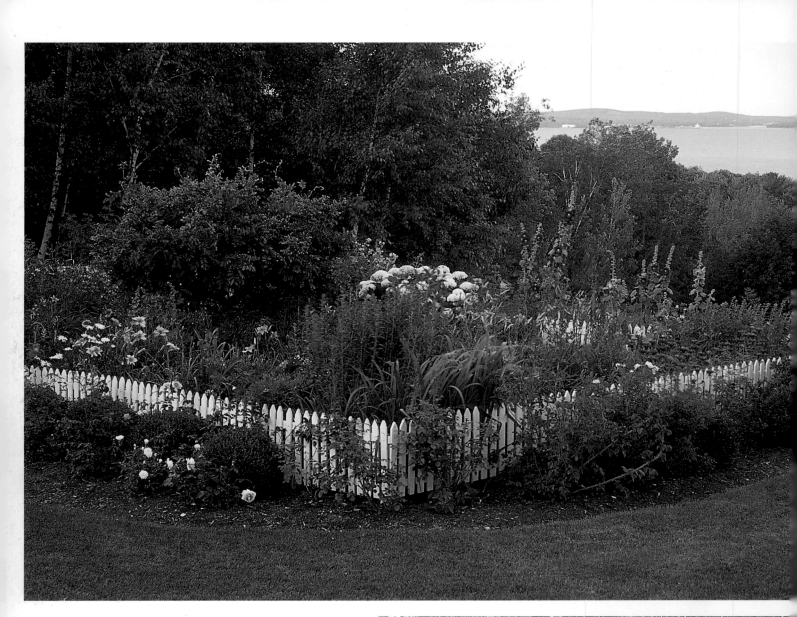

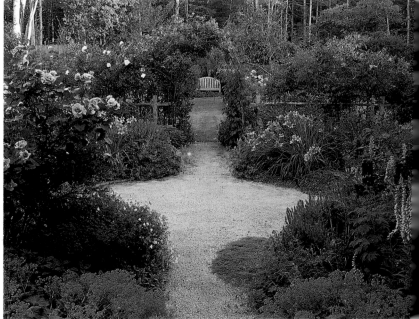

Above: Framed by a picket fence and resplendent with old-fashioned flowers, Marie Keller's masterful design evokes a nineteenth-century cottage garden. Hollyhocks, mallows, asters, irises, and daylilies compete for attention; a neatly trimmed lawn keeps the scene looking orderly.

Right: Professional gardener and writer Barbara Damrosch filled her midcoast garden with 'William Baffin' roses, delphiniums, and other cold-hardy perennials. A geometric layout lends a touch of formality to the exuberant display. Ground covers and bowers of roses soften the garden's edges.

summer savory blends pleasingly with equally pungent salt air. The ever-present music of the ocean and the gull's piercing cry join a chorus of garden sounds: buzzing bees, trilling songbirds, and, perhaps, laughing children. Always, the visual sensation of endless sea and sky competes for our attention.

Whereas visitors savor the moment, gardeners keep moving. Season after season they confront the obstacles placed in their path, all because they dare to work the land in such a harsh environment. Among the most renowned of coastal challenges are relentless winter winds that displace the already thin topsoil and suck the moisture from woody plants. Herbaceous perennials, which die back to the ground come winter, escape this punishment yet fall victim to another, equally onerous fate: wintertime freeze-thaw cycles that literally heave them out of the ground and expose the crowns of tender plants to subsequent freezes. Moreover, just as they do inland, slugs, Japanese beetles, voles, groundhogs, deer, and other voracious pests are only too happy to eat their way through entire gardens, if given the opportunity.

Almost without exception, Maine's seaside gardeners eventually arrive at a truce with nature, abandoning all initial, vain attempts to outwit her.

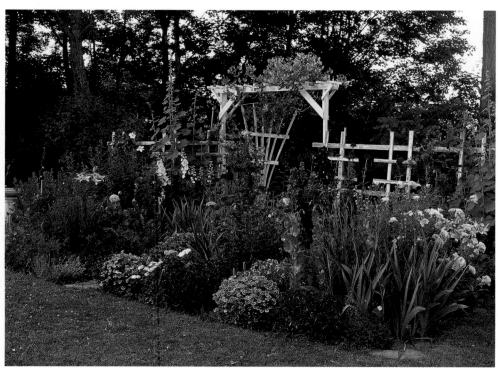

Above: Campanula, poppies, catmint, and ornamental grasses show Carolyn Kriegman's keen eye for color and a thorough knowledge of plants that succeed on the coast.

Left: Garnet-hued annual dianthus returns from seed each spring in the Belfast garden of Misko Willis. Sited a hundred feet up from the water, the garden benefits from a stand of tall trees that blocks the stiff winter winds.

Rather than try to "conquer" desiccating winds and hungry animals, these resourceful gardeners devise innovative solutions that assume rather than challenge nature's dominance. On Monhegan Island, for instance, professional gardener Kathie Iannicelli has been studying island conditions for most of her life. Reminiscent of Maine's early, unpretentious dooryard gardens, Monhegan's simple cottage plots are much like "little meditations," Ms. Iannicelli says. Graced by lilacs dating back to the nineteenth century, the gardens project an exuberance that belies the seriousness of the island's prim, straightforward houses. To keep her gardens in the pink, Ms. Iannicelli renews the soil with a product that's plentiful, easy to find, and doesn't cost a cent. Seaweed (coarse rockweed as well as finer sea moss) contains important trace elements, including iodine, potassium chloride, sodium carbonate, and boron. In December, using a wheelbarrow or, if she can borrow one, a small pickup truck, Ms. Iannicelli begins hauling seaweed from the shore to cover the many garden beds that islanders have placed in her care. Come February, she's still on the beach raking her favorite natural resource, making sure that every bed and border has a protective blanket three to four inches thick. The heavy seaweed stays put, even in a gale. In spring, before herbaceous perennials emerge, she moves most of the seaweed to the sides or back of the beds, leaving a half-inch mat to hold the soil. By late May, sea moss will have decomposed entirely; leathery rockweed takes at least a year. As the season progresses, she deposits the remaining seaweed on vegetable gardens and turns it under, or adds it to compost piles. Seaweed has an additional advantage: slugs don't like its saltiness. Long an island nuisance, the slimy gastropods will usually look elsewhere for their evening meal.

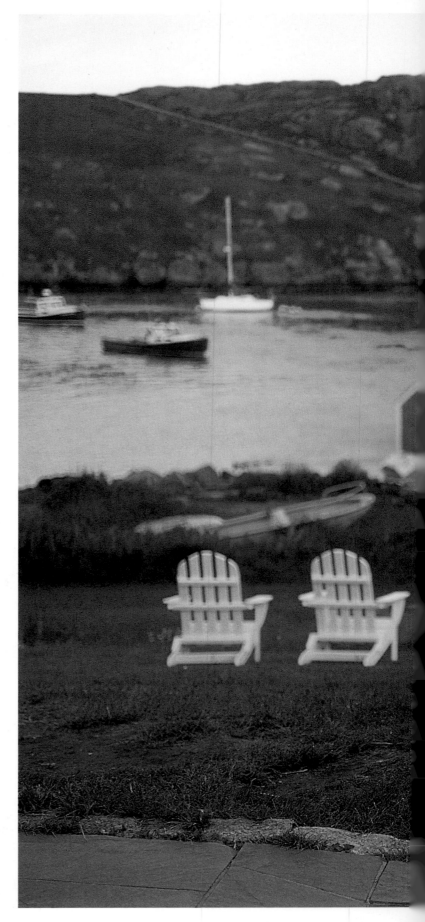

Daybreak on Monhegan Island illuminates bluish purple catmint and other hardy perennials that stand up to strong winds and sea spray.

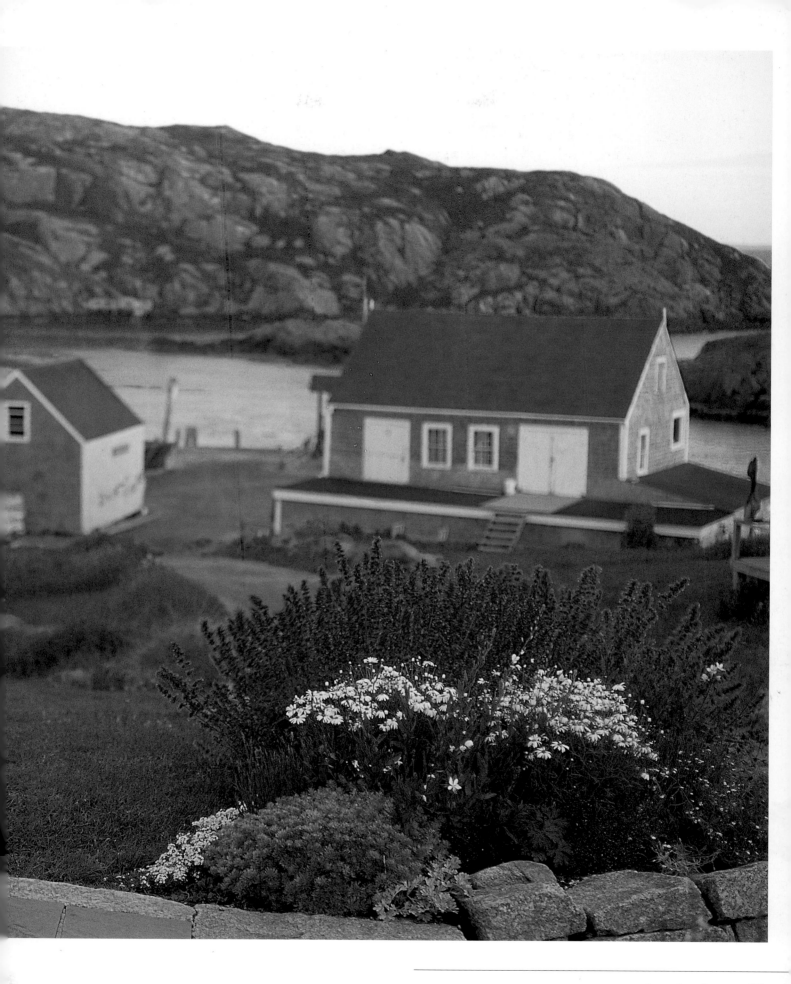

Above: Built in 1871 by Sylvester Blackmore Beckett—an attorney, ornithologist, and poet—the southern Maine castle-cottage required a complete renovation when purchased by its current owner in 1982. Lilies of all types, daisies, and other perennials now grace the once-abandoned site.

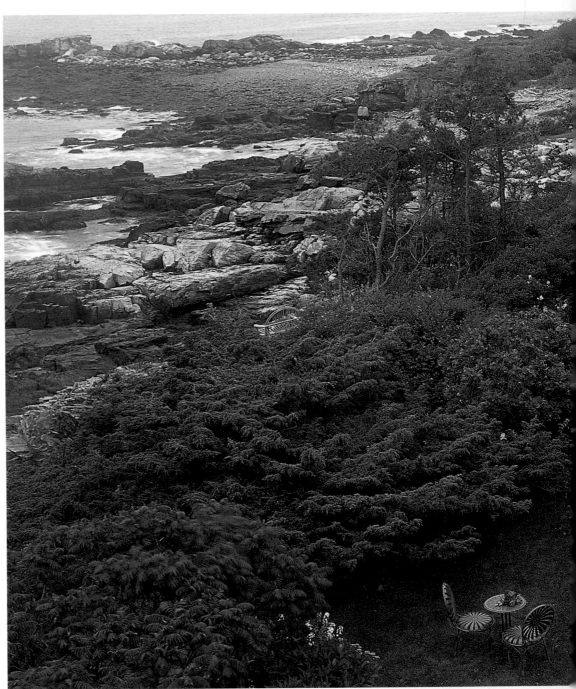

Farther east, in Southwest Harbor on Mount Desert Island, professional gardener Joy Lyons is likewise at the mercy of high winds that ravage her shrubs and dry out the soil. But she has another problem of equal gravity: deer. With each passing year the herd grows larger, she notes, leading her clients to construct fences at least five feet high. Although hedges of forsythia, spruce, and pine will help subdue the wind, they won't protect lilies,

dahlias, and delphiniums from the jaws of hungry fawns and their parents. The days of sowing favorite annuals anywhere she desires are long over. Only within the confines of a walled plot does she dare nurture cosmos, zinnias, and nasturtiums. Outside the fence she must plant defensively, selecting solely those plants she knows from experience the deer won't touch. These include catmint (in fact, all members of the genus *Nepeta*), lavender, poppies

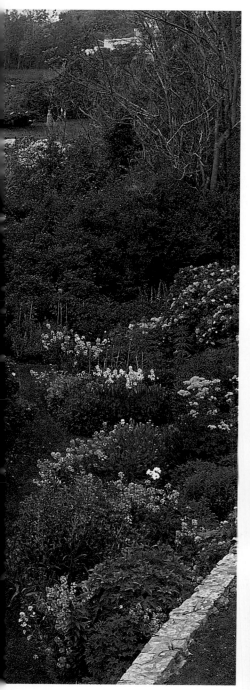

Left: More than a hundred varieties of roses flourish at Beckett's Castle, where every cubic inch of soil had to be trucked in. To protect her roses in winter, the owner waits for the soil to freeze, then applies composted cow manure to the depth of one foot. In spring, she removes the cold-weather "blanket" and distributes it among other perennials.

Below: Colorful annuals on the windswept porch of a 1906 cottage at Moody Beach, in Wells, must be set in large, heavy containers, but around the corner, the perennial bed benefits from a sheltered southern exposure. Here, Maureen and Steve Quill and gardener Helene Lewand, of Blackrock Farm, raise hydrangeas, roses, and sedum with great success.

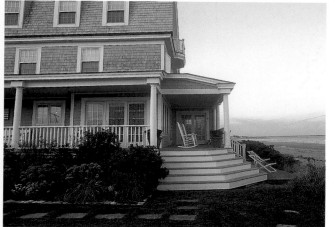

Bottom: About two hundred feet from the water, a former tennis court has been reborn as a glorious cutting garden. The board fence stands five feet tall to temper the wind and keep out marauding deer. Guests enjoy peeking over the scalloped gate to admire immaculately weeded rows of vegetables, herbs, and flowers.

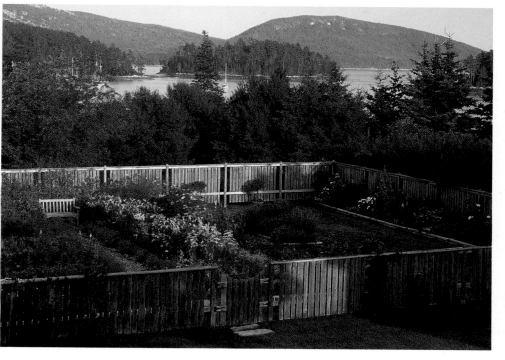

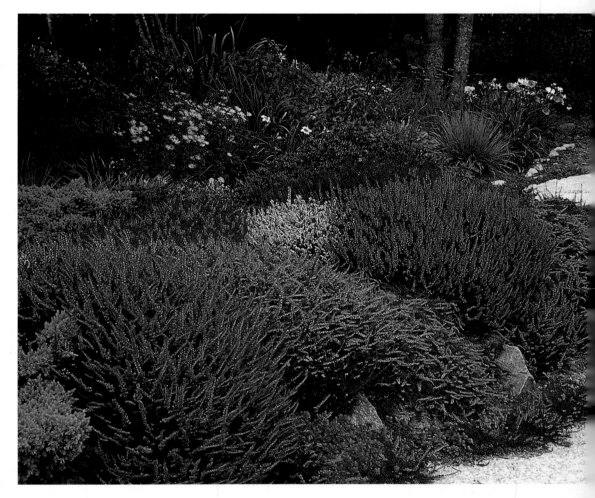

For nine years, heathers in the Great Wass Island garden of Dr. Chuck Richards have proved impervious to gale-force winds and salt spray. Daylilies and junipers make good bedfellows.

(all types), artemisia, salvia, and sage. Quite by accident, she has discovered that her favorite fertilizer, made from fermented salmon, also deters browsing deer and rabbits, and fights mildew, too. Enhanced with vitamins as well as amino and fatty acids, this all-organic by-product of Maine's fish processors can be diluted with water, then sprayed on foliage. It may also be sprinkled on newly planted seeds to stimulate germination and around the base of plants to promote root growth. (Fermented Salmon Fertilizer is produced by Coast of Maine [207-345-9315], maker of compost-based soils and fertilizers.)

In autumn, after most annuals have been killed by frost, Joy Lyons boosts the health of her plants still further by digging in ample amounts of cow manure, obtained from area farms. (As more and more farms give way to development, she can't help wondering what she will use in the future.)

Then, in December, she covers the gardens in her care with a three-inch blanket of hay weighted down with brush. "I don't worry too much about any weed seeds that might be in the hay," she says. "The weeds will be blown in anyway. I'll be dealing with them in the spring no matter what I do." Any leaves raked up from elsewhere on the property are also deposited on garden beds.

Regardless of the severity of the winter, the wetness of the spring, or the dryness of the summer, some plants simply keep on thriving. At his renowned Great Wass Island garden, botanist and retired plant taxonomist Dr. Chuck Richards cultivates with great successes many ericaceous plants, among them dwarf rhododendrons *(R. impeditum* 'Purple Gem' and *R. i.* 'Little Gem'), bog rosemary *(Andromeda glaucophylla)*, and other heath family members. Hardy heaths include *Erica carnea* 'Springwood Pink', a low, spreading shrub with tiny rose-

Beach Beauties

The wildflowers and foliage plants that bedeck Maine's beaches provide helpful clues for gardeners in search of foolproof plants to try at home. Many, such as broom *(Cytisus scoparius)* and wild morning glories *(Convolvulus arvensis),* have lent their genes to today's showy hybrids, making those hybrids good bets for tough conditions. Just above the high-water mark, beach plants thrive despite (or because of) high winds, salt spray, and acidic soil. Some of these plants are even edible; beach peas can be cooked just like their domesticated cousins, although not everyone appreciates their rather dry texture. Others are strictly beautiful, offering a quiet charm appreciated by many garden-ers. Much loved, in particular, is Scotch broom, with flowers that last at least a week in a vase. Savvy beachcombers know the golden rule of foraging: Never touch a plant without determining its status first. Threatened or endangered species must be left unmolested. Moreover, before eating any wild plant, obtain a positive identification.

Clockwise from top: Beach pea; wild morning glories (hedge bind-weed); broom

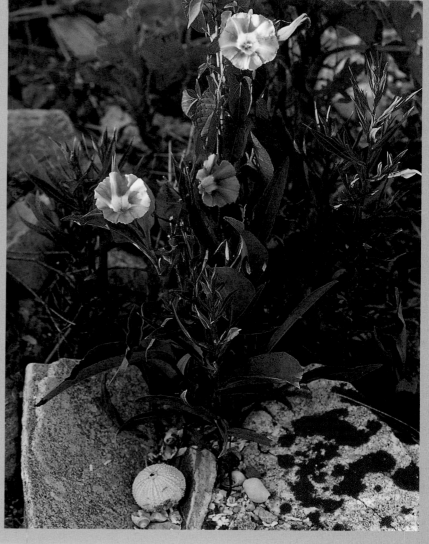

colored, tube-shaped flowers in early spring. Heathers recommended by Dr. Richards include *Calluna vulgaris* 'County Wicklow', whose mauve, bell-shaped blooms in summer are much favored by pollinating insects. Acid-loving heathers should be planted in full sun, he advises, in soil amended with plenty of peat moss. Heathers need supplemental watering in periods of drought, Dr. Richards notes, because peat dries out quickly.

Other good bets for coastal gardens include the justly famous rugosa roses. Although many roses can indeed be "rather troublesome customers," as Beatrix Farrand once put it, the rugosas bloom furiously (and sometimes repeatedly), are not subject to black spot or mildew, and seldom contract diseases of any kind. In return for no pruning or staking, they give decades of joy. Commonly believed to be indigenous to New England, rugosas did not in fact reach North America until 1872, when they were imported from the Far East, says noted Maine rosarian Suzy Verrier. In the early years of the twentieth century, American, Canadian, and European

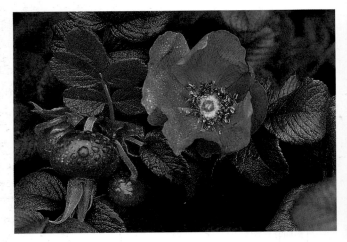

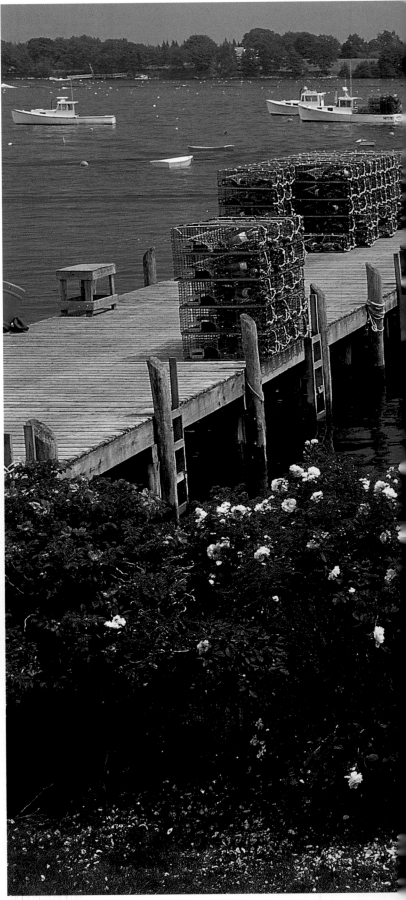

Above: *Rosa rugosa* 'Rubra', the red-flowering form of the true species rugosa (which varies in color from pink to crimson), boasts a sweet fragrance that travels with the sea breezes. In autumn, large edible hips make this six-foot shrub a key player in oceanfront gardens.

Right: Hybrid rugosas (so named for their wrinkled, or rugose, leaves) line the shore at the Duckett family cottage in Friendship. Deadheading encourages rebloom and keeps the shrubs tidy.

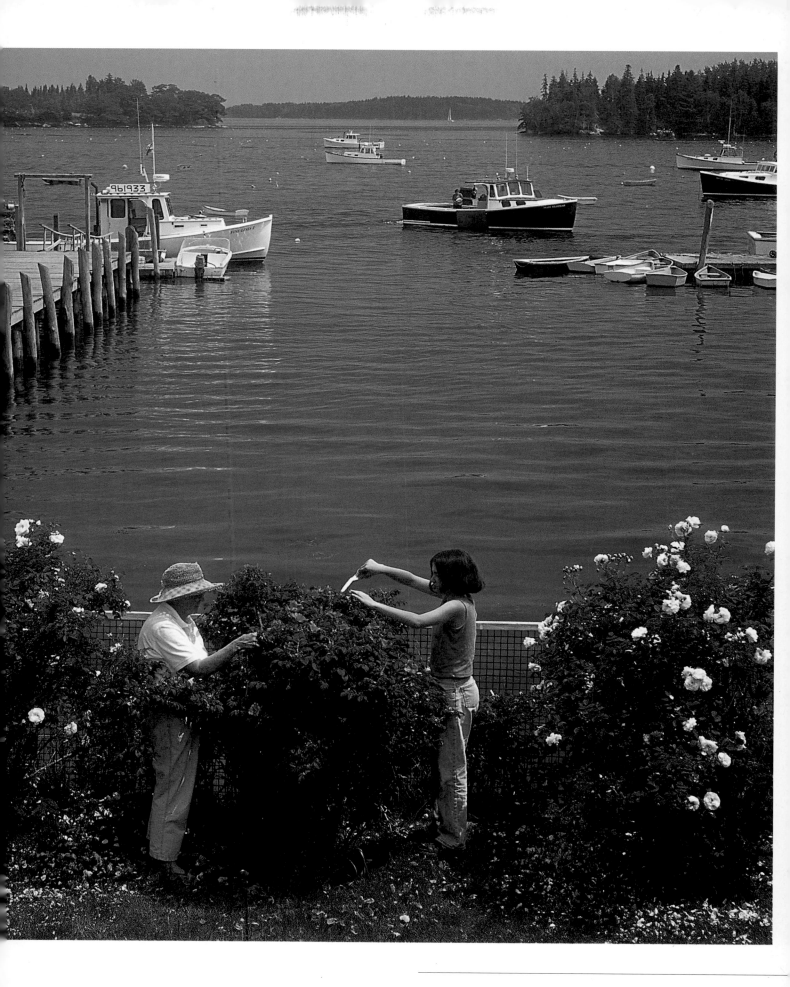

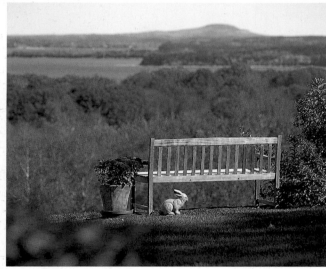

Seating placed correctly turns a garden into a room with a view. **Above:** Bill Phinney made the stone couch, or "Mother Nature's sofa," as he calls it. **Left:** Ideal for moments of quiet reflection, the classic wooden bench will turn silver with time.

Right: Deep blue hybrid delphiniums, orange Asiatic lilies, and red pelargoniums lend painterly richness to the garden of artists Morris David Dorenfeld and Robert Davis in Spruce Head. Granite blocks that define beds and pave walkways were hauled from a local quarry and cut at the site by the gardeners themselves.

hybridizers began crossing *R. rugosa* with hybrid teas, damascenas, floribundas, ramblers, and other types to produce a gallery of highly scented, easy-care beauties, some with fully double blossoms. Extremely hardy and adaptable, rugosas quickly naturalized up and down the seacoast. Today, what many people think of as "wild beach roses" can be cultivated in home gardens in a wide variety of forms and colors.

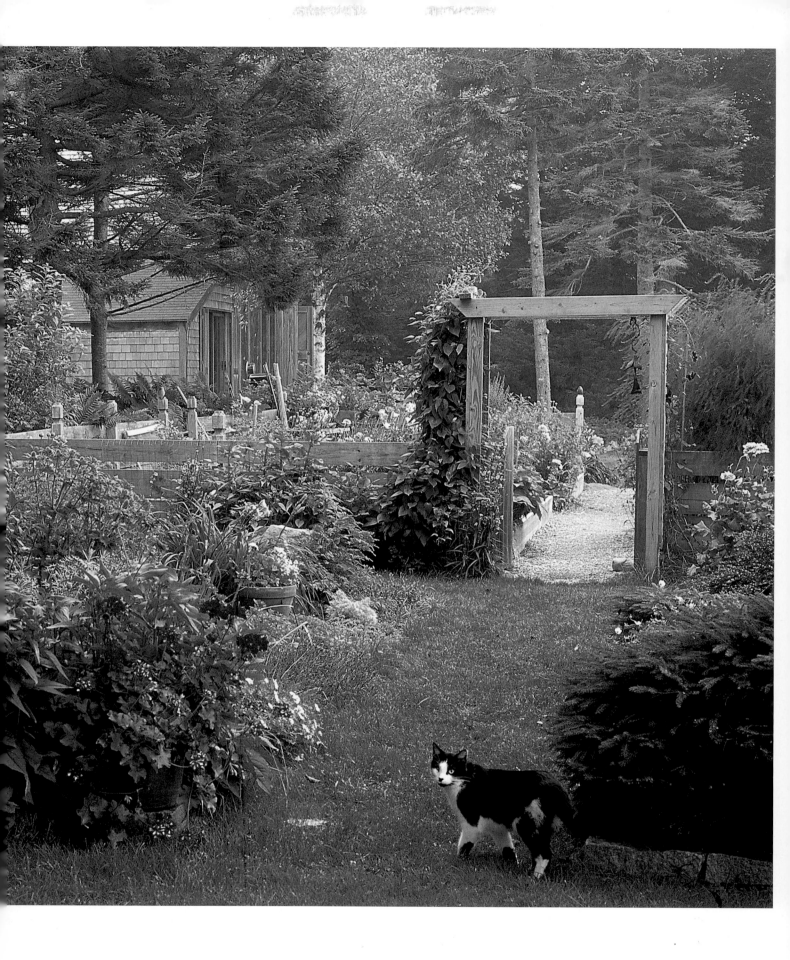

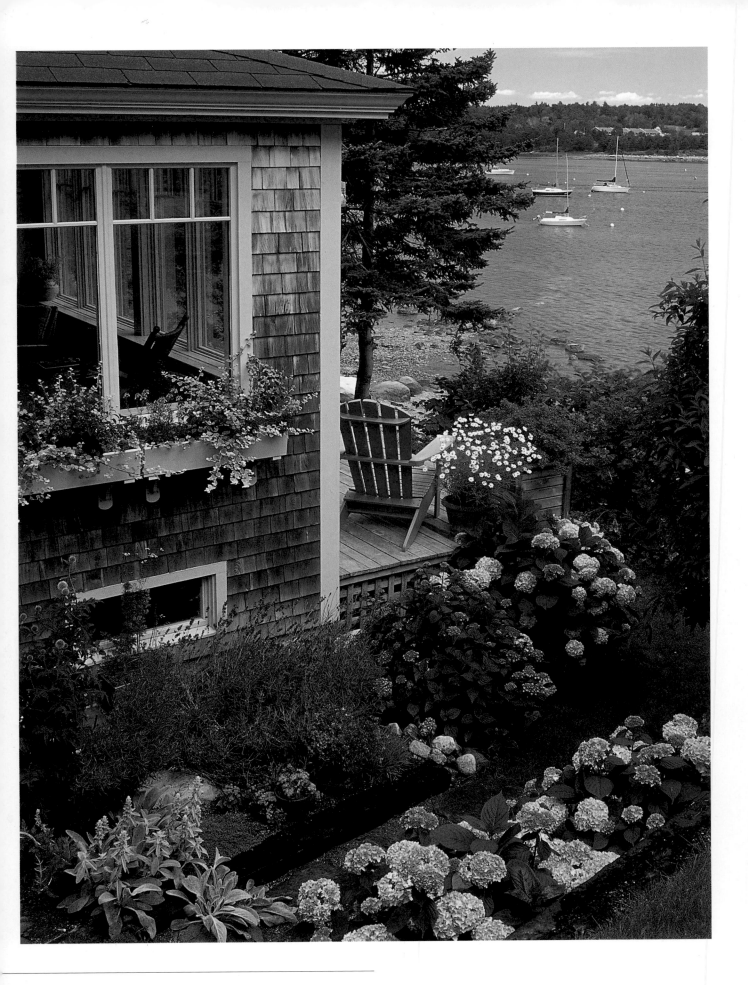

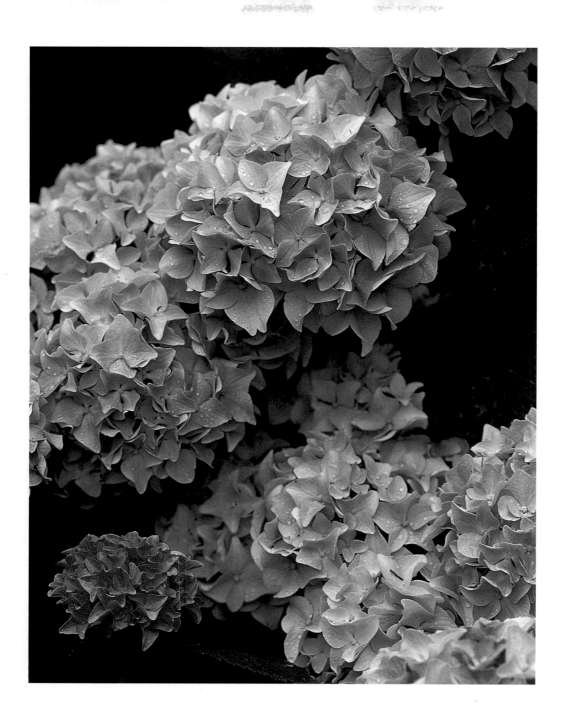

In the Belfast garden of
Susan Weinz and Daniel
Krajack, hydrangeas
(*H. macrophylla* 'Nikko Blue')
harmonize with the deep
blue sea and the cottage's
painted trim.

Glorious, old-fashioned hydrangeas offer yet
another reason to celebrate the coastal climate.
Whereas *Hydrangea macrophylla* 'Nikko Blue' might
perish from cold just thirty miles inland, this much-
loved shrub manages quite well when exposed to
the warming influence of ocean currents. In Belfast,
Susan Weinz and Daniel Krajack have watched with
pleasure as the hydrangeas they planted in 1995
grow increasingly robust. Shrubs are top-dressed in
spring and fall with plenty of compost, and each is
treated to a half cup of powdered aluminum sulfate
to "blue up" the bush. In late winter, Mr. Krajack

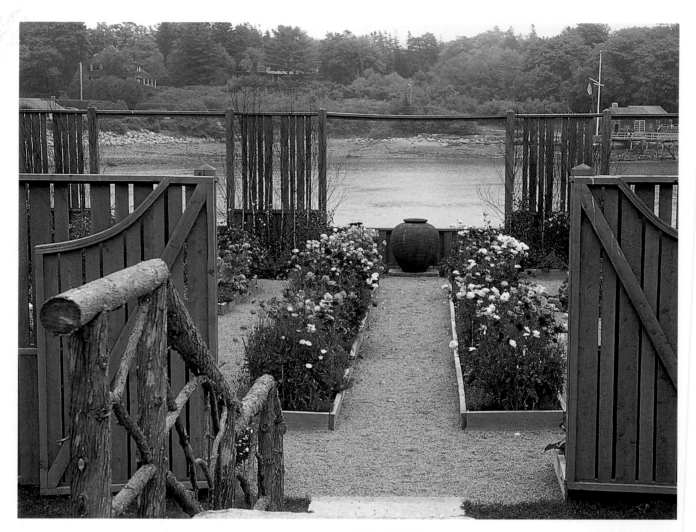

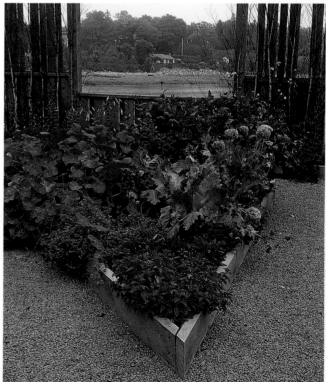

removes dead wood and cuts back branches to where new buds begin, stimulating new growth and encouraging ever larger flower heads. The shrubs face south and enjoy the protection of the couple's picturesque cottage.

Across Penobscot Bay, in Harborside, another unlikely hydrangea causes an annual sensation when it puts on a grand show come July. For six years, Arletta Ashe has been nurturing a stand of blue lacecaps *(H. macrophylla* 'Blue Billow'), which conventional wisdom holds simply is not hardy north of Zone 7, or perhaps Zone 6 with protection. In Ms. Ashe's Zone 5 garden, the lacecaps sit happily in their own microclimate at the base of a slope. Protected from high winds by a stand of evergreens and a greenhouse wall, the eye-catching shrubs don't even receive full sun. Ms. Ashe doesn't cut them back, and she feeds them solely with fish-based compost.

Opposite, top and bottom: Raised beds fill a coastal court where tennis balls once reigned. Large "windows" keep the air moving while preventing animals from sampling tasty lettuce, dill, and edible flowers. Gravel paths stay dry in wet weather and cut down on weeding.

Right: 'Butter and Sugar', the first nonfading yellow Siberian iris, was hybridized by Dr. Currier McEwen in the 1970s. From his South Harpswell test garden, the famed plantsman has been introducing iris cultivars since the 1940s.
Below: Dr. McEwen shares his trial beds and his botanical adventures with both professional and amateur horticulturists, always reminding visitors that Siberian iris are in fact native to Europe, not Siberia. The tough plants thrive in Maine's acidic soil.

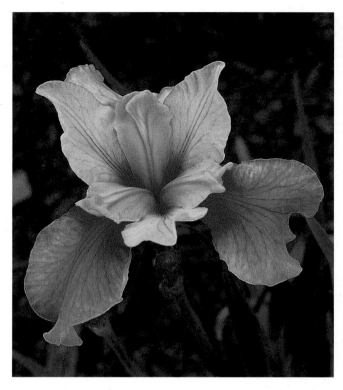

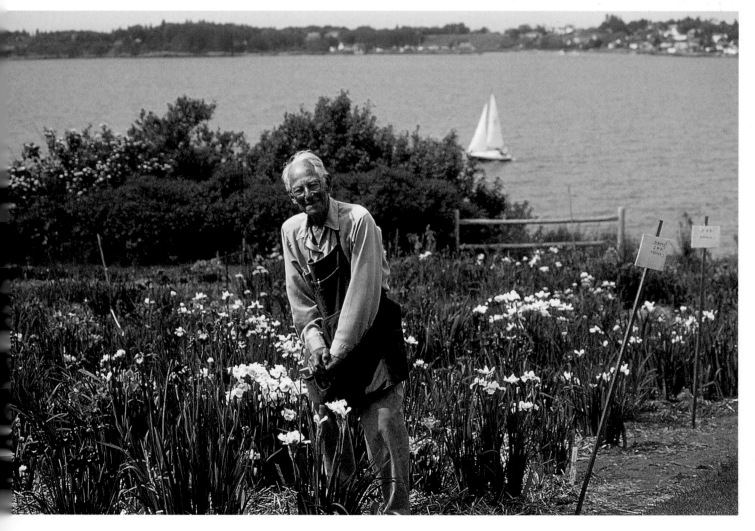

Above: Plants that thrive on the coast include 'Hidcote' lavender, nurtured by veterinarian George Holmes in his Northport office garden. Dr. Holmes keeps his plants high and dry in a south-facing bed raised six inches above ground level.

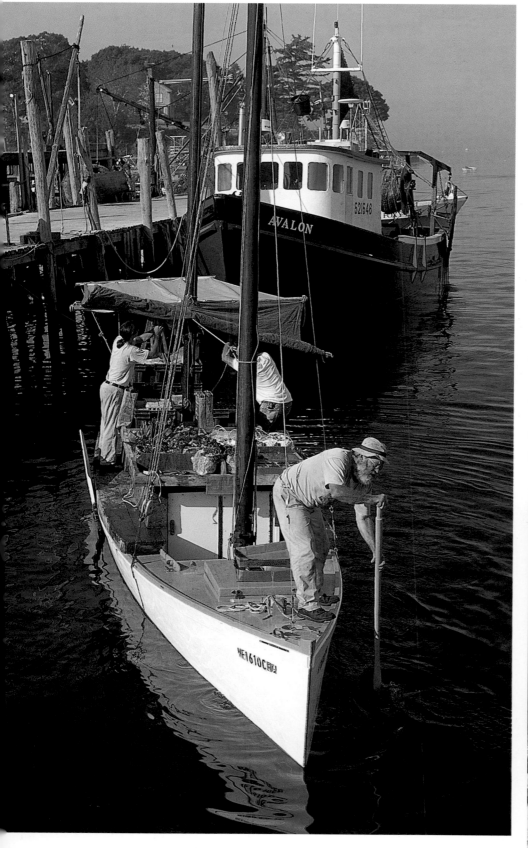

Left: The market boat from Merrymeeting Farm, in Bowdoinham, departs South Bristol to deliver produce to waiting islanders. Dubbed the *Beth Alison,* the thirty-four-foot New Haven sharpie is a reproduction of boats used a century ago to harvest oysters from Long Island Sound. Delicious cargo includes tomatoes, mesclun, raspberries, pencil-thin green beans, and other organic produce raised by David Berry and his family.

Below: Fully understanding that humankind does not live by organic produce alone, Alison Berry prepares to provision the *Beth Alison* with buckets of gladioli grown on the family farm.

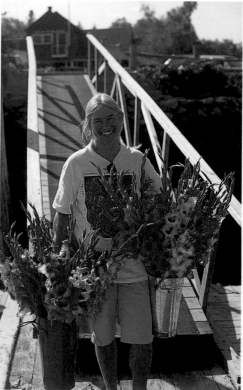

Maine's gardens by the sea are full of surprises. Perhaps the greatest surprise of all, though, is the satisfaction that gardeners feel when they prevail against the odds. Never inclined to admit defeat, the resourceful men and women who have created these well-designed landscapes are consistently and richly rewarded.

Below: On Barters Island, near Boothbay, a terraced hillside that follows the sweep of the cove provides ample room for daylilies, rugosa roses, and low-growing rock-garden plants.

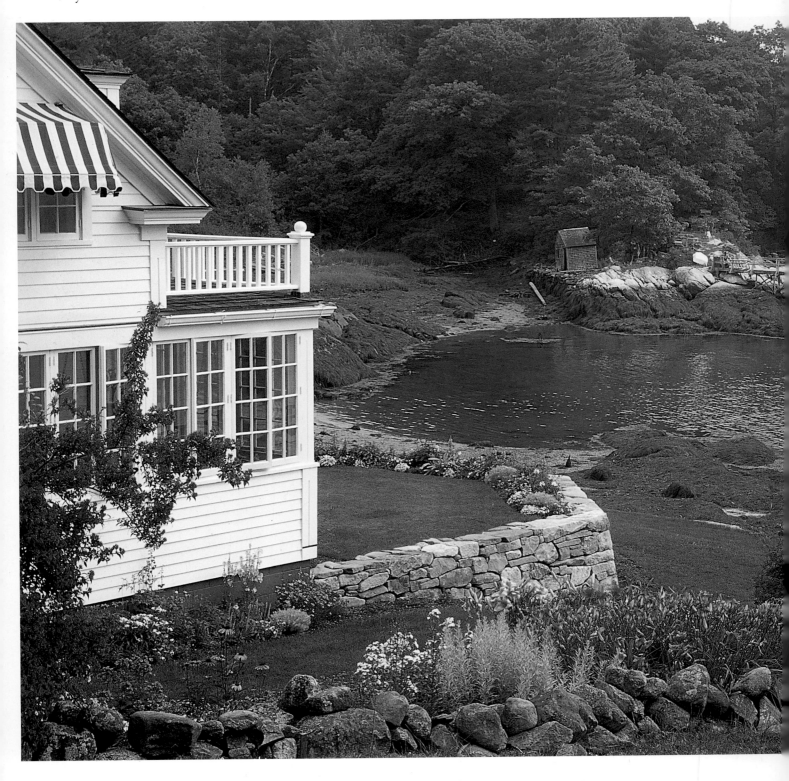

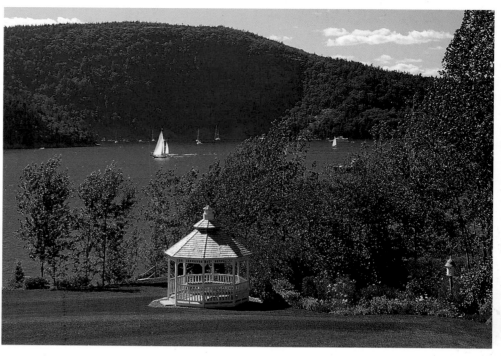

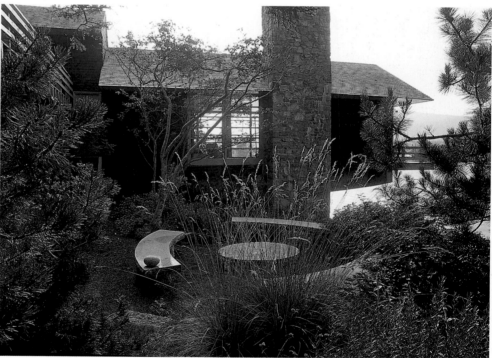

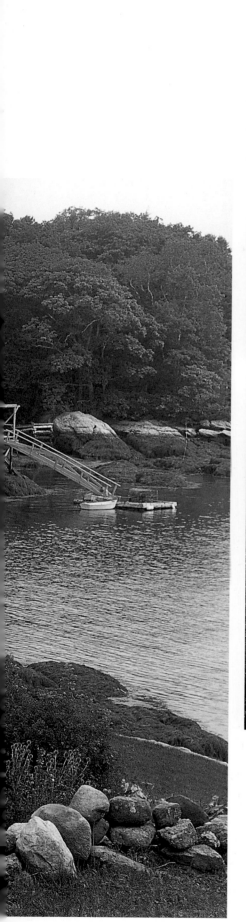

Top: The sea view takes center stage in this classic Northeast Harbor setting. Trees temper the wind and supply privacy; a romantic gazebo offers shelter from late-afternoon thunderstorms.

Above: Understated elegance reigns in a down east garden where the emphasis is on ornamental grasses and shrubs both deciduous and evergreen.

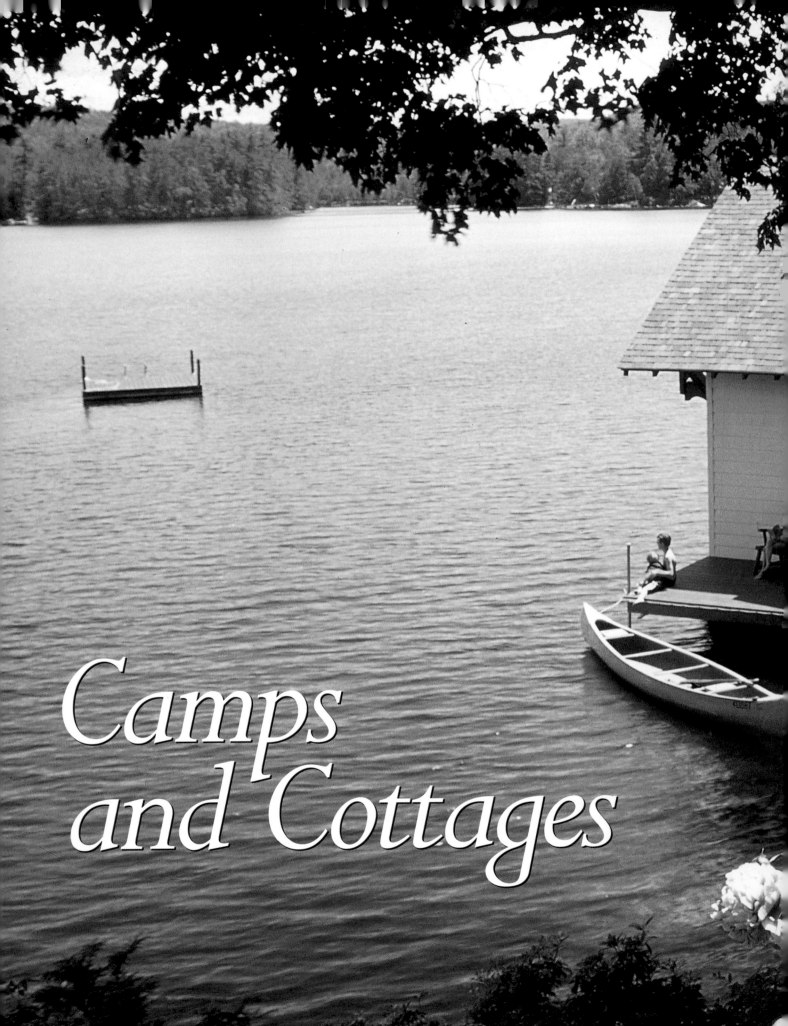

Camps
and Cottages

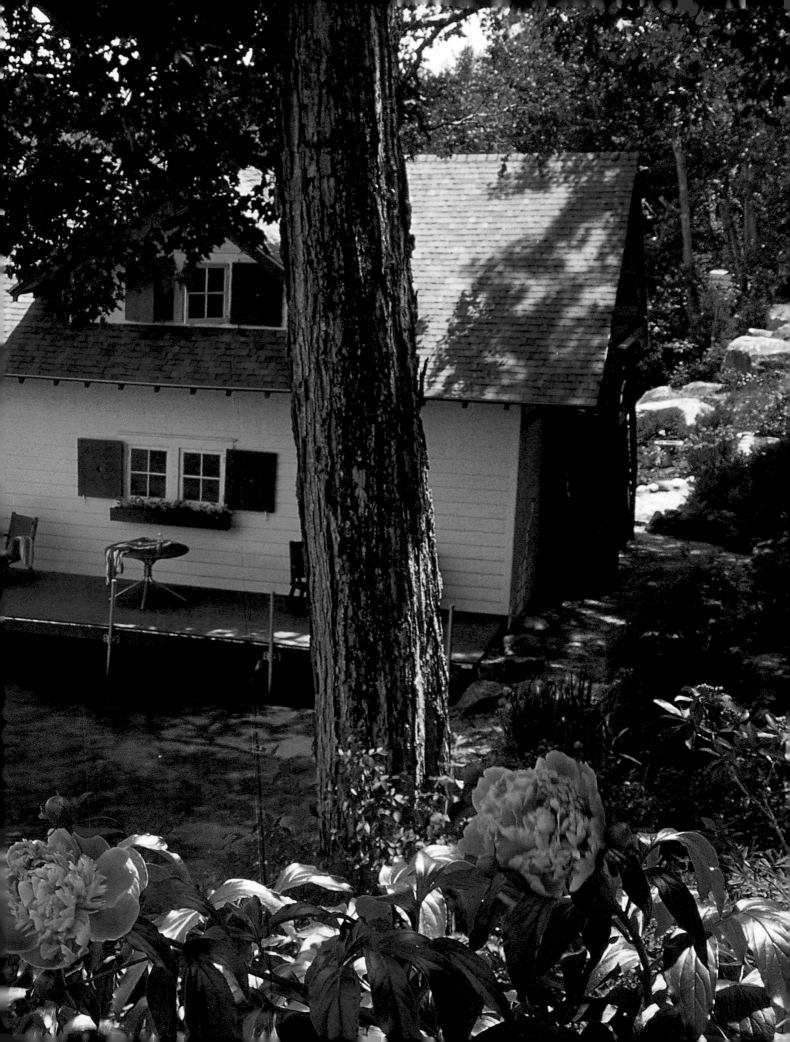

Pine-scented air, shadowy forests carpeted in ferns and wildflowers, sparkling lakes, loons' cries, neon fireflies, bushes heavy with ripe blueberries: it's a potent mix, and those who sample it in youth sometimes spend their entire lives trying to repeat the experience. The most successful camp gardens take their owners back in time, to a place where having fun in Mother Nature's living room was the chief reason for living.

In Brooksville, Alice Ann Madix thought back to her own childhood and remembered another good thing about being outdoors in summer: getting away—not just from school or from grownups. "Everyone needs a private, special place," believes Ms. Madix, so, with help from carpenter David Kissel and artist and landscape designer Barbara "Choo" Whyte, she built a "garden and story house" for her granddaughter Grace. The red-haired six-year old uses her hideaway for reading picture books and serving tea to friends real and imaginary. The exterior walls of the diminutive dwelling are the backdrop for Grace's favorite annuals, among them 'Big Smile' sunflowers, Drummond phlox (*Phlox drummondii*), and sweet peas. A practical child, she also tends tiny 'Thumbelina' carrots and ever-bearing raspberries.

Previous page: Peonies announce the arrival of summer in Jenna and Scott Smith's Bryant Pond garden. Comfortably seated on the dock beside the restored boathouse, guests enjoy a tranquil water view backed by a hillside thickly planted with roses and mountain laurel dating back to 1915, when financier William Ellery built the camp for his wife, Bessie, a concert violinist.

Above and right: A sixteen-by-sixteen-foot story house features live-edge siding (boards with the bark intact), a decorative door by artist Barbara "Choo" Whyte, recycled windows, and a front porch just right for reading one's favorite storybooks.

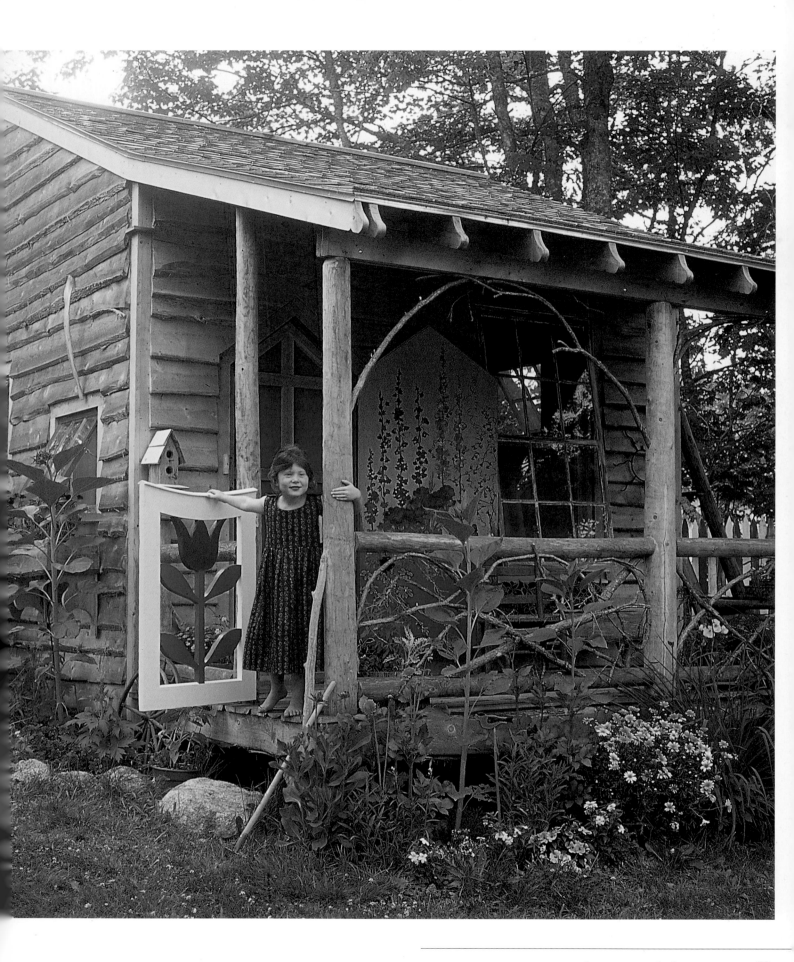

This page: Sometimes, "gardening" at camp means nothing more than tending a window box or two. White boxes planted by Alize Felton hold pink pelargoniums and silver dusty miller; beneath them, a fringe of eye-catching succulents resists the jaws of snacking groundhogs and deer. A box three windows wide accommodates the cook as well as passersby; bright-hued annuals and culinary herbs make happy companions. To accent the windows of a rustic sauna, a hollowed-out log packed with shade-loving impatiens adds color from June through October.

Opposite: On Long Pond, near Belgrade Lakes Village, nothing much has changed at Castle Island Camps since the first guests arrived in the late 1920s. The picturesque setting includes birch, maple, and ash trees, as well as signature towering pines. To perk up the circa 1928 lodge and cabins, owners Horatio and Valerie Castle fill planters and window boxes with deep-pink petunias, which bloom until frost, long after summer has become a memory.

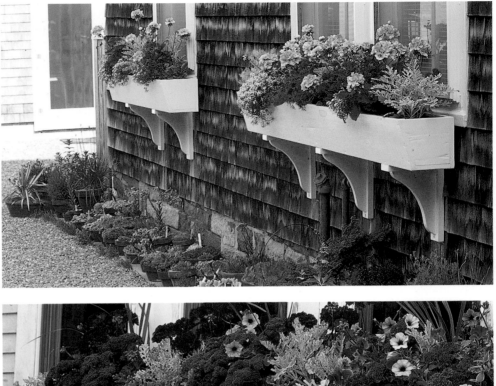

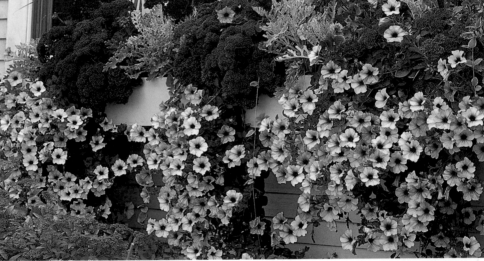

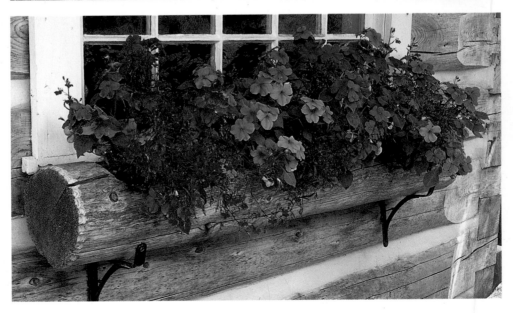

Around Grace's story house, cultivated plants mingle happily with natives. Even at a young age, Grace knows that wildflowers and plants that were already there when she started her garden help make her camp the special place it is.

Helping gardeners create landscapes that enhance rather than replace existing terrain is the business of Rick and Gail Sawyer, owners of Fern-wood Nursery & Gardens in Swanville, which specializes in shade and woodland plants. Before turning over a single shovelful of soil, gardeners are advised to ask themselves how much time they really want to spend in the garden. Landscapes that emphasize plants correctly chosen to suit specific conditions will free up the gardener for other pastimes, such as enjoying camp with family and

Right: Paths draw the eye and invite a quiet stroll. Especially effective are curved walk-ways, which even the mildly curious find irresistible. Options for romantic paths include pine needles accented by lush ground covers (**opposite**) or turf grass outlined in colorful flowers, as in Judy and Lincoln Paine's garden near Wiscasset (**right**).

friends. Low-maintenance ferns, cimicifugas, daylilies, ground covers, small native trees such as striped, or moose, maple *(Acer pensylvanicum),* and shrubs such as pagoda dogwood *(Cornus alternifolia)* can be especially valuable to gardeners with little free time, as well as to those who visit their camp in summer only. "Take a look around and see what's already there," Mr. Sawyer counsels. "For instance,

if you see ferns, you know they're a good bet." Areas that remain moist but not wet are candidates for ostrich fern *(Matteuccia struthiopteris),* whose newly emerging fiddleheads are edible. For locations where root competition is an issue, male fern *(Dryopteris filix-mas)* is worth considering. Royal fern *(Osmunda regalis)* and interrupted fern *(O. claytonia)* tolerate more sun than most species, up to several

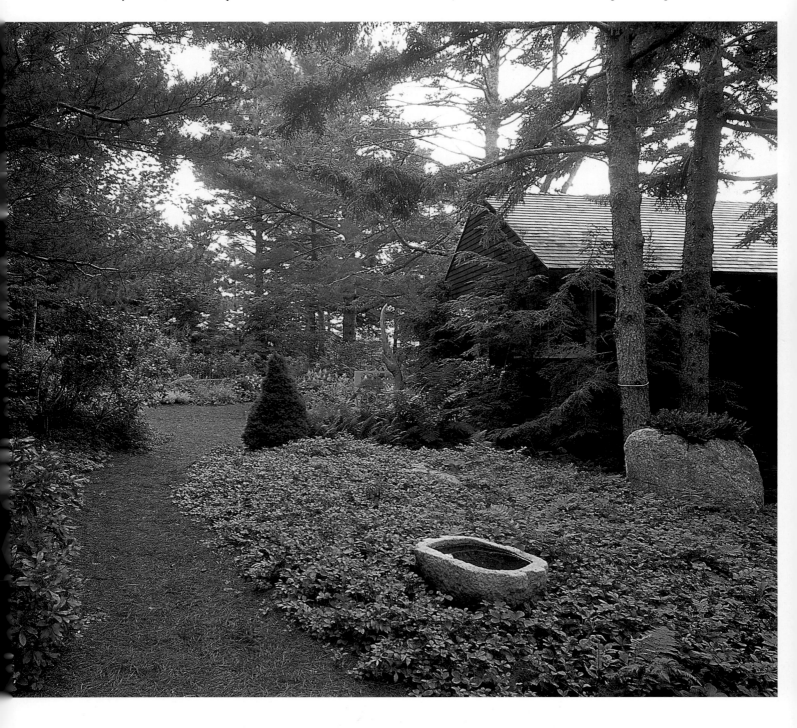

hours per day. Excellent as a background planting or to line a path or drive is cinnamon fern *(O. cinnamomea),* a tall, erect species with fronds two and a half to five feet long. All these ferns are extremely cold hardy (to Zone 3).

Another advantage of ferns is their ability to withstand repeated deer assaults, something that many wildflowers, including trillium, are unable to do. With the size of Maine's deer herd increasing rapidly, Mr. Sawyer notes that gardeners are shying away from many traditional shade-loving plants, including hostas, which animals will devastate almost as soon as they are planted. Replacing them in today's camp gardens is cold-hardy bowman's

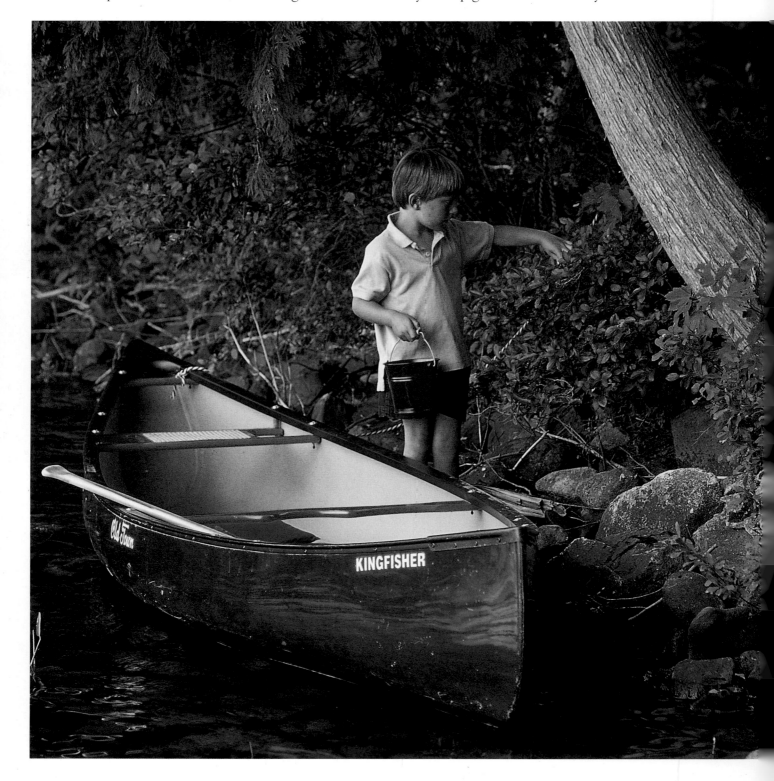

Wild highbush blueberry *(Vaccinium corymbosum)* that hugs the lake and holds the soil makes up the best "garden" a boy could ask for. Bumper crops, which arrive in alternate years, can be frozen and enjoyed all winter long. Highbush cultivars purchased at nurseries are useful when restoring a damaged shoreline. Good bets include 'Blue Jay', 'Bluecrop', and, for regions south of New England, 'Cape Fear'. Acidic, peaty soil is a must for successful cultivation.

root *(Gillenia trifoliata)*, a particular favorite of Mr. Sawyer; this three-foot perennial boasts star-shaped white flowers tinged with red throughout spring and summer. Other animal-resistant stalwarts include such native ground covers as wintergreen and bunchberry. Gardeners who must contend with deer are advised to avoid planting most maples, as well as hemlock, arborvitae, and cedar, in favor of ash, oak, and white pine. To safeguard a natural setting, Rick Sawyer counsels gardeners to mulch with shredded leaves, aged (partially decomposed) bark, and twigs, as opposed to fresh bark. "Groomed areas and paths will look just like the forest floor," he says. More important, gardeners should be mindful of potential runoff when disturbing the natural contours of the land. Residue from soil amendments may end up in lakes, streams, and groundwater, as will chemical fertilizers. Before disturbing the soil, it's best to observe the land over the course of four seasons to note all the plants already established there. Some favorite wildflowers, such as lady's slipper and trillium, may leave no visible traces during their dormant season.

Elements that can turn a plain-Jane homesite into a charming "camp"-style garden include window boxes, paths, fences, and stone walls. Window boxes, in particular, are well suited to life in the woods. For one thing, deer most often cannot reach them easily, and even if they can, only extreme hunger will induce them to do so. Another advantage to windowsill horticulture is that herbs and even miniature vegetable varieties can be cultivated at arm's length. Some gardeners enjoy mixing salad

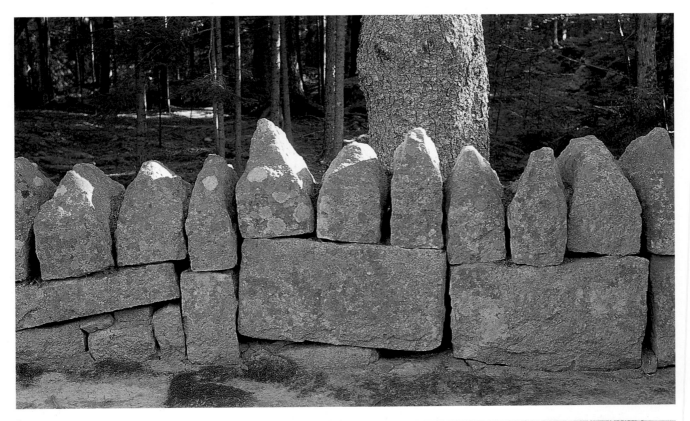

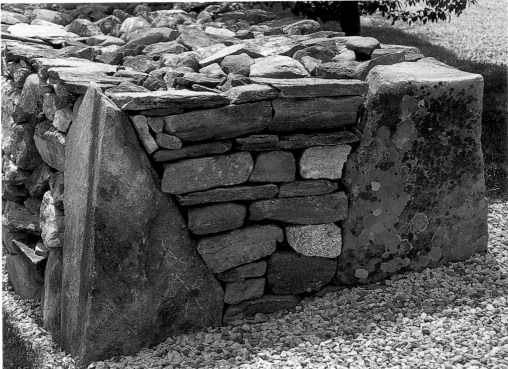

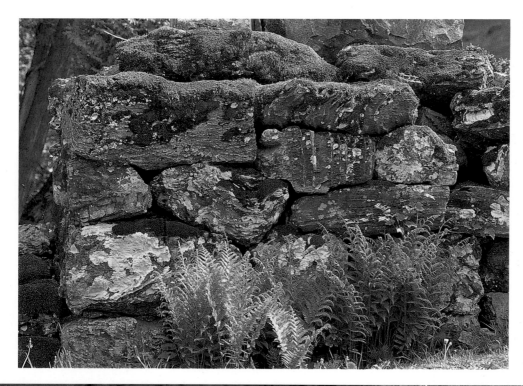

Throughout New England, stone walls are as varied as their builders' imaginations. Mortar is seldom used; it could shatter in winter's freeze-thaw cycles, when the earth literally moves. Some walls become especially beautiful over time as mosses and lichens take hold, softening the rough surfaces. Powdered sulfur sprinkled on stone surfaces and paths will encourage mosses to grow.

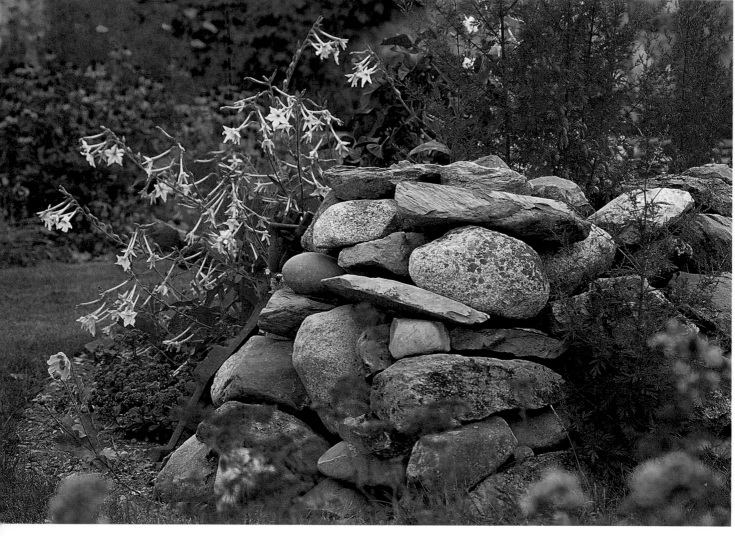

greens and herbs with nasturtiums, dianthus, and other flowers for cutting. Window-box annuals, perennials, and herbs should be grouped according to shared needs: sun lovers separate from shade lovers, for instance. Plants that require supplemental food or frequent watering will fare best in the company of like species.

Key to a successful camp or cottage garden is the understanding that plants are only part of the picture. Toads, butterflies, spiders, birds, and foxes are all essential ingredients in the great environmental stew that makes "camp" so special. Some gardeners who wish to fit in with the scene rather than dominate it never disturb the soil around their house. In South Bristol, naturalist, artist, and author Sharon Lovejoy and her husband, Jeff Prostovich, garden only on their porch, in containers. Fragrant herbs and flowering vines are specially chosen to attract pollinating insects and birds—hummingbirds, in particular. Passionately fond of spiders, Ms. Lovejoy points out that arachnids—like dragonflies, birds, butterflies, and moths—occupy central positions in the web of life. Her inviting porch doubles as laboratory and art studio; here, the naturalist records her observations in watercolor. Hummingbirds probing nasturtiums for nectar,

Near Christmas Cove, a seventy-year-old cottage once served as a boy's camp bunkhouse. Sharon Lovejoy and Jeff Prostovich opted to leave the grounds surrounding their home intact and "planted" their porch instead. Containers of insect-attracting flowers include nasturtiums (trained on a twig tripod) and trailing yellow Dahlberg daisies. Through the screen door (made by Waldoboro craftsman John Otterbein, of the Wooden Screen Door Co.), visitors can glimpse John's Bay.

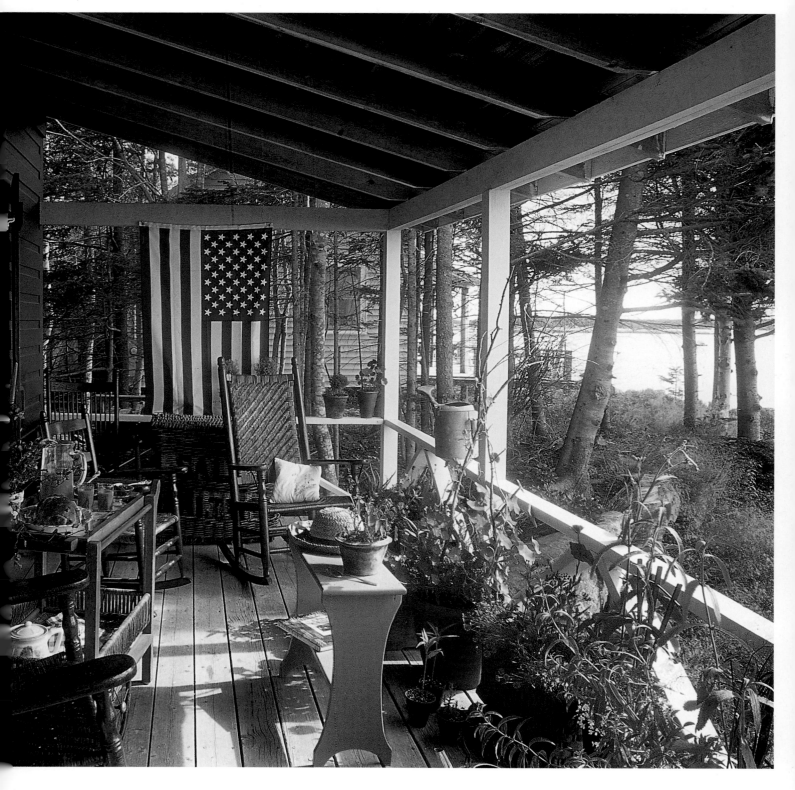

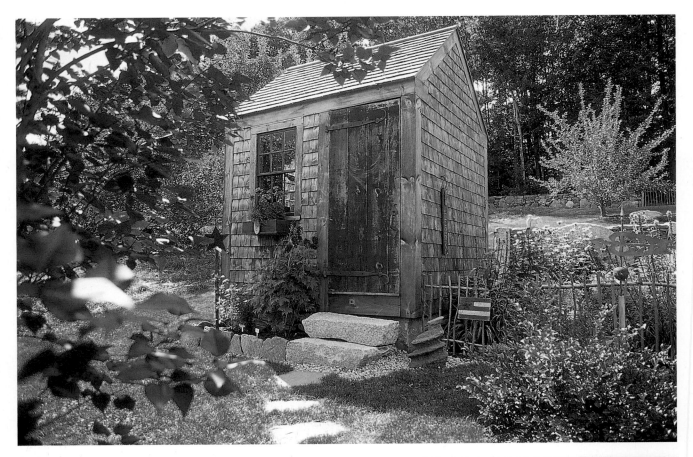

Above: In Debra and Guy Paulin's Limington garden, an old two-seater outhouse is now a weathered toolshed. Beside it, snapdragons, hollyhocks, and foxgloves fill a garden that butterflies cannot resist.

Right: Near Damariscotta, an outbuilding does double duty as a storage shed and handy surface on which to train flowering vines.

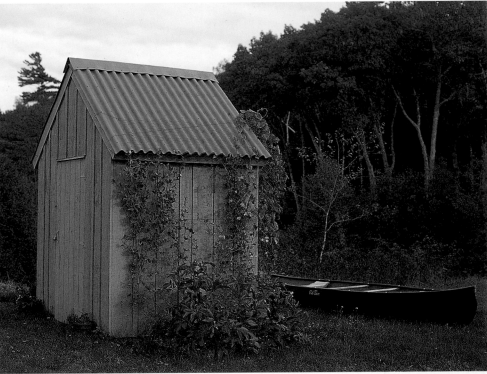

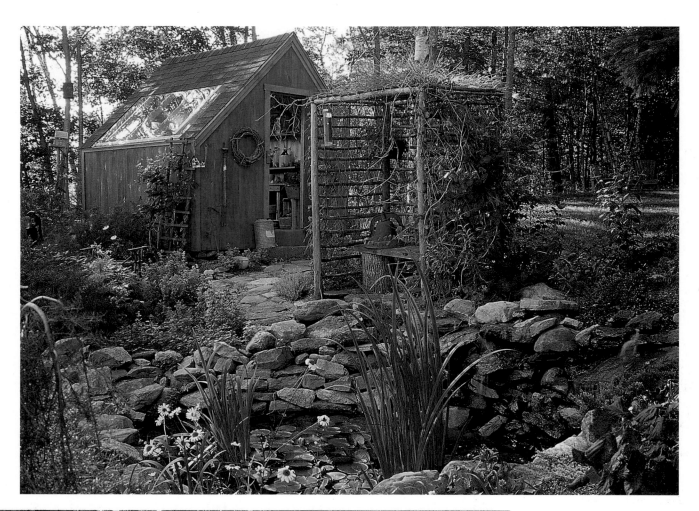

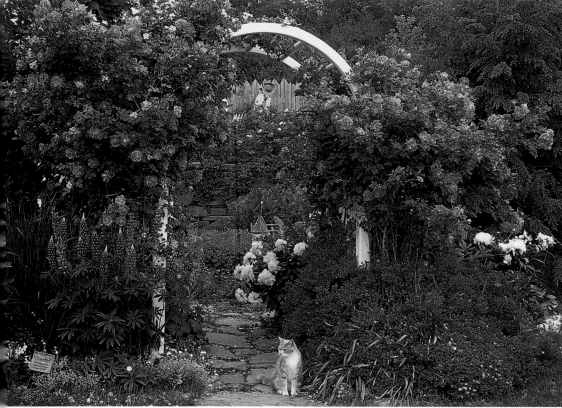

Above: In the village of Brooks, Audrey Muir used cedar saplings and alder branches felled by winter storms to fashion a rustic arbor for an extra-hardy 'Dropmore Scarlet' honeysuckle. For stability, she set the cedar corner posts in cement.

Left: In Judy Paine's garden, on the banks of the Sheepscot River, hardy 'William Baffin' roses scramble over a classic white-painted arbor.

and bumblebees and butterflies exploring the charms of lemon verbena, sweet alyssum, and fragrant nicotiana are all likely subjects. Deliberately left unscreened, the porch is also where Ms. Lovejoy and Mr. Prostovich take many of their meals. The occasional noisome mosquito is viewed as nourishment for spiders. "This property is perfect as it is," says Ms. Lovejoy. "I don't want to make a ripple."

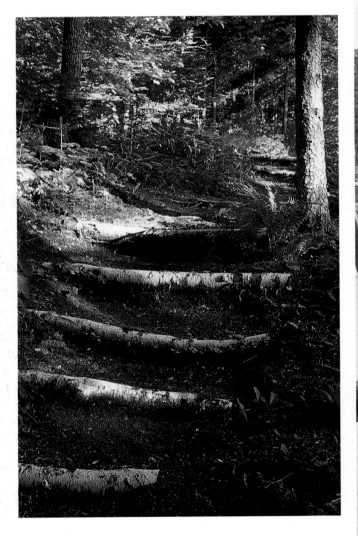

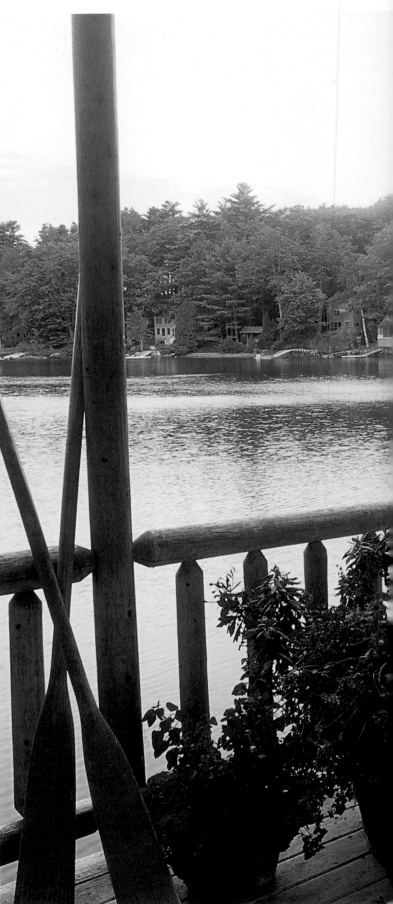

Above: Steps created from birch logs encourage further exploration. The most inviting staircases and paths are made from indigenous materials (stone or logs, for instance), which harmonize with their surroundings.

Right: Pots of colorful annuals and fragrant herbs perk up the east-facing deck at Mary Alice Foster's Lake Megunticook cottage. The pots spend most of the day on the cottage's sunny south side and are moved to the deck just before company arrives.

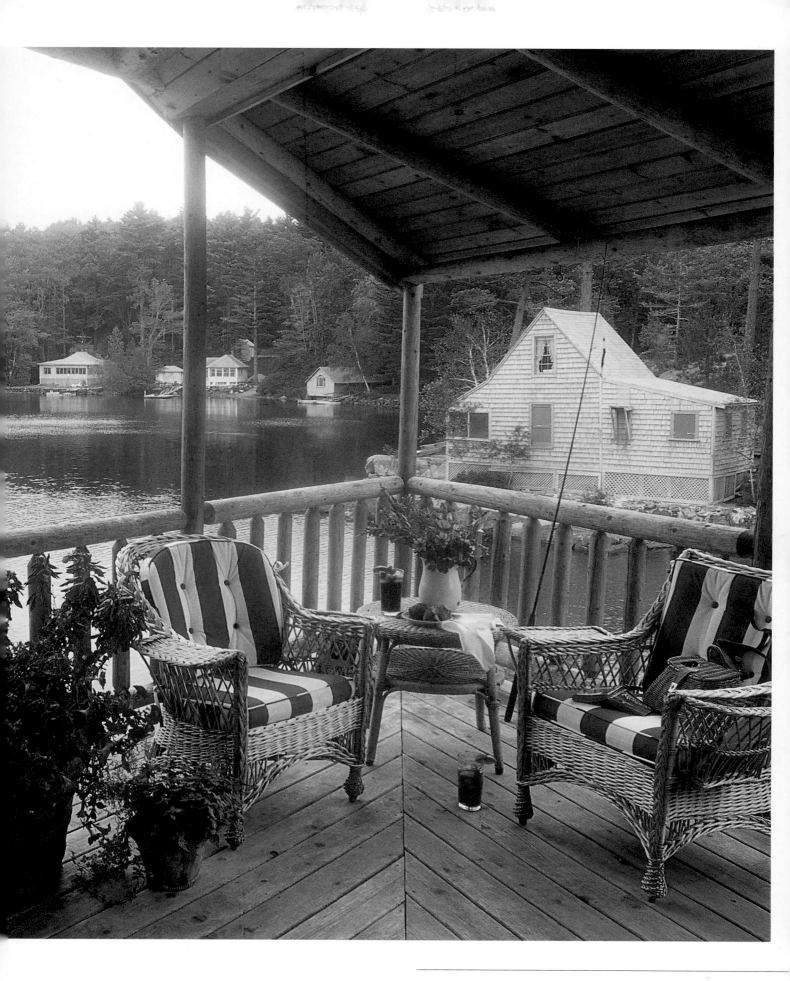

Fenced In

Fences can be used to mark property lines, create privacy, or prevent deer, groundhogs, and rabbits from eating up the entire contents of the family vegetable patch. In Colonial times, fences were usually required by law to exclude livestock, which freely roamed the streets of towns and cities. Fences can offer handsome support for top-heavy plants (shrub roses, for instance) or flowering vines, including sweet peas and morning glories. Moreover, they can serve as a backdrop for mixed borders of annuals, perennials, and herbs. In addition to traditional picket fences (painted white or protected with an easy-care opaque stain), free-form twig fences can be fashioned from pliable willow or from maple or alder saplings. Wattle fences, popular in medieval times, are also making a comeback.

Below: A cedar fence built in the 1930s by John Allen and Howard Perver surrounds land once used by E. B. White to pasture his cow.

Right: A whimsical fence of alder saplings took shape on the spur of the moment, without any preconceived plan.

Right: Few can resist the romantic appeal of 'Carefree Beauty' and 'Bonica' roses cascading over Grace Wetherill's white picket fence in Wiscasset.

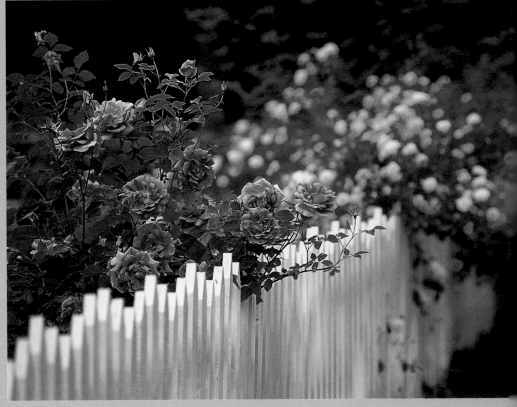

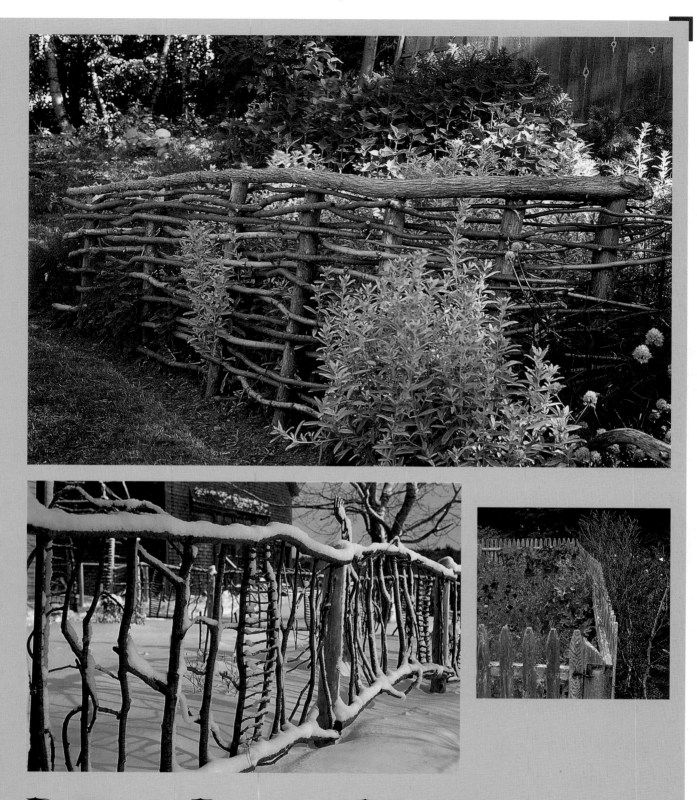

Top: A basketlike wattle fence of bent alder keeps Audrey Muir's herb and perennial garden looking tidy.

Bottom left: An alder fence at Waldoboro's Well-Tempered Kitchen is the work of artist Anne Cox, of Martinsville.

Bottom right: To the right of a weathered picket enclosure, a second "fence" of stacked brush supports climbing sweet peas.

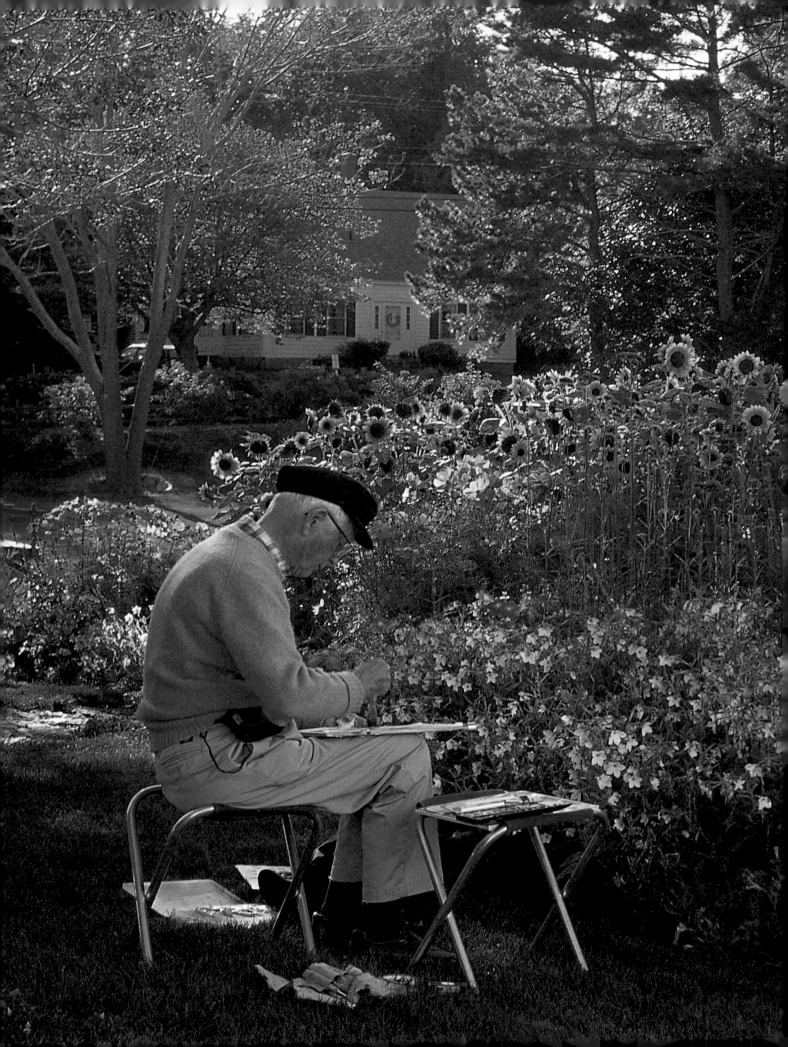

In Town

More than half of all Maine residents live in cities and towns that owe much of their charm to generations of devoted gardeners. Habits of thrift and ingenuity, intact since the eighteenth century, have produced compact landscapes of remarkable diversity. Traditional dooryard plots (originally enclosed by fences to keep out marauding livestock) have evolved into painterly cottage gardens, rose gardens, French-inspired *potagers,* formal topiary gardens, and informal tapestries of native wildflowers and ornamental grasses. All can be glimpsed behind (and sometimes in front of) Maine's garden gates.

Confronted with a short growing season, town gardeners often spend years perfecting their garden's "skeleton"—the walls, hedges, pergolas, large evergreens, and other architectural elements that lend interest even in deep snow. Gardens with good "bones" are useful year-round, enjoyed from behind a picture window on a cold winter day or as an inducement to venture outside. No one knows this better than Dr. Stephen Huyler, a writer, photographer, cultural anthropologist, and self-described "spiritual gardener." Together with his wife, Helene, Dr. Huyler transformed his family's flat 1.2-acre lot in Camden into an all-season oasis unusual for its

Previous page: An artist succumbs to the charms of an in-town garden at the Ogunquit Museum of American Art, in Ogunquit.

Right: Stone walls in the Huyler garden shelter spring-blooming bulbs and creeping phlox. Tulips bloom ahead of schedule owing to warmth radiated by the rocks.

Opposite top: Carpeted in grass and enclosed by vine-covered walls, a circular "room" is just one of eight in Stephen Huyler's Camden garden. A block away from this verdant oasis, the traffic of Route 1 speeds on by.

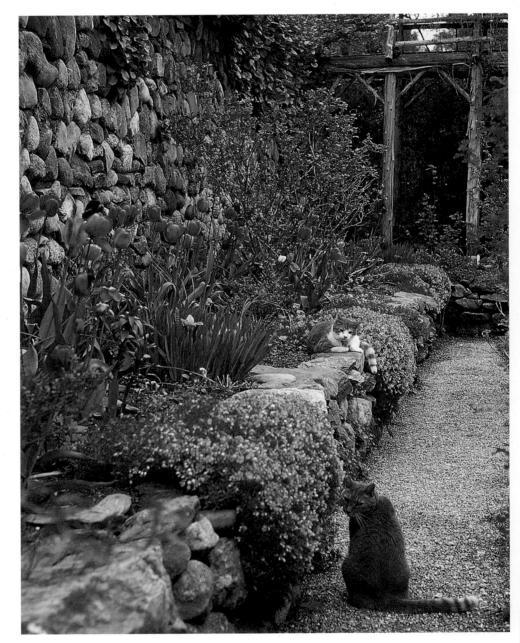

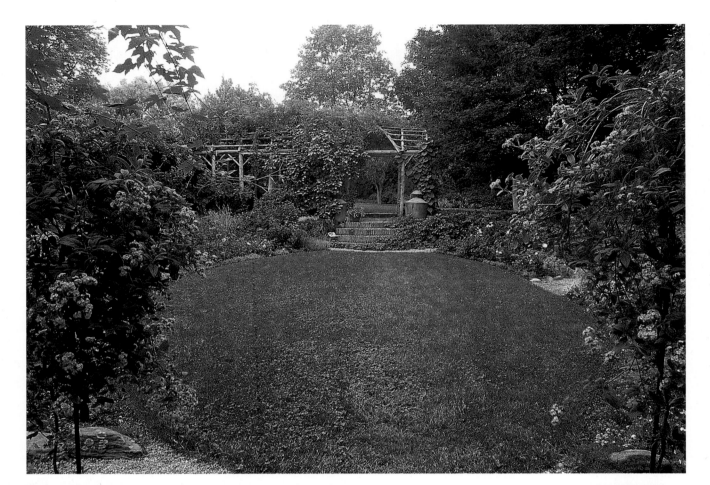

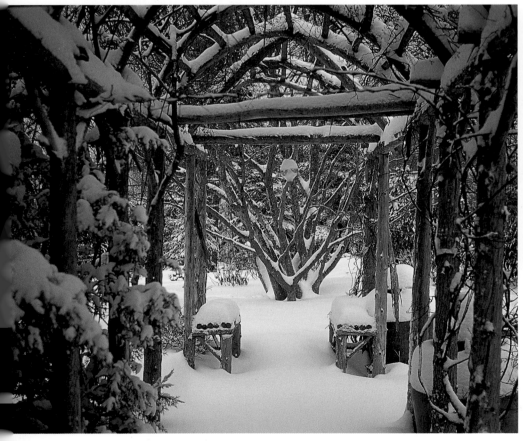

Left and above: Created from long-wearing cedar logs, Stephen Huyler's rustic pergola entices visitors no matter what the time of year.

organic symmetry. "We started with nothing," Dr. Huyler recalls. To create the walls that divide the garden into eight distinct areas, he visited neighborhood construction sites and offered to remove unwanted rock. The dry-stacked stones (five hundred tons' worth) now furnish a backdrop as well as support for more than twenty-five hundred plant species, many selected and cared for with help from professional gardener Beth Long. The handsome walls also create a microclimate for old roses and perennials that require protection from stiff sea breezes.

From the start, a chief goal was to enhance the

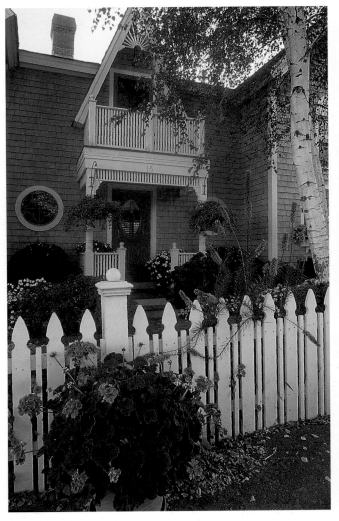

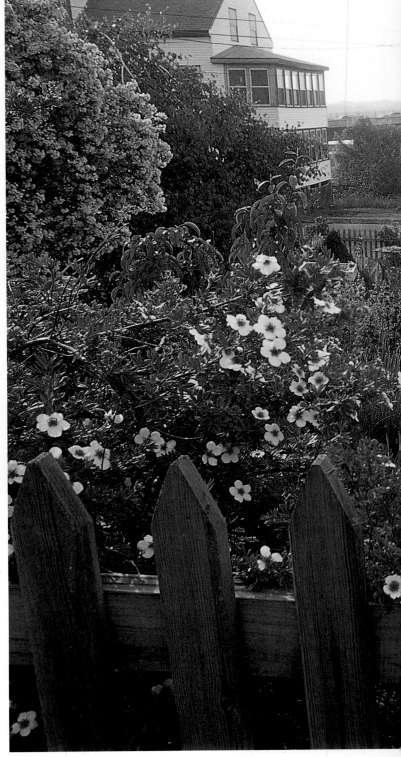

Above: In Ogunquit, pelargoniums and other bright-hued annuals enliven the façade of Bill Stremmel's contemporary dwelling. The picket fence and white-painted house trim intensify the colors still further.

Right: In Portland, Polly Peters and Bear Blake have transformed a once desolate site near downtown. Picket fences enclose their half-acre of evergreen shrubs, English roses, phlox, nicotiana, and other annuals and perennials.

natural setting and explore what Dr. Huyler calls the relationship between man and plants. "There is something we can gain from one another, a mutual enrichment," he believes. In pursuit of harmony, he designed the garden's beds to echo forms found in nature. An S-shaped antique apple tree, for example, lent its curvaceous outline to a border of robust perennials. Nearby, a rustic cedar arbor, cloaked in hardy kiwi vines and Dutchman's pipe, appears to have risen out of the ground entirely on its own. Whether strolling silently on the path that winds through the woodland garden, or seated

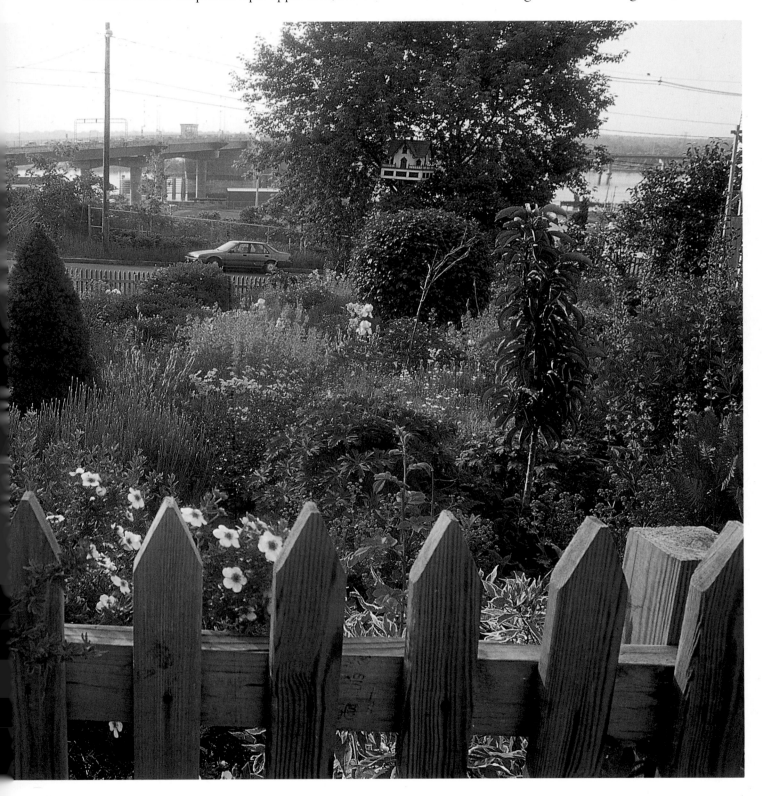

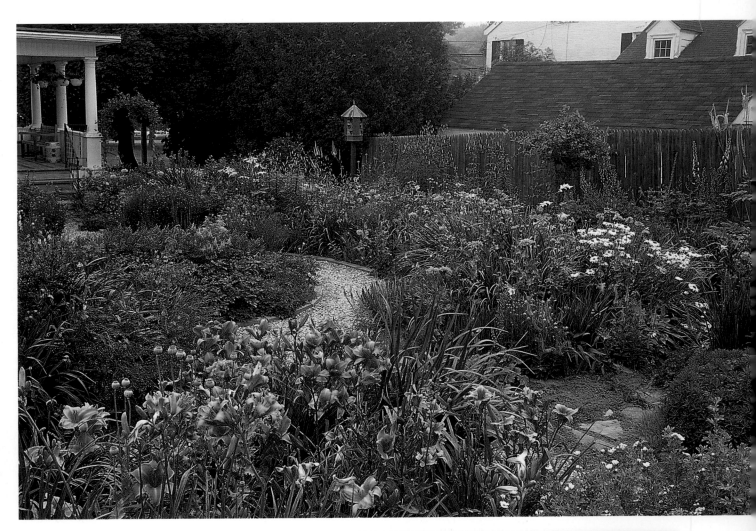

comfortably on the artfully laid brick terrace, visitors quickly recognize the garden's contemplative style of beauty. Often on the road in the course of his work, Dr. Huyler is never mentally very far from his garden. "At least once a day, I make the spiritual connection with it, no matter where I am."

Like Stephen Huyler, Belfast gardener Muriel Krakar took an architectural approach when designing her garden. To give her in-town plot year-round interest, she and her husband, John, erected arbors and defined beds with low walls of stone. A network of crushed limestone paths connects mass plantings of Siberian and Japanese iris, a broad range of lilies, and herbs. Edged in granite, the paths discourage weeds and drain quickly in wet weather. The quarter-acre garden sits in full view of passersby, who can't help but be attracted to Mrs. Krakar's luxurious mix of perennials, roses, and herbs. Although the large number of plants and the

Top: Lilies, herbs, Chinese tree peonies, and Siberian iris grace a central Belfast garden formerly filled with rubble and broken shopping carts. Muriel Krakar cleared away the rubbish and turned the site into a neighborhood showplace. **Above:** Hostas, bloodroot, lungwort, and foxgloves light up a shady spot, illustrating the art of designing with foliage.

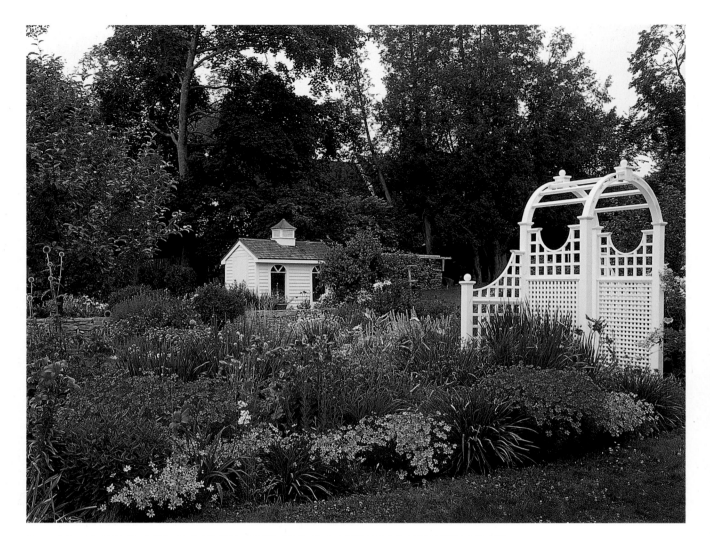

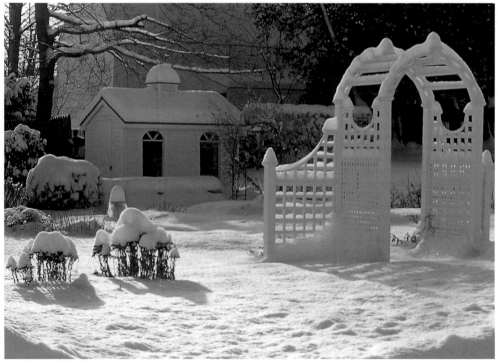

An arbor and a Colonial-style toolshed built by a local carpenter serve as year-round focal points. In late fall, Muriel Krakar cuts back only some of her perennials, leaving others to catch and hold the snow.

garden's exquisite design draw the eye, to be sure, more striking still is the robust good health of every flower and shrub.

It's all in the compost, Mrs. Krakar is happy to explain. Tucked out of sight near a Colonial-style toolshed sits the chipper-shredder used by John Krakar to make what many believe to be Belfast's richest humus. Twigs, leaves, and plant clippings, composted for several weeks, are slowly fed into the shredder. A separate pile holds grass clippings and kitchen waste, composted to an internal temperature of 140 degrees Fahrenheit. This "green" matter is then combined with the shredded "brown" matter and stored in large containers near the shed. Mrs. Krakar uses the nutrient-rich "black gold" to top-dress flower beds and to amend the soil at planting time. In general, she avoids mulch, because it prevents the *Nigella damascena* and foxgloves she loves so well from self-sowing. Although mulch does suppress weeds, "I'd sooner till the soil," she says.

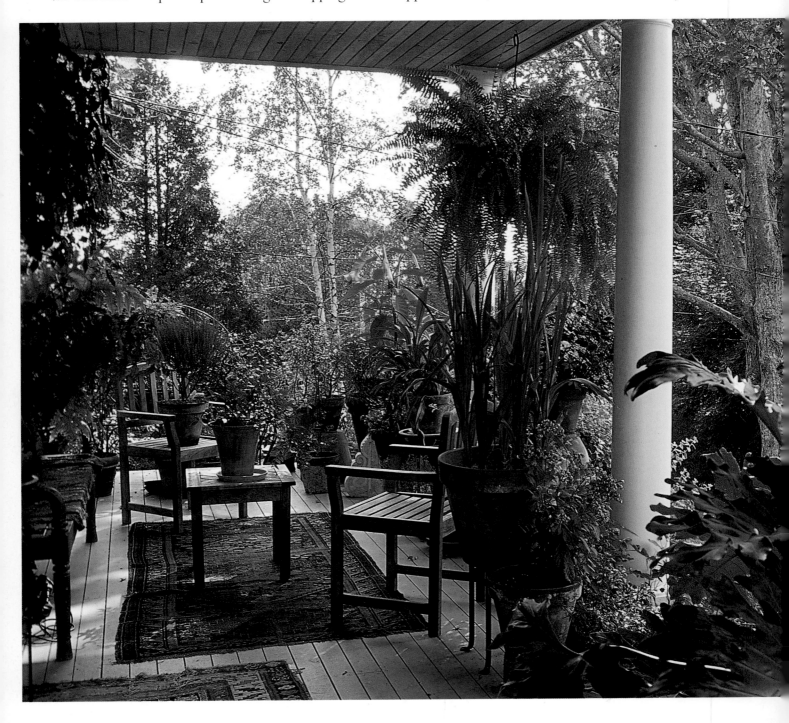

Right: In historic Hallowell, up the hill from the Kennebec River, a gracious veranda connects house and garden. Robert and Judy Demos completely restored the 1825 property.

Left: For town gardeners with little land, a porch can provide opportunity for experimenting with plants raised in containers. On Carleton Leavitt's Rockport porch, houseplants enjoy a summer vacation.

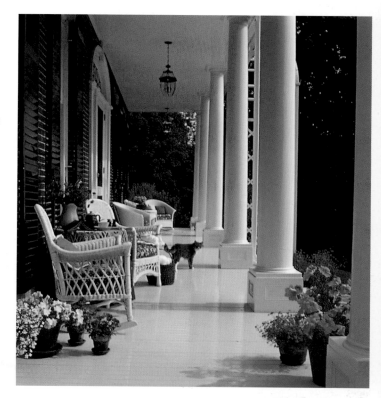

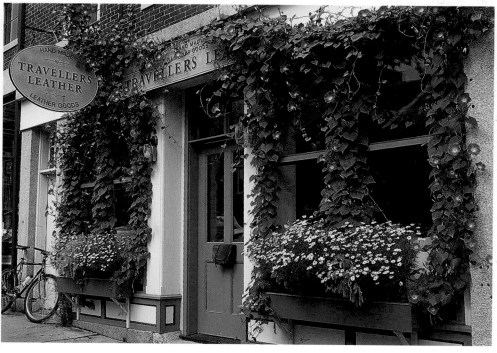

Above: Like outdoor draperies, morning glories frame the windows of Travellers Leather, in downtown Belfast. Owner Robin Lawlor and gardener friend Sheila Coombs filled window boxes with potted seedlings, then ran twine between the boxes and the wooden trim above the windows. Conscientious watering (three times a day during dry periods) encourages a steady succession of pretty blue flowers. While conventional wisdom mandates regular application of fertilizer, Mr. Lawlor finds supplemental feeding unnecessary.

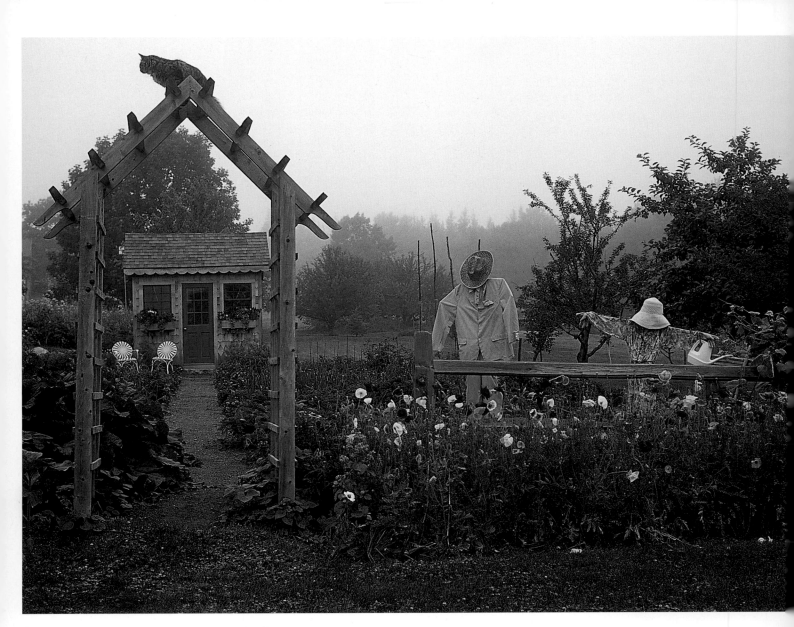

Above: A well-dressed couple stands watch near Leslie Clapp's vegetable garden as the famous Blue Hill fog rolls in. Soon scarlet runner beans will scamper up and over the arbor.

Whereas some gardeners, such as Muriel Krakar, are pleased to share their work with their neighbors, others prefer a little privacy, thank you very much. Picket fences and tall hedges keep the outside world at bay. Houses with minuscule front yards may boast backyards of generous proportions, where gardens offer sanctuary to family and friends as well as animals. In Blue Hill, professional gardener and photographer Leslie Clapp and Blaise De Sibour have what may be the roomiest in-town backyard in the state—ten acres in all. A small farm since the mid-nineteenth century, the property lies close to the town's center and recalls a time when farms were smaller and villages more compact. The 1868 house itself affords privacy for the herb gar-

Below: A gazebo fitted with screens offers relief from mosquitoes. To define the bed of lavender, lilies, lamb's ears, and other perennials, Leslie Clapp built a low fence of twigs.

Bottom: Terraced beds make every inch count in Joe Medina's Falmouth Center garden. Japanese maples and weeping birches help screen the garden from a busy intersection nearby. In the foreground, near arching junipers and variegated euonymous, thyme and creeping phlox spill over a stone wall.

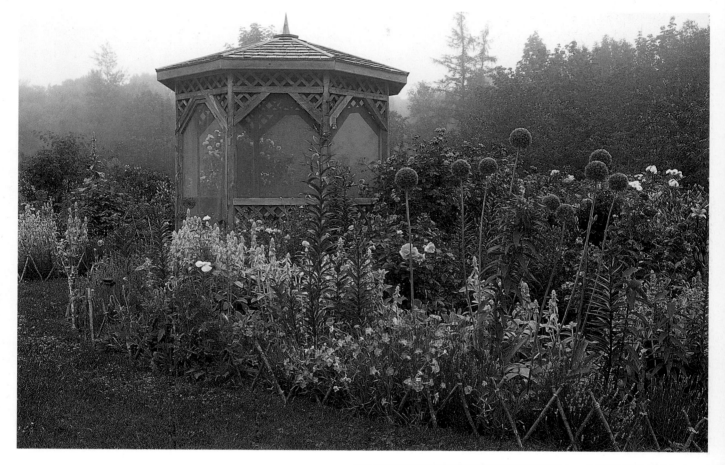

den that lies directly behind, while several other garden "rooms" owe their aura of seclusion to fruit trees, arbors, and a gazebo. These and other structures also anchor the various plots and provide focal points for Ms. Clapp's naturalistic plantings of native plants and low-maintenance perennials. A thirty- by ninety-foot vegetable garden yields harvests of leeks, lettuce, tomatoes, and rhubarb. Onions are this gardener's specialty, and no fewer than five varieties head from garden to kitchen each summer.

Descended from a family of gardeners, Ms. Clapp grows many of her plants—perennials as well as annuals—from seed. In late winter and early spring, she's likely to be found upstairs in the

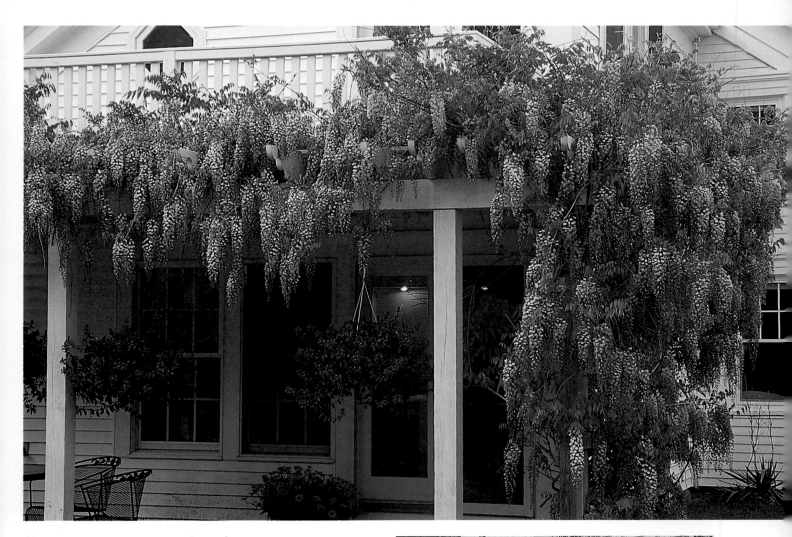

attic, where hundreds of seedlings get their start under grow lights. The attic's cool temperature helps plants stay compact; most are transplanted just once, into cold frames in April. Still, the amount of work is nothing short of monumental. Ms. Clapp insists that growing from seed is well worth the effort (and the expense, when electric bills are factored in). "The choices available by mail through seed houses are so much greater than what's available locally," she says. "Unusual annuals as well as familiar ones in uncommon colors and forms can be had if you're willing to raise your own plants." Passionately fond of animals, Ms. Clapp and Mr. De Sibour avoid cutting down their plants at season's end, so that birds have nourishment and protection through the winter.

Gardeners such as Leslie Clapp do their best to nurture as many different plants as possible. Others, though, use their in-town plots as laboratories

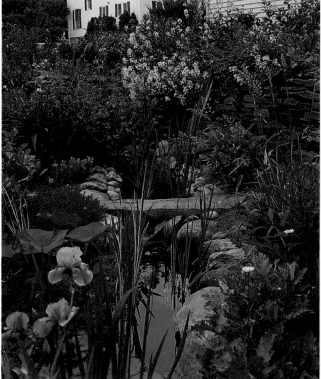

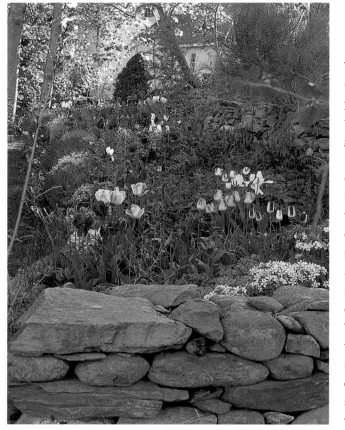

Opposite top: In glorious full bloom in May, Japanese wisteria announces the arrival of a new gardening season. It also lends intimacy to an in-town porch. Although wisteria will grow in Maine's interior, it usually needs the warmth brought by coastal currents to bloom.

Opposite bottom: A delightful stream banked by moisture-loving plants dominates the backyard garden of Belfast resident Arthur Pierce.

This page: In Dimitri and Charlotte Stancioff's backyard, perennials succeed flowering bulbs in a show that goes on all summer long. Mr. Stancioff propagates his own tulips (especially Darwin hybrids) through division, and finds many easy-care perennials (including phlox, mallows, and New England asters) along abandoned railroad tracks and around old building foundations. Terracing the slope has transformed a formerly difficult site into a lush garden. Ground covers soften the wall of local stone that marks the base of the three-level garden.

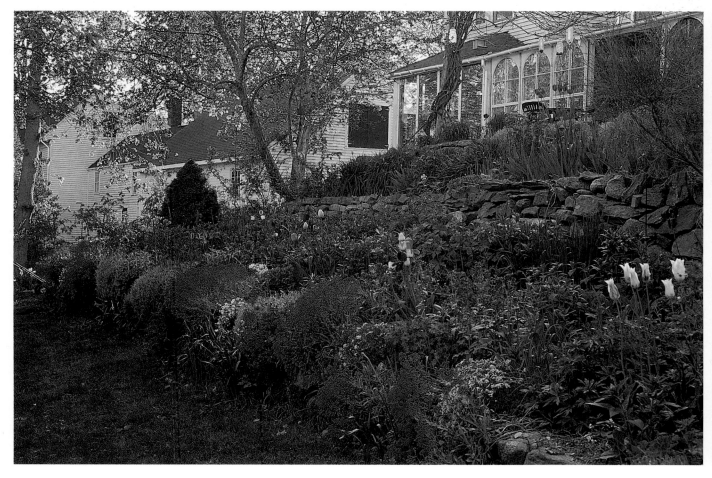

devoted to a single genus. In Camden, ragtime pianist Glenn Jenks and his wife, professional gardener Faith Getchell, knew that their favorite flower, the rose, had a less than stellar reputation among Maine gardeners. Unpredictable freeze-thaw cycles are the nemesis of modern hybrids as well as heirloom roses. Undaunted, the couple proceeded to turn their small (less than an acre) lot into a showcase for nearly two hundred roses. Twenty-three years after planting their first 'Peace' (a hybrid tea that Mr. Jenks finds prone to black spot yet irresistible nonetheless), the couple are admired throughout the state for their cultural expertise and deep knowledge of the genus *Rosa*. Together they have shown the viability of hybrid teas and perpetuals in Maine and have shared their methods for success in countless public forums.

The key to successful rose gardening in a challenging climate is choosing the right varieties, Mr. Jenks believes. He advises gardeners to consider the Gallicas and damasks, two classifications that stand up well to tough winters (Gallicas have the added advantage of blooming just once, before the emergence of Japanese beetles). Modern shrub roses, too, are worth a try, the ragtime rosarian notes. Flourishing in the Jenks-Getchell eden is everything from 'Honeysweet' (bred for cold-hardiness by Dr. Griffith Buck) to David Austin's "English rose" 'Graham Thomas'. To winterproof their roses, in November the couple mounds topsoil around the base of each bush, to a depth of eighteen inches. Then, the first week of December, they top this layer with a heavy mulch of leaves so the ground stays frozen, keeping the roses in a dormant state. To protect their less hardy shrub roses, they wrap the mulched bushes loosely in burlap, allowing for plenty of air circulation. Come April, the winter blanket is carefully removed. The curtain goes up in June, when the Getchell-Jenks garden once again becomes a gift to the entire neighborhood.

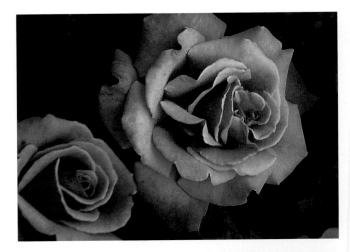

Top right: As demure in appearance as the most delicate hybrid tea, 'Honeysweet', a compact hybrid shrub rose, stands up to subzero temperatures and resists black spot.

Right: Roses wrap the Camden cottage of Glenn Jenks and Faith Getchell.

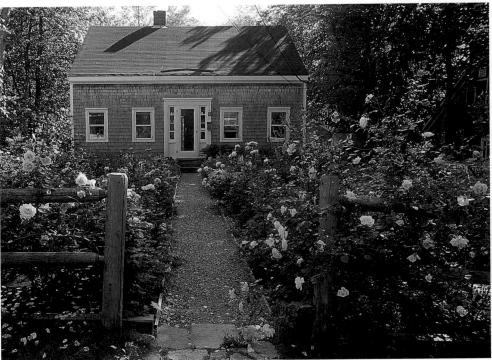

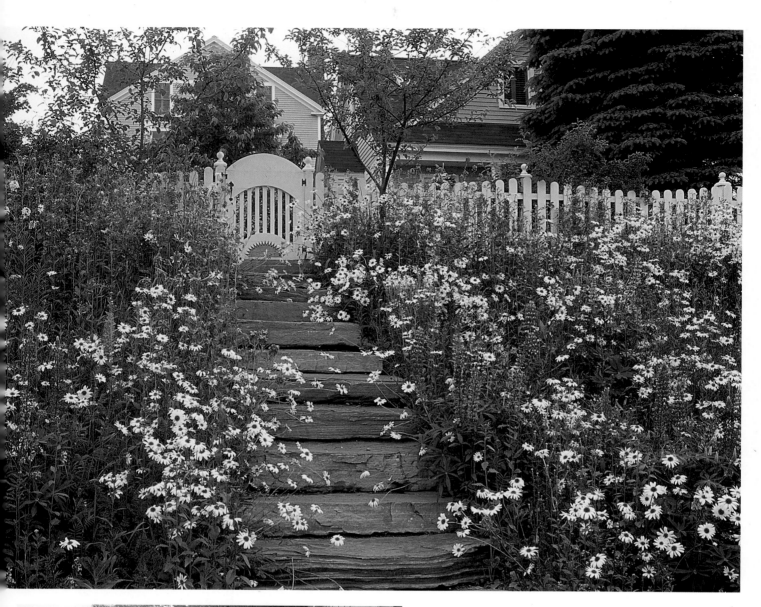

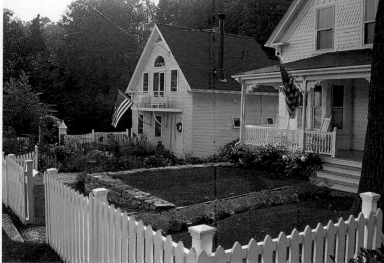

Left: Neatly enclosed by white picket fences, twin gardens evoke dooryards of old. The house at left was moved to its current site after years as a wharf house on the Camden waterfront.

Above: Wildflowers bank a flight of steps leading to a sidewalk. Although the colorful annuals and perennials will reappear in successive years, gardens such as this one still require care. If not weeded regularly, they will be overrun by dandelions, crabgrass, and other invaders.

For the Table

It might be tempting to view Maine's ubiquitous vegetable gardens as quaint throwbacks to a simpler time. After all, what is more charming than a late-summer tapestry of corn, tomatoes, and squash enlivened with flowers for cutting and protected by a weathered fence? And what is more old-fashioned than the annual race for the first plump peapod or the first ripe tomato?

In fact, Maine's gardeners are on the forefront of a nationwide trend toward eating more locally grown food. Thirty years ago, the occasional rural farm stand was about all Maine cooks could hope for in their hunt for fresh produce. For a while, farmers' markets had offered hope, but in 1970, after years of struggle, only two served the entire state. "Now, nearly every major town and city has

Previous page: Zinnias, snapdragons, bachelor's buttons, and other flowers for cutting join forces with herbs and vegetables in a classic Maine-style *potager*. Raised beds make improving the soil easy, because nutrients are concentrated where they are needed most. Eliza Sweet planned the garden to be equally appealing to eye and palate.

Right: The simplicity of a camp kitchen reflects the straightforward nature of some of Maine's best-loved culinary delights: steamed lobster, fresh corn, and strawberry shortcake.

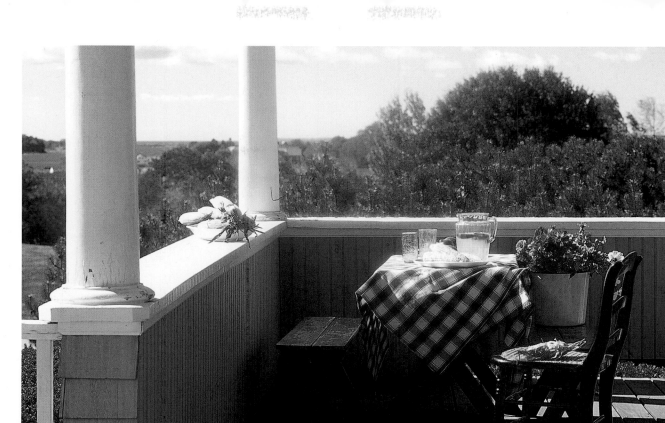

Top: Come summer, the best seat in the house is often on the porch.

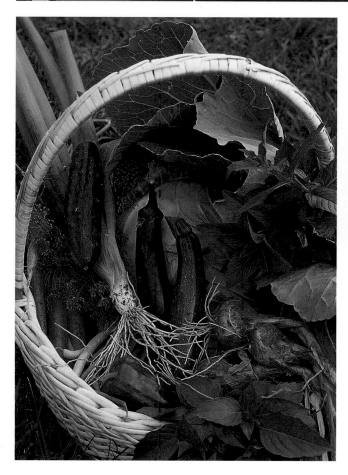

Above and left: The freshest herbs and vegetables make the most memorable summer suppers.

Right: 'Moon and Stars', an heirloom watermelon once thought lost but now popular again in Maine's home gardens, dates to the 1930s. Kent Whealy, of the nationwide Seed Savers Exchange, rediscovered the deep green beauty, whose tiny "stars" and larger "moons" are echoed in the vine's foliage. Avid seed saver Jon Thurston, of Searsmont, grew this succulent fruit.

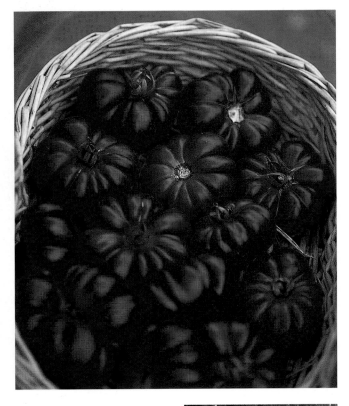

Below; Fluted 'Costoluto Genovese' heirloom tomatoes are favored for salsa. Sliced crosswise, they add a decorative flourish to summertime picnic platters.

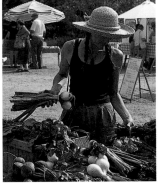

Right: Gardener Robin Jarry inspects the goods at the Camden Farmers' Market.

both a farmers' market and an independent natural foods store or cooperative," says Russell Libby, executive director of the Maine Organic Farmers and Gardeners Association, a nonprofit group affectionately known as MOFGA (pronounced "Moffga"). "Most leading restaurants seek local foods in season for their menu, and hundreds of Maine farmers now provide organic food to a growing number of citizens," says Mr. Libby. Farms that participate in Maine's Community Supported Agriculture (CSA) program sell "shares"; the farmer benefits from the reliable cash income, while shareholders enjoy weekly supplies of organically grown produce. Today's cooks can count on a steady seasonal source for pencil-thin haricots verts, rainbow-hued mesclun for salads, and potatoes in every size, shape, and color. And summer visitors can continue to take home vivid memories of lobster dinners gilded with just-picked sweet corn, succulent tomatoes, and native-blueberry pie.

The success of Maine's nine CSA farms is reflected in the heightened interest in raising diverse crops at home. Hooked on fresh produce, gardeners are branching out, trying new or forgotten cultivars. Whereas 'Beefsteak' tomatoes may have been sufficient a generation ago, 'Costoluto Genovese' and extra-early 'Moskvich' (just 60 days from seed to fruit) now grace the picnic table. Many of these "new" varieties are in fact decades

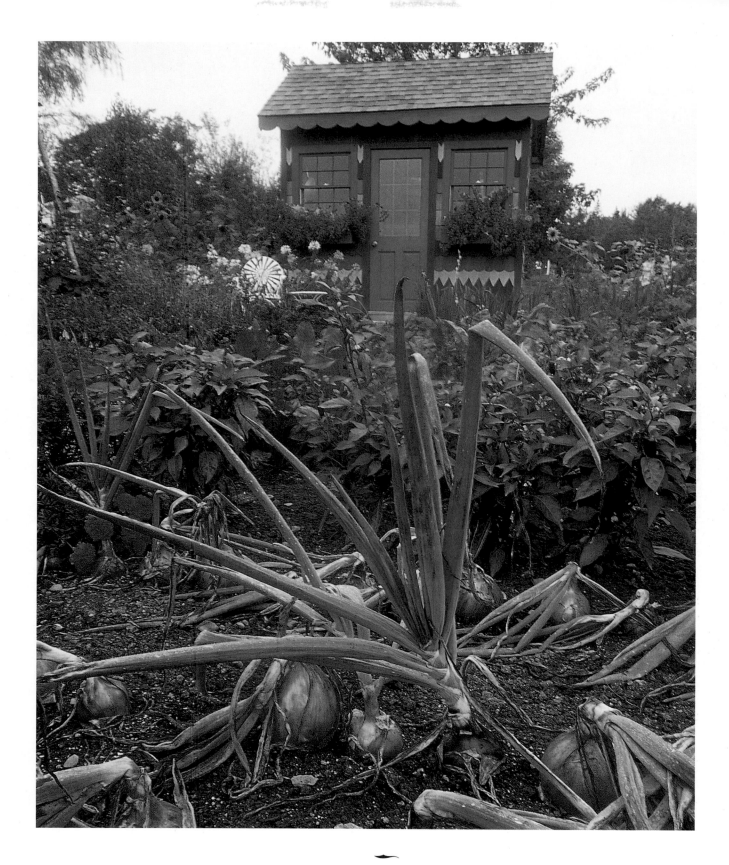

'Ailsa Craig Exhibition', 'Red Baron', 'Copra', and other onions dry in front of Leslie Clapp's Blue Hill potting shed. Increasingly, gardeners in Maine experiment with multiple varieties of the same crop in a single season.

old. The seeds have been handed down from generation to generation, just like family silver and photographs. Sometimes, the varieties originated abroad: 'Costoluto Genovese', for example, traveled to America with Italian immigrants. 'Moskvich' tomatoes hail from Siberia, making them especially tolerant of Maine's cool temperatures.

Gardeners are saving seed for more than tomatoes. Heirloom rutabagas, corn, beans, and pumpkins are common to produce plots throughout the state. Those unwilling or unable to save their own seeds are likely to be members of the nonprofit Maine Seed Savers Network (MSSN), whose annual catalogue includes dozens of unusual vegetable varieties (for a copy, write to MSSN at Box 126, Penobscot, ME 04476). Founded in 1995, the network conducts research, identifies and propagates exceptional varieties, and "delves into seed-growing practices and techniques, exploring the boundaries of seed production in Maine," explains founder and director Nicolas Lindholm. Although heirlooms are stressed, any nonhybrid variety with outstanding hardiness and superior flavor is sure to find a following within the group. Joining MSSN in the quest

for quality cultivars for home gardens are Maine's seed growers and breeders, who have gained a national reputation for their research and development efforts. For example, at Johnny's Selected Seeds, in Albion, vegetables on trial include a new zucchini with higher than average levels of lutein, an important antioxidant. (A catalog is available by calling 207-437-4301.) Fedco Seeds, in Waterville, is also an excellent source of cold-hardy and heirloom vegetables (catalog available: 207-873-7333).

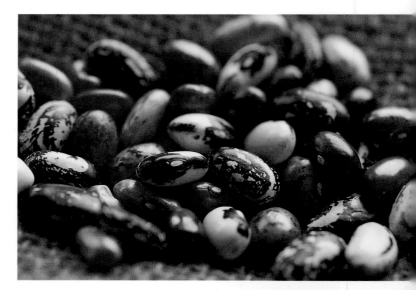

Above right: Heirloom bean seeds destined for members of the Maine Seed Saver's Network include 'Low's Champion', 'Maine Sunset', 'Roberts Royalty', and 'Viktorka'. To remain viable, seeds must be stored in airtight containers.

Right: Heirloom tomatoes assembled and researched by Fedco Seeds await browsers at the Maine Organic Farmers and Gardeners Association's Common Ground Fair, held in Unity every September.

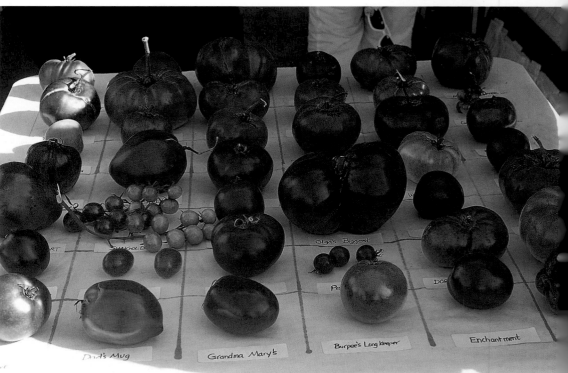

To the Forest for Fiddleheads

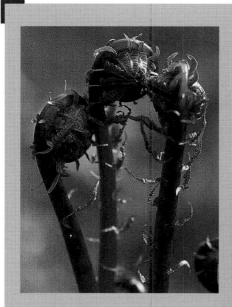

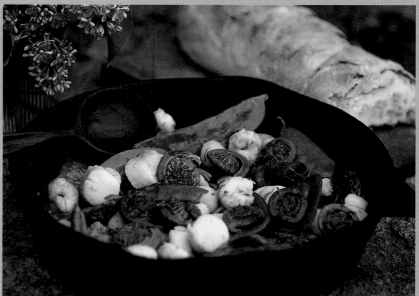

Like the scroll of a violin, the fronds of nascent ferns (known as fiddleheads) appear tightly coiled and full of promise. Harvested in May when just six inches or so tall, fiddleheads are downright tasty, too—with a flavor similar to that of mild asparagus—provided you know which species are edible and which are not. (Beware the royal fern and the bracken fern, both of which are reputed to be carcinogenic.) Most popular is ostrich fern *(Matteuccia struthiopteris),* cherished by Native Americans, who for centuries have scoured the woods of Maine where the stately fern proliferates. To avoid poisonous ferns, modern-day foragers are careful to take along an expert familiar with wild foods, someone such as Tom Seymour, of Waldo. Mr. Seymour will tell you that if you can't give the fern a bulletproof identification, procure your fiddleheads instead from a greengrocer who carries the crunchy morsels for a limited time each spring. A third option is to raise your own—a popular choice, because the plants are easy to grow without chemicals or pesticides. All that's needed is the moist shade of a woodland garden and soil that is free draining, slightly acidic, and rich in humus. To avoid weakening your stand of ferns, never harvest more than three or four of the dozen fiddleheads that typically emerge from each plant's crown.

Top left: Sparse, khaki-colored scales adorn edible ostrich fern. Inedible fern species are tougher and more thickly scaled.

Above: A spring skillet supper features shrimp, scallops, peapods, and fiddleheads.

Left: Spring gold fills the hands of master forager Tom Seymour.

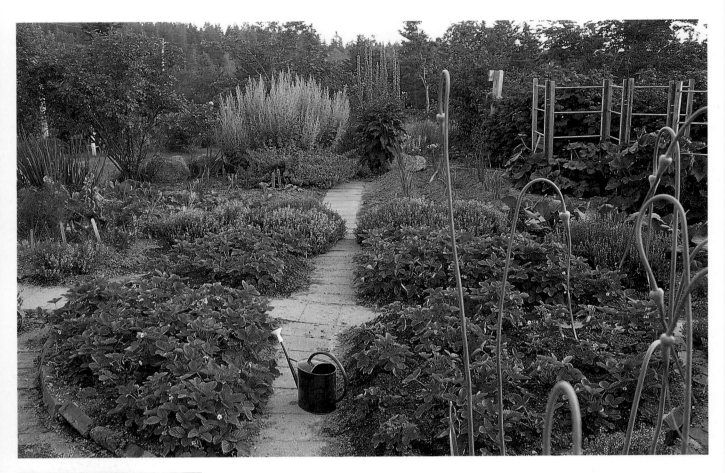

Above: Jutta Graf planted stately yellow mullein (in the background) and gooseneck Egyptian onions to add drama to her Deer Isle kitchen garden. Recycled bricks edge a circular bed of strawberries.

Left: Refeshments on an oceanfront deck in South Bristol include mixed berries and fresh bread served with borage butter.

Still, many old favorites show no sign of relinquishing their featured positions in Maine's vegetable gardens. At Pinetree Garden Seeds, in New Gloucester (207-926-3400), more than three thousand orders for 'Early Girl' tomatoes, hybridized by Burpee in 1975, were filled for the 2000 growing season. "'Sun Gold', 'Brandywine', and 'Sweet Million' are popular, too, but 'Early Girl' is still the favorite tomato of many, many people," says Richard Meiners, Pinetree proprietor and seedsman. For the most part, though, "Vegetable and flower varieties go in and out of style, just like everything else," he says. For instance, everlasting flowers (strawflowers, gomphrenas, statice, and the like), wildly popular a decade ago, have recently taken a backseat to medicinal herbs, Mr. Meiners notes. He attributes the shift to renewed interest in herbal medicine and to the adventurous spirit of many Maine gardeners, which leads them to sample the unfamiliar.

Because food is eaten first with the eyes, flowers for garnish or household adornment have

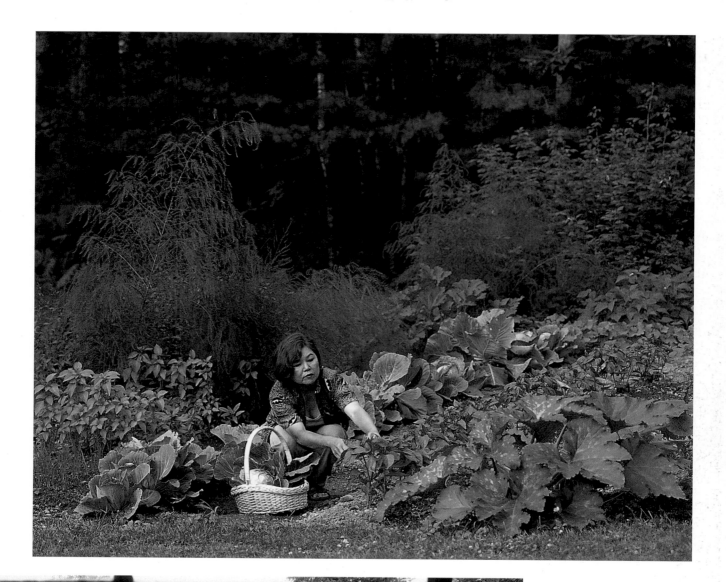

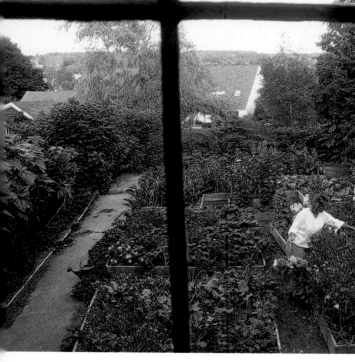

Above: Chef and caterer Bich Nga Burrill grooms 'Ace' bell peppers in her half-acre Winterport garden. Started from seed indoors in winter, signature herbs and vegetables required for the cooking of her native Vietnam, as well as Thai, Mexican, French, and Spanish fare, all flourish here in carefully tended beds.

Left: Viewed from a second-story window, Eliza Sweet deadheads spent blossoms in her kitchen cutting garden in Waldoboro.

The Versatile Herb

Before over-the-counter medicinal remedies, before imported spices, even before adhesive bandages, there were herbs. Maine's Native Americans knew the value of indigenous plants, and, later on, settlers "from away" brought other medicinal plants with them, some of which soon became naturalized in their new habitat. For example, papoose root, or blue cohosh *(Caulophyllum thalictroides)*, native to new England, has been used to treat everything from rheumatism to hysteria. Pennyroyal *(Mentha pulegium)*, a member of the mint family imported from Europe, has long been a favored insect repellent, as Sarah Orne Jewett described in *The Country of the Pointed Firs* (1896). The soft, absorbent leaves of lamb's ears *(Stachys byzantina)* came in handy for wrapping wounds, and the common dandelion was relied on to treat liver and kidney ailments. These

and other traditional herbs filled the family pharmacopoeia. Cooks, too, reached for fresh and dried herbs to enliven the limited diet typical of nineteenth-century rural life.

Today, with their popularity at an all-time high, herbs have become a veritable industry. Medicine cabinets are once again stocked with salves, tinctures, and soaps from the many companies offering Maine-made herbal preparations. And in the kitchen, cooks still blend herbs in original ways, creating their own culinary signatures. Whether grown for health, flavor, or fragrance, herbs show no sign of relinquishing their central position in Maine's gardens.

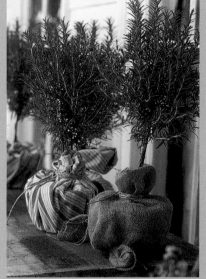

Top: Echinacea (purple coneflower), is an ever-popular cold and sore-throat remedy.

Above: Potted rosemary topiaries, packaged in burlap, at Marston House Antiques in Wiscasset.

Above left: Freshly gathered sage and other herbs. In years when winter arrives late, fresh sage can still be harvested for seasoning the Thanksgiving turkey.

Left: The gate at Audrey Muir's garden, in Brooks, makes it clear that herbs are not an afterthought.

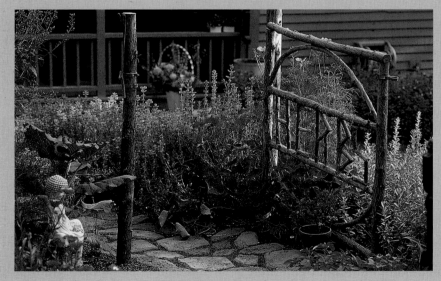

a much-honored place in vegetable gardens. Traditional favorites include Chinese chives (*Allium tuberosum,* sometimes called garlic chives), borage, calendula, and other plants with edible blossoms. Annuals that have filled vases in Maine for generations include sweetly scented mignonette and stock, both of which prefer cooler temperatures. China asters (*Callistephus chinensis*) and bachelor's buttons (*Centaurea cyanus*) lend tabletop cheer, as do corn cockle (*Agrostemma githago*) and nasturtiums. Along with zinnias, cosmos have dominated Maine's cut-flower beds ever since the dawn of the twentieth century, when hybridizers developed early-flowering strains. With regular deadheading, all these annuals will bloom continuously until struck down by autumn frost. To brighten interiors in the winter days that lie ahead, gardeners grow certain flowers specifically for drying. These include *Hydrangea paniculata,* German statice, larkspur, globe amaranth, and everlastings (*Helichrysum* spp.).

Below: At the Pilgrim's Inn, on Deer Isle, edible flowers raised on-site and used as garnishes in the dining room include yellow-orange calendula, blue-purple borage, and nasturtiums.

Bottom: Wooden planks neatly edge a cutting garden in Southwest Harbor. The densely planted beds provide a ready source for guest-room bouquets.

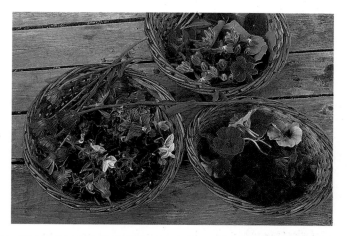

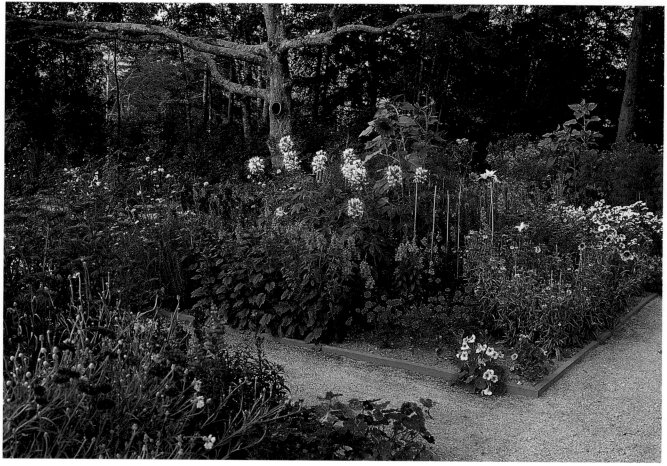

The unofficial end to the gardening season, frost usually occurs in Maine anytime between late August and late September. Savvy gardeners who claim that they can feel the frost approach gather in the last tomatoes and squash, leaving cauliflower, cabbage, and other brassicas to "sweeten" a while longer in the ground. Families pay a last visit to their neighborhood farm stand, gathering gourds and stocking up on apples. By now, larder shelves are filled with blueberry jam, tomato chutney, corn relish, and dill pickles. Come Thanksgiving, tables will groan with bounty that transcends the generations.

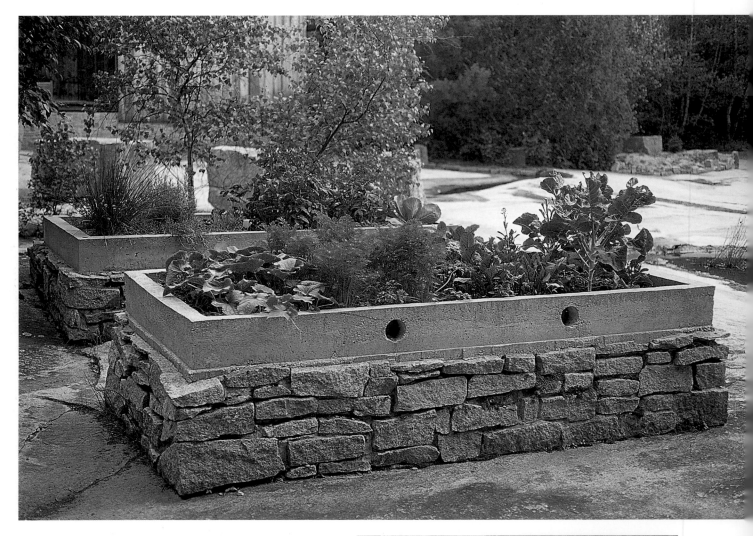

Above: Raised beds with foundations of mortared stone make gardening possible even in an abandoned granite quarry. Perforated PVC pipe provides drainage, and concrete collars "true up" the rims on carefully constructed beds that guarantee a steady supply of fresh produce for the West Sullivan kitchen of Phid and Sharon Lawless.

Right: Everyone loves blueberries.

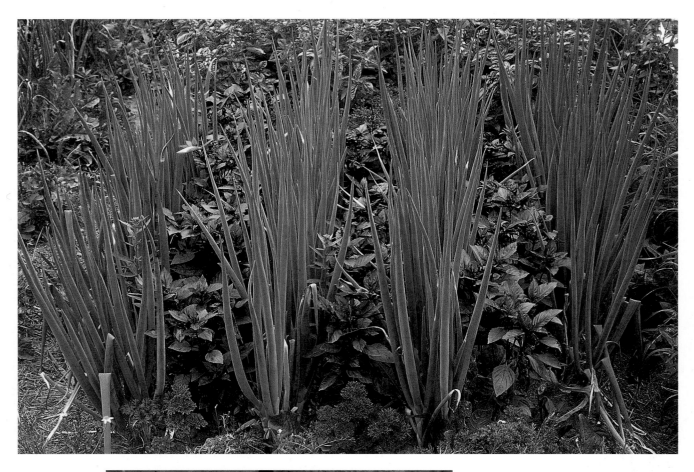

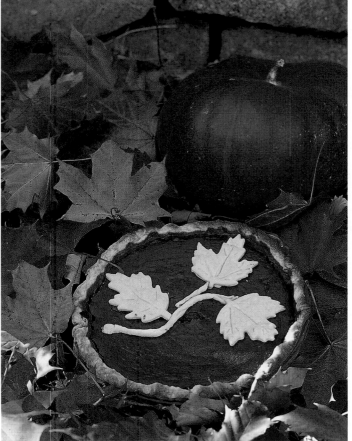

Above: In a tribute to Europe's ornamental kitchen gardens, Paula and Mark Fulford, of Teltane Farm in Monroe, alternated rows of green onions and purple basil to form an edible tapestry.

Left: A Thanksgiving pie made by Patti Mendes, of Westport Island, from heirloom Cinderella ('Rouge Vif d'Etampes') pumpkins epitomizes the joy of the harvest.

Past Perfect

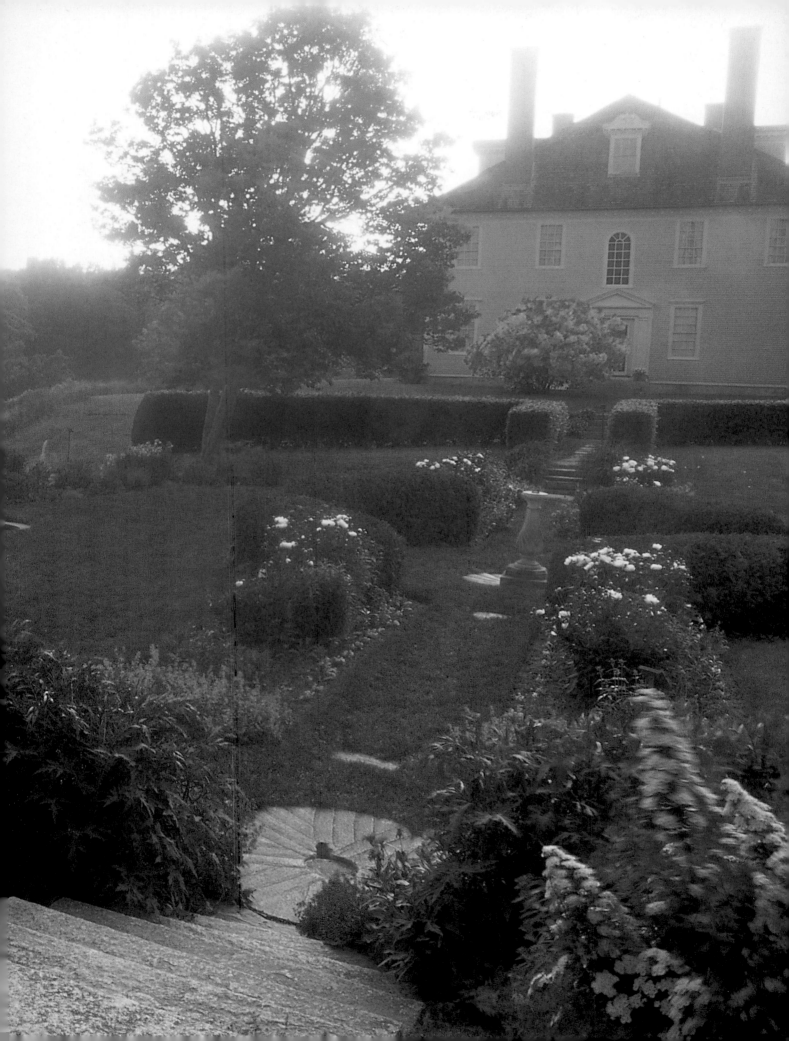

Like buried treasure, gardens long forgotten await rediscovery throughout the state of Maine. Some of these neglected jewels are the work of America's acclaimed landscape architects. Other, smaller gardens designed and maintained through the years by dedicated amateur horticulturists show that a deep love for plants can be as important as deep pockets to a garden's ultimate success. Although a handful of Maine's historic gardens have been rescued from oblivion and restored, others lie sleeping, ready to dazzle us anew with help from devoted gardeners and preservation groups.

Returning a historic garden to its original state can be even more difficult than restoring a house. While the outlines of a dwelling, even an abandoned one, remain distinct, the design of a garden can be obscured by weeds and brush in just a few years. Determining the exact boundaries of beds and borders often takes considerable research, especially when walls, paths, fences, and other "permanent" structures have been demolished. Without blueprints or written records, horticultural historians and dedicated homeowners have little to go on. Moreover, the time and expense required to maintain a garden once it is restored can be prohibitive. It's not unreasonable to ask, is restoring a forgotten garden really worth the effort?

The answer, of course, is a resounding "yes." In the southern Maine town of South Berwick, for example, the gardens that surround Hamilton House, a local landmark open to the public, illustrate what a tremendous resource a historic garden can be. A living record of superb design, the house and surrounding landscape take us back to the nineteenth century, when large numbers of Americans began gardening purely for pleasure. Created by a wealthy

Previous page: Overlooking the Salmon Falls River in South Berwick, the gardens of Hamilton House took shape in 1900 and were modified almost continuously until 1949.

Above: As old as many of the gravestones they shade, Pee Gee hydrangeas *(Hydrangea paniculata* 'Grandiflora') grace many Maine cemeteries as well as historic houses. Panicles snipped from home gardens and dried (away from direct sunlight, in a well-ventilated room) in late summer provide welcome color indoors in winter.

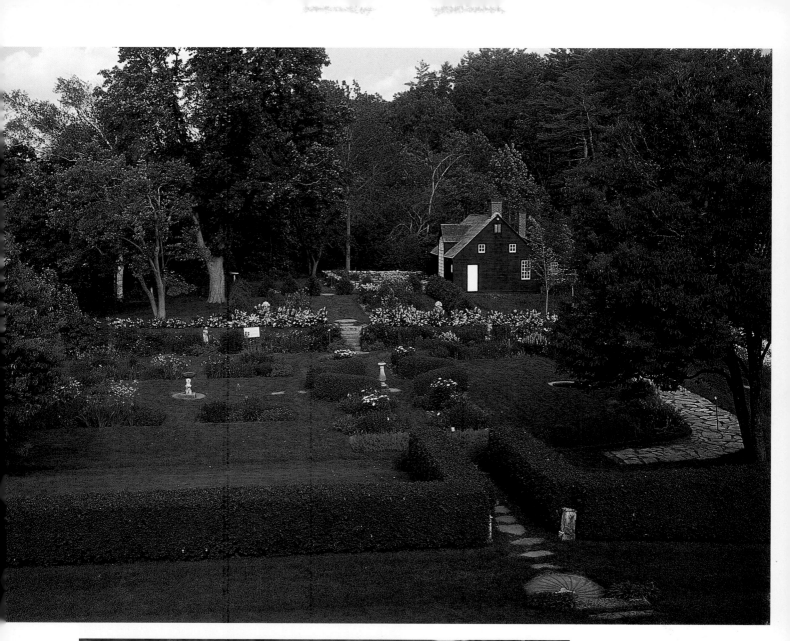

Above: At Hamilton House, clipped boxwood frames geometric beds of period plants.

Left: In Castine, white petunias draw attention to a weathered stone wall cloaked in lichen. The flowers grow happily in a depression along the top of the wall.

widow named Emily Tyson and her stepdaughter, Elsie Tyson Vaughan, between 1900 and 1949, the garden "evolved from a working site," notes Diane McGuire, director of landscapes for the Society for the Preservation of New England Antiquities (SPNEA). "The property's riverfront location links it to our early history, when so many prominent houses were oriented toward the water. But its pleasure gardens show the transition to our own era."

In 1898, when the Tysons paid four thousand dollars for Hamilton House, the grandest mansion in town, gardens other than utilitarian ones were nowhere to be found at the site. Previous owners, including Colonel Jonathan Hamilton, who built the stately Georgian house in 1785, had used the land for light farming and livestock. With help from architect Herbert W. C. Browne, the Tysons went to work creating a showplace that combined the formal outlines of an Italian villa garden with the lush exuberance of an English-style cottage garden. Terraced beds tamed the steep riverbank, and straight walkways flanked by rectangular flower beds lent careful symmetry to the geometric layout. A marble fountain imported from Italy and classical statuary added to the garden's near perfect balance, and alluded to America's infatuation with European antiquity.

By 1949, though, when Elsie Tyson Vaughan died, the vine-draped pergolas and trellises that defined much of the garden had begun to weaken. "A hurricane in the early 1950s finally destroyed most of them," says Gary C. Wetzel of SPNEA, which took over the property in 1950. Soon, all that remained were bits and pieces—finials and column fragments, mostly. In 1995, when restoration began in earnest, Mr. Wetzel, landscape manager of SPNEA properties in southern Maine and coastal New Hampshire, and his colleagues didn't have much to go on, until they unexpectedly discovered the Tysons' own photo albums in the SPNEA archives. To ensure that the gardens would comple-

ment the interior of the house, the period chosen for restoration was the late 1920s. Today, noted timber framer Arron Sturgis is hard at work rebuilding the garden's pergola, arbor, and trellises.

Determining the correct flowers to plant in the garden's restored beds has proven more difficult, because the Tysons kept only minimal plant lists. Black-and-white photographs reveal eight-foot-tall rudbeckias, as well as the foliage of various irises, lilies, ageratums, petunias, and more. Many of these were raised in a local nursery frequented by the Tysons, and most now appear in the garden once again. Other leads for replanting, such as the pairing of tiger lilies and phlox, have come from period newspaper and magazine articles that chronicled the Tysons' progress. Although the Tysons took cues from their counterparts in Europe, clearly they did things their own way. "Plantings were tall, full, and loose," Mr. Wetzel notes. "There was plenty of allowance for flowers to migrate around."

Regular guests at Hamilton House in the garden's heyday included writer Sarah Orne Jewett (1849–1909), who grew up in South Berwick and persuaded her friends the Tysons to purchase the

Now displayed only in secure locations, the pots of acclaimed craftsman Eric Ellis Soderholtz (1867–1959) were once common in Maine gardens up and down the coast.

property. (In 1901, the beloved Maine author used Hamilton House as the setting for her novel *The Tory Lover*.) William Sumner Appleton, founder of the Society for the Preservation of New England Antiquities, was another regular guest. SPNEA has continued to maintain and restore the property since acquiring it the year following Elsie Tyson Vaughan's death. Every year, more than two thousand visitors enjoy the gardens. Gary Wetzel couldn't be happier: "After studying the Tysons' photo albums for so long, it's exciting to know that others will soon be seeing in reality what I've been seeing on paper."

Hamilton House and other gardens now open to the public, such as Woodlawn (the legacy of another wealthy seaman), in Ellsworth, and the gardens of Blaine House, in Augusta, are valued for the lessons they teach us about the past as much as for their classic good looks. Still other gardens, however, are saved simply because they are beautiful. In South Paris, abutting a major road dotted with fast-food restaurants and other signs of contemporary life, sits the Bernard McLaughlin Garden, the masterwork of a local grocery-store clerk and former bank teller. For nearly sixty years, Bernard

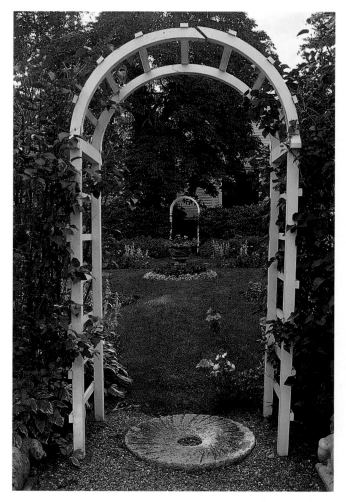

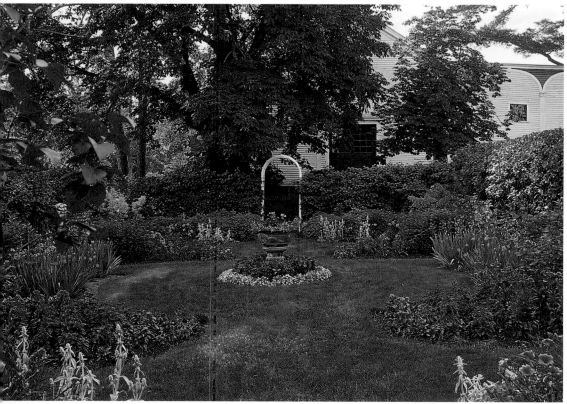

Above: At Woodlawn, in Ellsworth, an old millstone makes a handsome threshold to the garden. On Pratts Island, craftsmen at Maine Millstones (207-633-6091) now hand-carve the massive granite stones for gardeners rather than millers.

Left: Dating to 1903, the formal garden at Woodlawn emphasizes plants popular at the turn of the twentieth century.

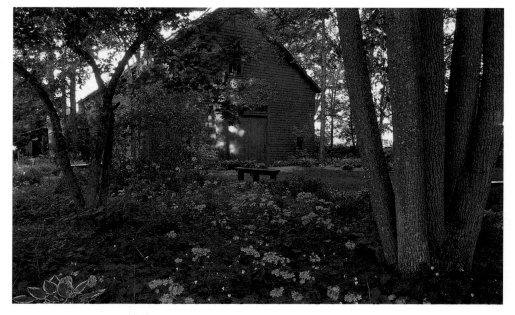

Right and center: In South Paris, the Bernard McLaughlin Garden features woodland walks and its own arboretum. In place of traditional sculpture, handsome boulders cradle ferns and wildflowers. Large collections of hostas, astilbes, trilliums, mayapples, and more than fifty varieties of ferns make the garden an important resource for professional as well as amateur horticulturists.

Bottom: Owned by descendants of a single family for the past 125 years, Gardiner's Yellow House features a garden patterned after one at the family's ancestral home in Hampshire, England. Lilacs and beauty bushes *(Kolkwitzia amabilis)* tower above century-old plantings of peonies and roses. Both house and grounds have been listed by the National Trust for Historic Preservation.

McLaughlin (1898–1995) planted and maintained more than five hundred varieties of plants, including Maine's largest collection of lilacs. He created a network of curving paths to guide his frequent guests through three acres of daylilies, iris, sedum, phlox, and wildflowers. Rare coniferous and deciduous trees made the property a popular resource for professional horticulturists and amateur gardeners alike. Today, gardeners continue to visit Mr. McLaughlin's garden, thanks to the considerable effort of volunteers who formed the McLaughlin Foundation in 1996 and saved the garden from dismemberment. Since then, the property's circa 1840 house and barn, as well as the garden, have been nominated by the state of Maine to be placed on the National Register of Historic Places.

Whereas some gardens have been restored and preserved by teams of volunteers, others remain in the care of descendants of the families that first planted them. Privately owned, these gardens receive no special funding; their very existence depends on the dedication of a few hardworking individuals. In Gardiner, for example, John Shaw and his wife, Kimberly, spend much of their free time weeding, pruning, and mulching the century-old roses, peonies, and gas plants *(Dictamnus albus)* that Mr. Shaw inherited in 1988 along with what area residents affectionately call the Yellow House. Built in 1814, the Federal-style residence has been

Living Antiques

Despite Maine's frigid winters and ice storms, some plants flourish for decades. Almost always, species with the greatest endurance survive because they require little or no care. The gardeners who first put them in the ground are seldom around as the plants enter old age.

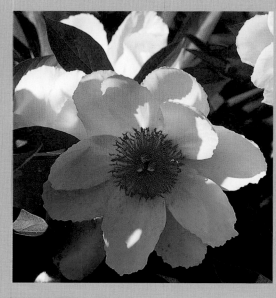

➤ **Top left:** A century-old gas plant (*Dictamnus albus*), central Maine

➤ **Center:** Japanese peony, central Maine, a hundred years old

➤ **Top Right:** Pee Gee hydrangea, coastal Maine, about ninety years old

➤ **Bottom right:** Mountain laurel, western Maine, about eighty years old

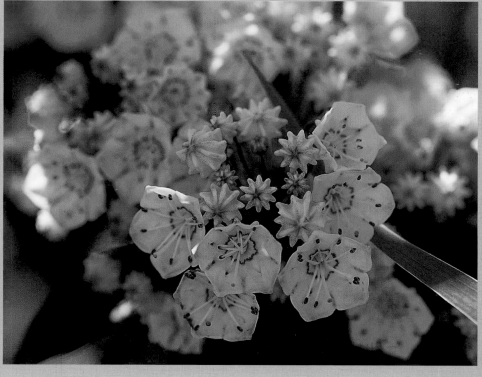

In historic Hallowell, common lilacs *(Syringa vulgaris)* planted by Dr. John Hubbard in 1865 still draw crowds in late May.

home to four generations of Mr. Shaw's family, among them writer and philanthropist Laura E. Richards. (Laura's mother, Julia Ward Howe, who penned "The Battle Hymn of the Republic" in 1862, visited the house at least twice a year between 1878 and 1910 and enjoyed writing on the veranda that overlooks the garden.) John Shaw's great-aunt, writer Rosalind Richards (1874–1964), served as Maine's official correspondent to the Arnold Arboretum, in Boston, and used the family garden to test new plant introductions for cold hardiness. Notes from her experiments are now part of the Yellow House Papers, housed at Colby College in Waterville. The design of the garden's symmetrical island beds is completely original, as are the many heirloom plants. Preserving the contours requires near-constant vigilance.

Up the Kennebec River from Gardiner, in historic Hallowell, Alicia Kellogg and David Bustin keep watch over four dozen lilacs planted in 1865 by Dr. John Hubbard, former governor of Maine and physician to three generations of rural families. The lilacs (now twenty feet tall) pay tribute to

Abraham Lincoln as well as to the doctor's eldest son, a Union soldier who died in battle in Louisiana. Living antiques, the lilacs provide a direct link to historic events. Moreover, they make eloquent reference to the era's most renowned poet. The year the shrubs arrived on Dr. Hubbard's doorstep from Boston, Walt Whitman's ode to the martyred Lincoln, "When Lilacs Last by the Dooryard Bloomed," arrived in bookshops. Despite their long association with loss, lilacs are extremely tough, surviving Maine's most brutal winter storms. Ms. Kellogg and Mr. Bustin cut back dead or weakened wood in late winter and boost soil pH with occasional autumn applications of lime. To improve flowering, they deadhead spent racemes, at least those they can reach. Come Memorial Day, when the lilacs achieve peak bloom, they become a gift to passersby and a point of pride for the entire city.

When a garden cannot be saved, it is gratifying to at least preserve the plants. The Asticou Azalea Garden, in Northeast Harbor, contains many of the rhododendrons, azaleas, and other ericaceous (acid-loving) shrubs that once graced Reef Point, Beatrix Farrand's garden on Mount Desert Island. In 1956, landscape designer Charles K. Savage accepted the plants from Mrs. Farrand and used them as the "furnishings" in a series of garden rooms enclosed by pine, spruce, and cedar. With little more than two acres at his disposal, Mr. Savage gave the garden Oriental overtones, in the form of artfully placed boulders, a lily pond, stepping-stones, and a "dry" garden, featuring sand raked into "waves" around rock "islands." Owned by the private, nonprofit Island Foundation, the Asticou

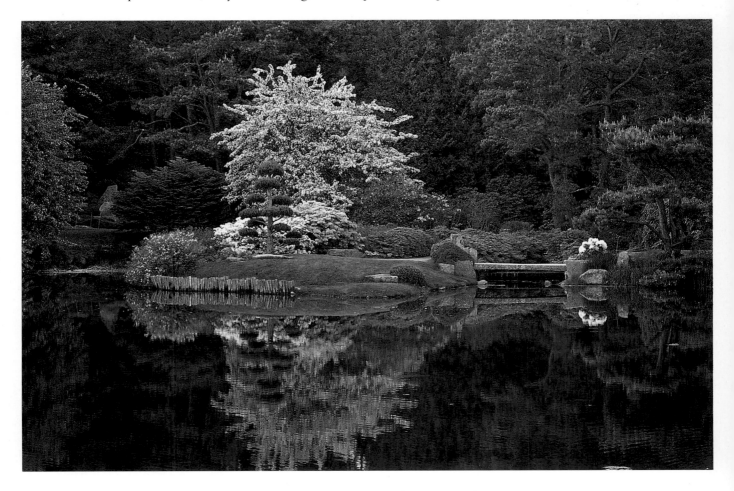

A spirit of quiet reflection pervades the Asticou Azalea Garden, on Mount Desert Island.

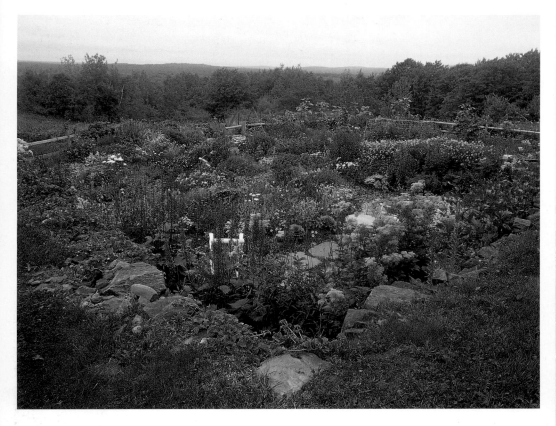

Azalea Garden is a place for quiet meditation, the garden's directors advise, not for picnics and fetes.

Sometimes, instead of a true restoration, owners of historic properties take on the equally interesting challenge of creatively re-using remnants of the original property layout. In Rockport, Tom and Dennie Wolf worked with professional gardeners Cheryl Denz, Manette Pottle, Nancy Syme, and Nancy Jackson to create a sunken garden in the foundation of a vanished farm building. The bramble-choked cellar hole, built in 1790 to support a large, multipurpose barn, features handsome walls of weathered fieldstone, each rock expertly placed to withstand the elements. After removing several decades' worth of weeds, the crew improved the cellar's drainage by laying a subfloor of sand, then edging the foundation's perimeter with perforated pipe. To visually soften the stone walls (one of which stands eight feet high), garden designer Nancy Jackson used clematis and other climbers. Among the many plants now growing at the historic homestead are herbs that Mr. Wolf, cofounder of Rockport's Bay Chamber Concerts, infuses in vinegars to be sold at charity fundraising events.

A two-hundred-year-old barn foundation became a sunken garden when planted with vines and perennials. The Rockport showpiece, owned by Tom and Dennie Wolf, includes massed plantings of hybrid lilies, dahlias, and other colorful flowers for cutting. **Right:** In late summer, the seed heads of *Clematis tangutica* cloak the foundation walls like luxurious draperies.

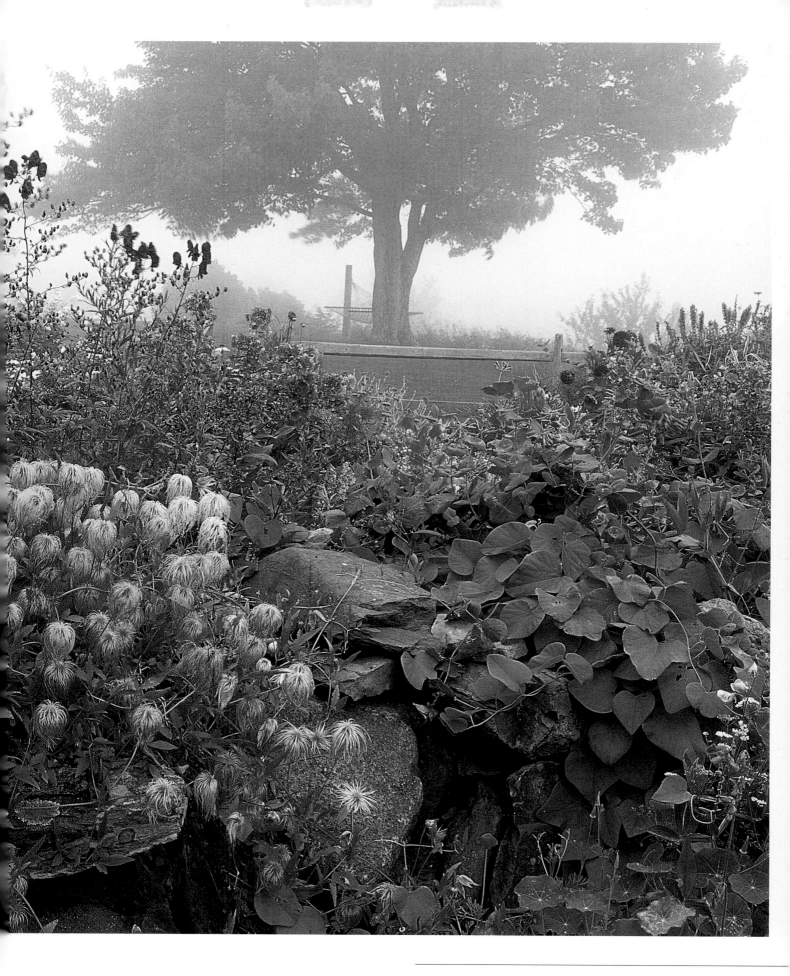

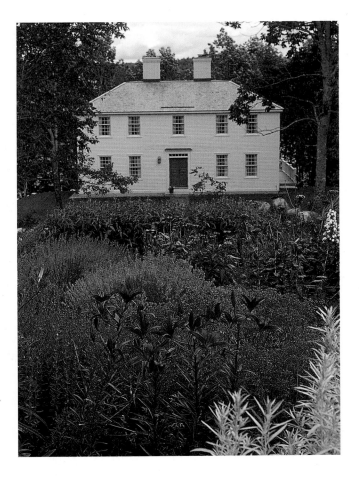

In Castine, easy-care perennials such as artemisia, hybrid lilies, Asiatic lilies, and catmint complement a Federal-style house designed by McKie Wing Roth and landscaped by Barbara Feller-Roth. Visitors are often surprised to learn that house and garden date only to 1993.

Even when left with nothing of historic significance, clever gardeners and designers still use the past to their advantage. In Castine, a coastal village rich with maritime and Revolutionary-era history, Barbara Feller-Roth and her husband, McKie Wing Roth, collaborated on a house and garden that fit the setting perfectly. To complement the classic lines of the Federal-style house her husband designed, Ms. Feller-Roth planted great drifts of colorful perennials, among them catmint and various lilies. Visitors who remember the rubbish that formerly littered the seven-acre site can only admire her efforts.

Helping to identify and preserve the state's horticultural legacy is the Maine Olmsted Alliance for Parks and Landscapes, a private, nonprofit organization with headquarters in Falmouth. In addition to promoting the design principles of Frederick Law Olmsted, Sr., and his successors, the all-volunteer organization supports the efforts of local groups and municipalities seeking to save landscapes of historic value. A four-phase survey of historic examples of landscape design, initiated by the alliance in 1991, identifies and documents these important resources.

For homeowners blessed with the remains of a historic landscape and intent on preserving their own piece of the past, the Olmsted Alliance advises the following: "(1) Work slowly. Match tools and machinery to the scale of your site. (2) Don't destroy existing archaeological resources. (3) Don't create a false historical appearance. Make replacements based only on documentation, not speculation. (4) Don't make irreversible changes that threaten the historic integrity of your site. (5) Finally, after your diligent work of researching, documenting, and studying your landscape's unique qualities, take pride in the process you've just completed. Feel confident that decisions have been made logically, realistically, and with a clear understanding of the past and how it will contribute to the future. Recognize not only what you have, but also how you have contributed to the preservation of our historic landscape legacy."

Historic Gardens to Visit

Blaine House Gardens, State and Capitol Streets, Augusta. Open daily 10 to 4, year-round. Lilacs, rhododendrons, and spirea dominate a three-acre landscape designed by the Olmsted firm in 1921. The circa 1830 Federal house is now the Governor's Mansion.

Camden Garden Theater, Main Street, behind the Camden Public Library. Open daily, year-round (telephone: 207-236-3440). Fletcher Steele designed this garden amphitheater in 1928.

Hamilton House Gardens, Vaughan's Lane, South Berwick. Open daily, year-round (telephone: 207-384-5269). Gardens designed and maintained between 1900 and 1949 emphasize plantings popular during the first half of the twentieth century and also show the influence of Italian gardens.

Woodlawn, formal garden at the Colonel Black Mansion, Surry Road, Ellsworth. Open June 1 to October 15, Monday through Saturday, 10 to 5 (telephone: 207-667-8671). Designed in 1903 to complement the 1826 Georgian-style mansion of Colonel John Black. Rhododendrons lining the driveway date to the 1880s.

Longfellow Garden, 487 Congress Street, Portland. Open June through October (except Independence Day and Labor Day), Tuesday through Saturday, 10 to 4 (telephone: 207-879-0427). Heirloom shrubs and perennials grace the recently restored garden. The poet's sister lived here until 1901.

McLaughlin Garden and Horticultural Center, 97 Main Street, South Paris (telephone: 207-743-8820). Open daily from sunrise to sunset, May through October. Woodland plants, arboretum, and outstanding collections of lilacs and irises, some dating to the 1940s, are now maintained by a private foundation. Call for information on special events, including educational programs for children. Web site: www.mclaughlingarden.org

Appledore Island, Isles of Shoals (telephone: 607-254-2900). Reservations (available late June through August only) are needed to view Celia Thaxter's cottage-style island garden, renowned for its poppies, sweet peas, and hollyhocks. Although Mrs. Thaxter's flower beds all but vanished after a 1914 fire, a restoration begun in 1970 captures the garden's exuberant spirit. Ferries to the Isles of Shoals depart from Portsmouth, New Hampshire.

Designed by Fletcher Steele in 1928, Camden's amphitheater is the site for a variety of outdoor events. Its ascending tiers are defined by blocks of quarried granite.

For the Joy of It

What, exactly, is a garden? While many will define the word as "a place where flowers and vegetables are grown," a quick look around shows that, in practice, gardens are as different as the people who grow them. In Maine, as in many American regions, attempts to pinpoint a defining style are made strictly in vain.

One obvious explanation has to do with Maine's varied growing conditions. What works well down east will likely prove inappropriate near the New Hampshire or Canadian border. Disposable income, too, will influence a garden's overall appearance. Without it, one cannot opt for handsome fieldstone walls or freshly painted picket fences. Far more significant, though, is the role played by personality. "The garden is said to be an index of the owner's mind," a Shaker gardening manual advised in 1843. Thus, gardeners who enjoy bending the environment to their will are likely to favor diligently weeded parterres, neatly shaped geometric beds,

Previous page: Piers the plowman never calls in sick and doesn't ask for overtime.

Right: On Southport Island, a six-year-old weeping pussy willow (*Salix purpurea* 'Pendula') centers a formal garden of 'Elizabeth Arden' and 'Big Chief' tulips, as well as other spring bulbs. Mary Louise Cowan designed the tidy plot with help from professional gardener Gregory Bond.

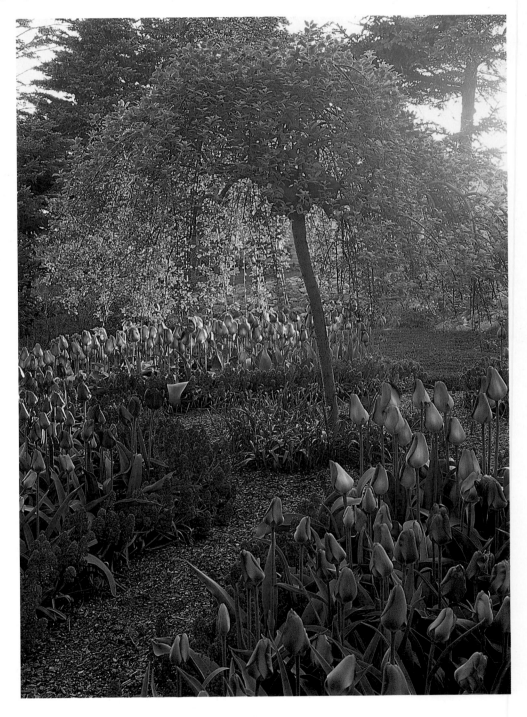

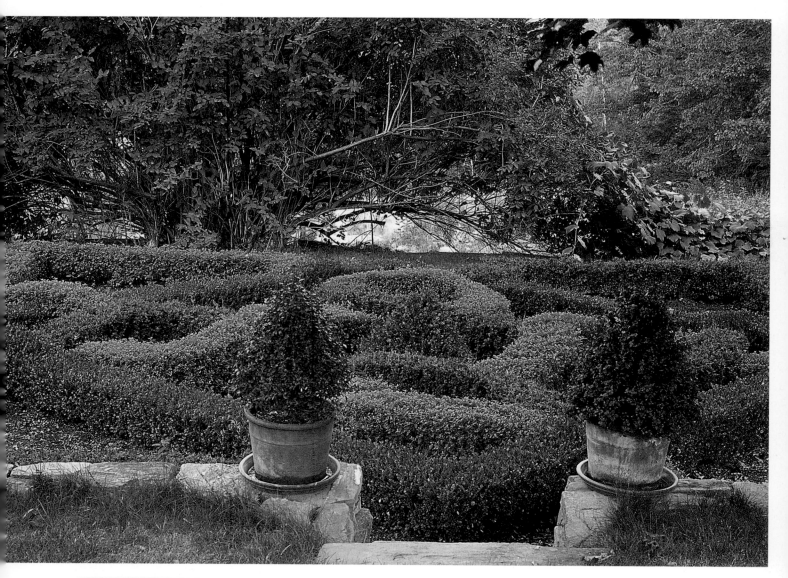

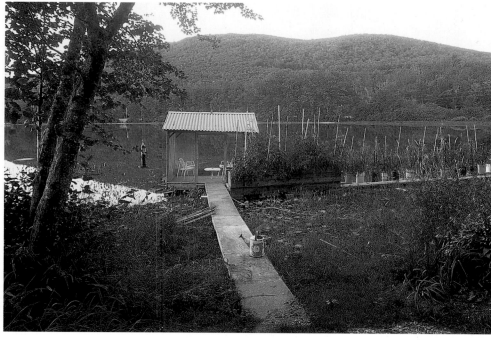

Above: Clipped hedges of Japanese boxwood and barberry form a classic knot pattern in a formal midcoast garden.

Left: In Searsmont, Richard Rosenberg expanded his gardening space by using his dock to grow tomatoes. In full sun, the plants grow quickly, owing to additional light reflected from the surface of the pond. Watering is no problem, either.

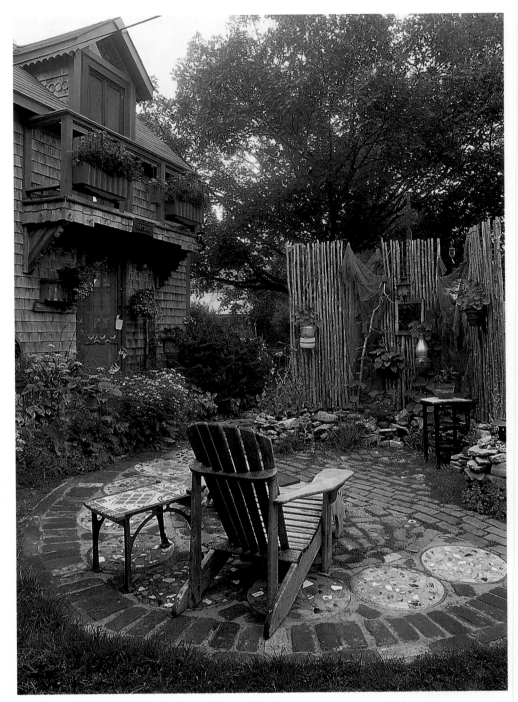

Right: A terrace of concrete circles edged in brick extends the summer living space of Carol and Peter Collins's Stonington home. Carol used rusty barrel hoops found at the dump as molds for the concrete circles.

Opposite: A copper toad stays alert for mayflies skimming the surface of Elsie Freeman's pond garden on Barters Island. Gail McPhee and Bill Phinney helped design this home for water lilies, yellow flag iris, and other moisture-loving plants.

or classic knot gardens. These formal landscapes represent the triumph of humankind over nature, which in the wilds of Maine is no small achievement. Such gardens may likewise indicate the luxury of time, for a considerable amount of it is needed to maintain any garden, especially one characterized by precision.

Informal gardens, on the other hand, often indicate a free spirit at work. Mixed beds of densely packed edibles and ornamentals laid out with no apparent scheme have a charm of their own—and the added virtue of camouflaging tiresome weeds. Sometimes, the apparent chaos is entirely deliberate, the result of an innate reluctance among many residents of Maine to appear "fancy." These relaxed gardens may take the form of cottage (or dooryard) gardens, combination vegetable and cutting gardens, and container gardens, prevalent on boat docks and camp decks. (Paradoxically, such informal displays can cost as much as formal ones;

seaside patios bedecked with ornate containers don't come cheaply.)

It's a third style, however, that truly establishes Maine as the home of the horticulturally free and brave. It is a style so independent and even iconoclastic as to appear to be no style at all. It is an anti-style that dares the viewer to compare what he or she sees with any garden, anywhere. These unique landscapes are the work of downright defiant gardeners who may be spotted toiling where no "normal" person would ever wield a trowel: along a rocky coastline, in a weedy bog, or in a denuded forest riddled with tree stumps. When handed a less than ideal site, these gardeners will meet any challenge (including springtime swarms of blackflies). They will pack soil between the rocks in a craggy cliff, drain a bog (or turn it into a pond), or remove the tree stumps from the site of a recent clear-cut.

Take Elsie Freeman, for instance. On Barters Island, a pond garden was what Ms. Freeman wanted, so a pond garden is what she got. Neither rock ledge nor thick brambles could stop her, and within a year she was planting yellow flag iris and water lilies and cladding boulders with moss transplanted from elsewhere on her property. She relished the challenge and is reluctant to see it end. "I tried to overwinter a lotus, but it didn't work out," she says with a sigh. "I'll just have to try again." (This year, she vows to place the lotus inside a black plastic bag filled with moist sand and store it in a dark, cool location.) And so the challenge continues.

Equally defiant when it comes to overcoming

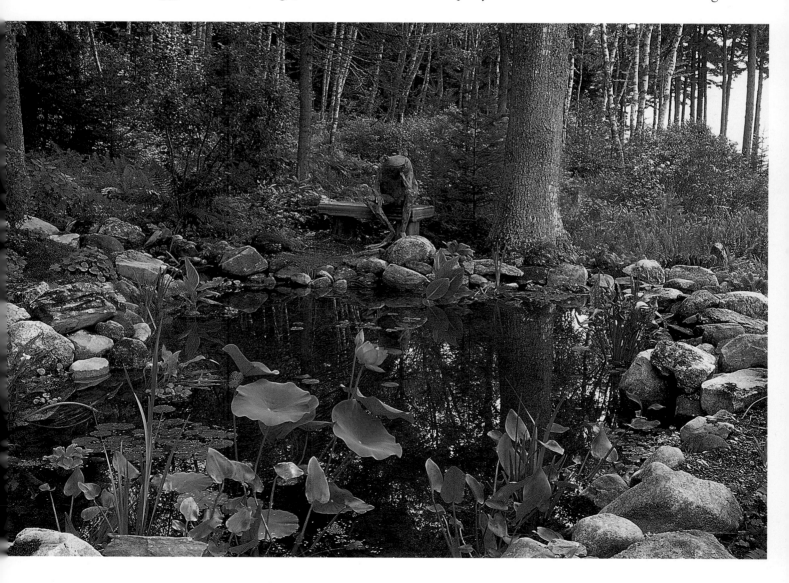

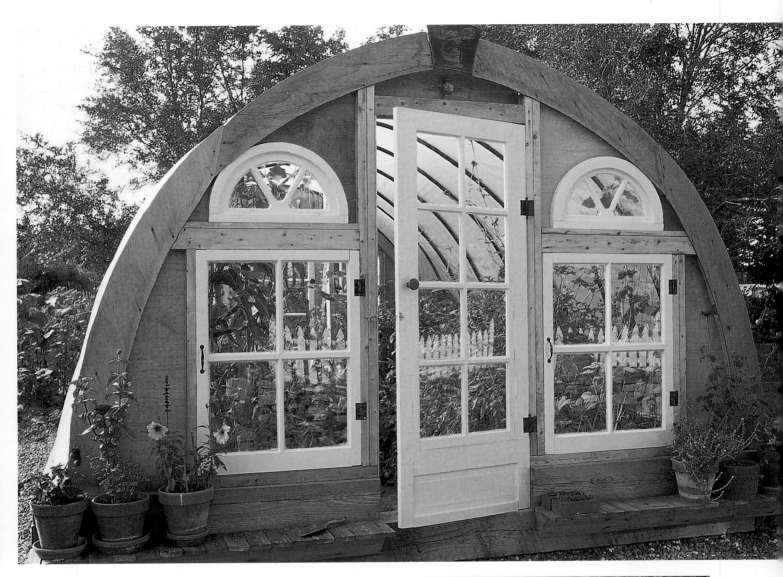

Above: A greenhouse built by Carol Collins features a recycled door and windows. Inside, Carol raises salad greens, tomatoes, and other crops from seed.

Right: Who's in charge? Unfortunately for birds as well as young plants, cats love gardens, too.

the odds is Carol Collins, near Stonington, on Deer Isle. Determined to extend the growing season and provide her family with fresh vegetables for as much of the year as possible, Carol knew she needed a greenhouse. So she built one, entirely by herself. The twelve- by sixteen-foot structure features greenhouse film laid over curved rebar cut in twenty-foot lengths and sleeved with PVC tubing. Discarded windows and a door found at the local dump provide ventilation and access. "I really like to do things myself," admits Carol, who no longer has to wait until August to harvest her first ripe tomato.

Edith Baker is one unusual "gardener" who never picks up a trowel at all. The Camden antiques dealer has been "growing" her collection of botanical ephemera (paper collectibles) for more than forty years. Vintage seed packets, advertising trade cards, seed catalogues, and children's board games with botanical themes have turned her home into a flower-filled retreat twelve months of the year.

A similar spirit of whimsy pervades many of Maine's most personal gardens. Here, plants are important, but they play supporting roles. Informal sculpture and folk art—birdhouses, scarecrows, even "men" fashioned from clay pots—help remind us that humor can be as central to a garden's success as the absence of weeds. A little laughter offers the perfect antidote to the serious business of feeding

Above: Set into a hollow in the trunk of an apple tree in Stephen and Helene Huyler's Camden yard is a custom-built house for garden sprites. At least a hundred years old, the tree still bears fruit.

Left: A "paper garden" assembled by antiques dealer Edith Baker includes vintage seed packets and advertising trade cards.

On the Wing

Whether or not birds choose to live in them hardly matters to the makers of birdhouses. It's the thought that counts. In general, for songsters to take up residence, the size of a birdhouse doorway should be tailored to the size of the bird (wrens prefer openings the size of a quarter, for instance). To prevent disease, birdhouses and nesting boxes are usually cleaned once a year, in late summer, after the chicks have fledged. In cold weather, birds that overwinter will use the houses for shelter. Unique to Maine are blackfly houses, the handiwork of members of the Maine Blackfly Breeders Association, based in Machias. Initiates must be able to dress in shorts and a short-sleeved shirt and stand (without swatting and with tongue firmly in cheek) for fifteen minutes on Memorial Day in Washington County's Jacksonville Cemetery.

Left: A specialty blackfly house by Marilyn Dowling and Jim Wells (on view at Woodwind Gallery, in Machias)

Below: A steeple-topped birdhouse in Joan Beal's Great Wass Island garden

Bottom left: A birdhouse built by Justin Derbyshire, of Mount Vernon

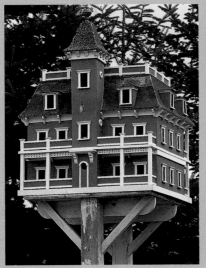

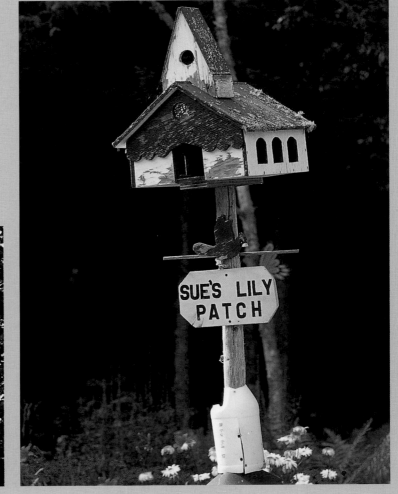

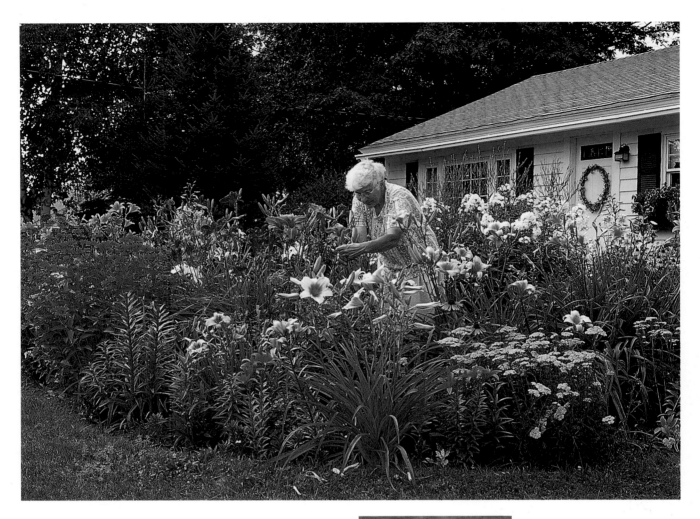

the soil, watering the vegetables, and picking off destructive beetles. Interestingly, gardeners with a well-developed sense of humor often turn out to have the most self-confidence. They can bend the rules and design a landscape that mimics no other. Savvy visitors are quick to get the message: "This is *my* garden. If you don't like it, too bad."

When asked why they garden, many gardeners will answer, "Because I must," placing their preferred activity in the same category as breathing. Stonington's Carol Collins gardens reflexively, guiding plant combinations, then standing back to see what happens. "I'm not a control freak," she says. "Gardening is something I have to do. It's a form of play as well as a creative outlet." In central Maine, Barbara Morin has tended her Guilford garden for "just twenty years." She, too, cannot imagine life without a garden. The daughter and granddaughter of devoted gardeners, Ms. Morin looks forward to that delicious moment each spring when the earth

Above: In central Guilford, Barbara Morin nurtures lilies of all descriptions, as well as tall yellow heliopsis, yarrow, and 'Simplicity' roses.

Left: Who says lettuce plants should be removed before they bolt? An artful gardener has her own ideas about when a plant outlives its usefulness.

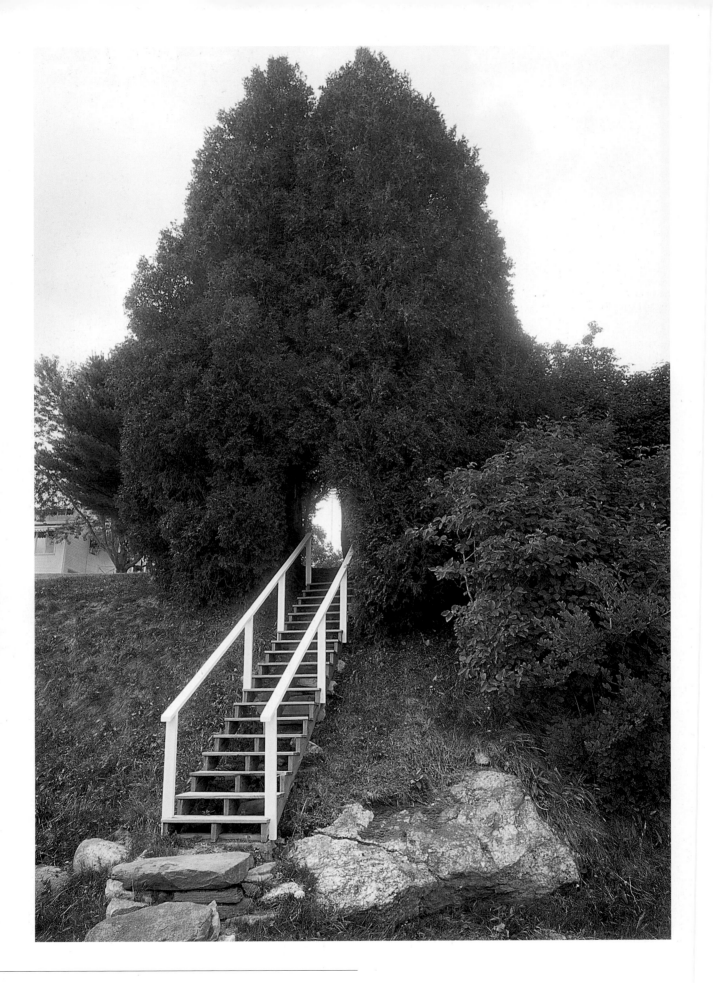

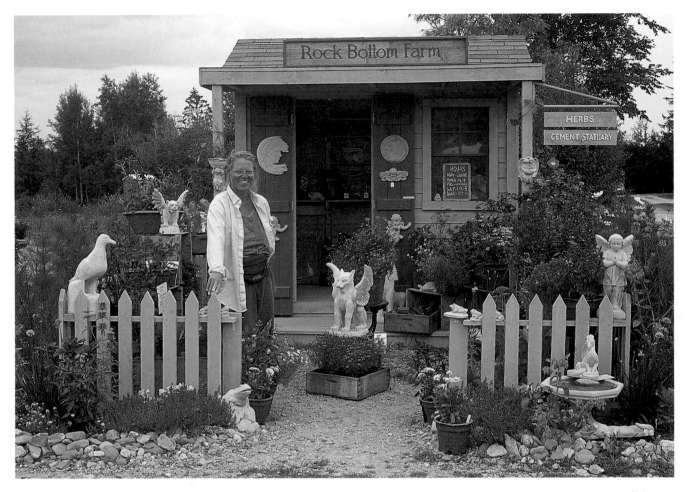

This page: Big ideas come out of Jennifer Pierce's small potting shed in Waldo. The owner of Rockbottom Farm, Ms. Pierce creates and sells diminutive vegetable plots, such as the tiny salad garden at left.

Opposite page: A clump of sixty-five-year-old arborvitae came with Catherine and Larry Latta's house on Barters Island, near Boothbay. Children and pets know where to go to get out of the sun.

awakens. "It's so remarkable to see the total dieback that we have every winter here in Maine and then to witness such a complete renewal. The earth simply explodes. It's all part of creation, I guess." For Jennifer Pierce, owner of Rockbottom Farm, in Waldo, and creator of miniature potted gardens for sale each summer, gardening is "a way of life." It is both vocation and avocation. "I was born with a trowel in my hand. I find myself gardening just for the sake of it as well as to earn a living." Moreover, she believes, "Growing anything is an act of faith."

Some of Maine's gardeners practice their art in reaction to years endured without access to the soil. After a decade in New York City, Linda Mattson found herself "walking through Central Park and hugging the trees." Now a resident of Freedom, Ms. Mattson admits to fairly swooning when she planted her first garden here more than fourteen years ago. "This may sound a little crazy," she confesses, "but I do feel a certain rapture when it comes to gardening. There's something mystical about it." Likewise, Elsie Freeman, who grew up in a large city, remembers vividly discovering the world of gardening during her years at Smith College. "I used to hang out in the campus greenhouse," she recalls. The garden she began fifteen years ago on Barters Island is a direct result of her teenage romance with her alma mater's perennial beds.

Without a doubt, nostalgia can impel an otherwise normal person to garden obsessively. Julie C. Wang, owner of a garden shop and nursery called Blue Poppy Garden in coastal Sedgwick, grew up in England "surrounded by beauty." Her adult life has been devoted to recapturing the botanical fairyland she knew as a child. "I've been gardening ever since I could walk," she says. "The whole thing is simply magic—especially in Maine where, come November, you wonder how anything could ever bloom again."

Although gardeners may say that they have embraced horticulture for reasons of artistic expression, self-sufficiency, defiance, or the search for lost youth, it's clear why they really spend so much time with their hands in the dirt: They garden, quite simply, for the joy of it.

Below left: Young Ben Peabody can't believe the heft of Edgar Jackson's prizewinning 'Dill's Atlantic Giant' pumpkin. Tipping the scales at 440 pounds, the gargantuan gourd didn't come close to the reputed world record of 1,131 pounds. But Mr. Jackson, of Belmont, vows to keep on trying.

Below right: An autumnal bed of hay sits invitingly outside the Mattson family woodshed in Freedom. Linda Mattson made the "shutters" from parts of an antique stove that she and her husband had used for years in Virginia. The couple's sons carved the jolly pumpkins.

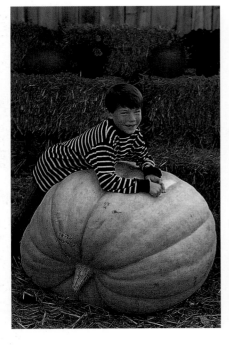

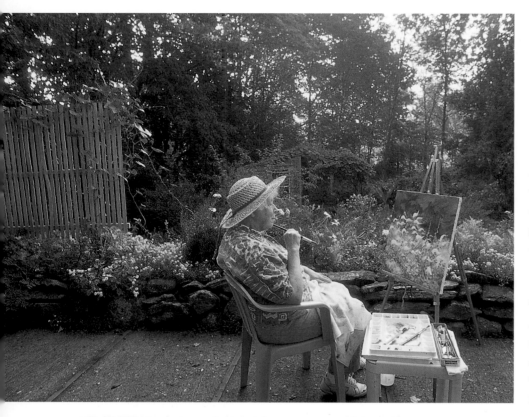

Left: Camden painter, printmaker, and enamelist Stell Shevis finds plenty of inspiration right in her own backyard. Nevertheless, throughout the summer she exchanges visits with other artist-gardeners to freshen her outlook on the world of flowers.

Below: Sedgwick gardener Julie Wang created her croquet lawn as a reminder of happy childhood moments in England. Ms. Wang and her family make good use of the cedar-wrapped court on the Fourth of July and other holidays.

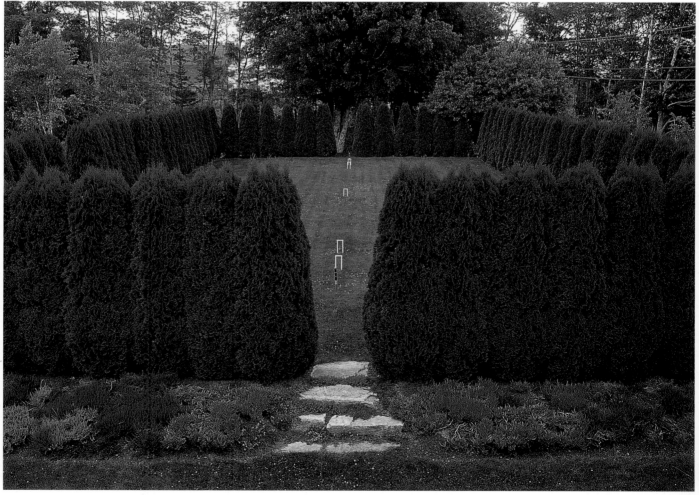

A Drive in the Country

"Welcome to Maine: The Way Life Should Be." For longtime residents and visitors alike, this sign beside Interstate 95 says it all. Yet those who most appreciate America's twenty-third state don't need the written word to tell them they've arrived once again in their spiritual home. They know it instantly by the tall pines and spruces that flank the highways and back roads. They know it as soon as they get out of the car and take a deep breath. (In Maine, they are convinced, even the air is sweeter.) They know it most surely in late May and early June, when spires of dark blue, purple, and pink lupine wave gently in the spring breeze. Later, in July, they quietly celebrate other roadside denizens, such as the orange daylilies that, like lupine, have naturalized throughout Maine. Then, in autumn, the celebration grows louder as maples and other hardwoods make leisurely back-road excursions simply irresistible.

For at least 150 years, artists, sailors, campers, hikers, and antiques hunters have traveled to Maine to pursue their interests. Now gardeners, too, are discovering the charms of the Pine Tree State. Public gardens and botanical parks draw ever more visitors. Historic farms and homesteads demonstrate innovative as well as tried-and-true gardening practices. Along scenic back roads, specialty nurseries offer hard-to-find plants in addition to the opportunity to gather information from dedicated horticulturists. (Garden tourists even have their own map, an initiative of the Maine Office of Tourism: *Maine Garden and Landscape Trail,* available by calling 1-800-782-6497, guides visitors to dozens of nurseries and public gardens.)

Annual tours of private gardens offered through local nonprofit groups in towns such as Auburn, Augusta, Boothbay, and Damariscotta (to name but a few) present the work of professionals and amateurs alike. Annual fairs and festivals showcase Maine crafts and agricultural products and offer a window on the "homely" arts—everything from how to garden organically to how to make blueberry pie. For further sustenance, dozens of restaurants proudly serve locally grown vegetables; some top eateries even maintain their own gardens, so that lettuce, herbs, and other produce are never more than a few hours old. Then, as night falls, weary travelers can retreat to an inn embraced by gardens, leaving no part of the day devoid of horticultural beauty.

Previous page: Route 52 in Lincolnville follows gentle curves around one of Maine's sixteen hundred lakes.

Right: In early June, naturalized lupines that bank roadsides throughout Maine signal that summer will soon be here.

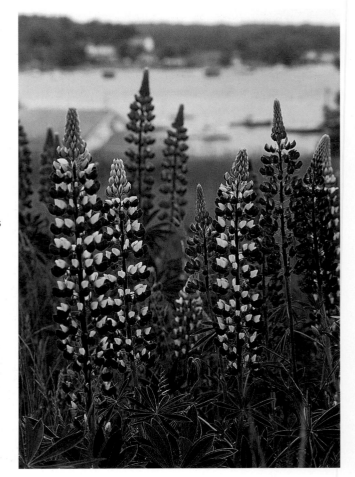

Botanical Gardens & Parks

Amen Farm Gardens, Naskeag Point Road, Brooklin (telephone: 207-359-8982). Open daily year-round, from dawn to dusk. Originally created by Roy and Helen Barrette, this series of well-furnished garden "rooms" now includes an arboretum of 150 uncommon trees.

Avena's Herb Garden, 219 Mill Street (off Route 90), Rockport (telephone: 207-594-2403). Open mid-May through early October, Wednesday through Saturday (call for hours). Avena Botanicals Apothecary & Gardens grows more than a hundred traditional and unusual herbs, many used for centuries in herbal medicine. Founder Deb Soule encourages visitors to explore the issues of holistic health, biodiversity, seed saving, and ecological restoration. Inside the 1830s farmhouse that serves as headquarters, a staff of eight prepares and packages herbs and medicinal tinctures made from

Above: Avena Botanicals owner and founder Deb Soule harvests lady's mantle, a centuries-old standby for easing mild aches and pains.

Right: Herbs and medicinal flowers flourish in Avena's Herb Garden, in Rockport. Purple coneflowers will be made into tinctures favored for strengthening the immune system. Orange and yellow calendula blossoms are destined for teas or salads.

plants grown organically at the site. Lectures and workshops at the Avena Institute examine herbalism, nutrition, organic and biodynamic gardening, ethnobotany (the study of plant lore), women's and children's health, and the care of animals. A schedule of events and a mail-order catalogue are available; contact the apothecary at 207-594-0694.

Coastal Maine Botanical Gardens, Barters Island Road, Boothbay (telephone: 207-633-4333). Open daily year-round, sunup to sundown, conditions permitting. Walking trails encourage visitors to explore this 128-acre horticultural resource on the Boothbay peninsula. Shorefront demonstration gardens provide ideas for selecting and nurturing healthy plants in the coastal Maine environment.

The Good Life Center, 372 Harborside Road, Harborside (telephone: 207-326-8211). Open year-round. Stewards and caretakers welcome visitors to the homestead of Helen Knothe Nearing (1904–1995) and Scott Nearing (1883–

1983), two of America's most inspirational practitioners of simple, frugal, and purposeful living. The Nearings left behind a charming hand-built stone house, an organic garden, and plenty of valuable lessons in self-sufficiency. Now managed by a nonprofit organization, the center offers educational programs on homesteading and sustainable living (call for a schedule of events). "Monday Night Meetings" (June through mid-September) on topics as diverse as composting and economic justice continue to draw visitors to this beautiful site on Cape Rosier.

Kelmscott Farm, Van Cycle Road (off Route 52), Lincolnville (telephone: 207-763-4088). Open daily except Mondays, 10 to 5 (May through October) or 10 to 3 (November through April). A garden of medicinal and culinary herbs and traditional dye plants complements the farm's assortment of rare livestock breeds, such as the Cotswold sheep that dot the pastures. The Kelmscott Rare

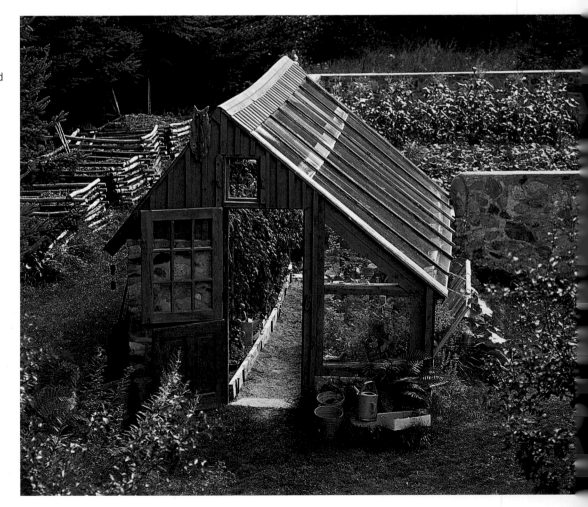

Now known as the Good Life Center, the former homestead of back-to-the-landers Helen and Scott Nearing, in Harborside, features a hand-built greenhouse.

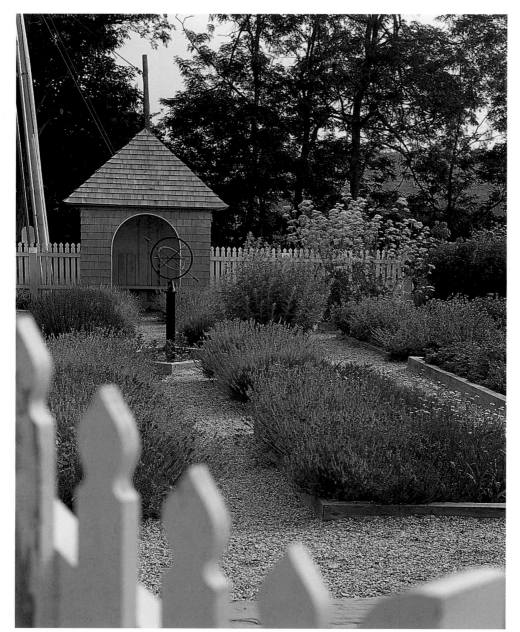

At Kelmscott Farm, in Lincolnville, a classic herb garden includes plants used for centuries to make dyes.

Breeds Foundation conserves historic but now endangered breeds in an effort to promote agricultural biodiversity. A favored destination for history buffs and families with children, the farm offers lovely views from its hilltop location.

Lyle E. Littlefield Ornamentals Trial Garden, University of Maine at Orono (telephone: 207-581-2918). Open daily, year-round. Nearly four thousand plants fill the twelve-acre site, begun in the 1960s by horticulture professor Littlefield and enhanced over the years by University of Maine students. The extensive collection of ornamental shrubs includes rhododendrons, crab apples, lilacs, and magnolias. A bird garden, pond garden, and wide assortment of indigenous plants make the park an important resource for professionals as well as home gardeners. Nearby, on College Avenue, the **Roger Clapp Greenhouses** (telephone: 207-581-3112) contain hundreds of tropical plants used in the university's demonstration gardens. More university gardens can be found just north, in Stillwater, at **Rogers Farm** (telephone: 207-942-7396). Here are the **Penobscot County Master Gardener Demonstration Gardens,** as well as handsome displays of annuals and perennials.

continued on page 136

The Maine Course

Maine's restaurateurs have joined forces with local farmers in an effort to serve the freshest produce. In season (and even out of it, thanks to innovative greenhouses that shelter crops in cold weather), patrons at many restaurants can count on pesticide-free greens, onions, potatoes, leeks, carrots, and other vegetables and herbs. The flavor is there; what's missing are the preservatives often used when food is trucked in from giant producers thousands of miles away. What *is* preserved are nutrients, 60 percent of which can be lost just two days after harvesting. In addition to purchasing crops raised on local farms, some restaurants now have their own gardens, where flower-bedecked pathways and patios encourage strolling. Here, a handful of the many Maine restaurants likely to delight gardeners. *(Call ahead for months and hours of operation. Area code for all numbers is 207.)*

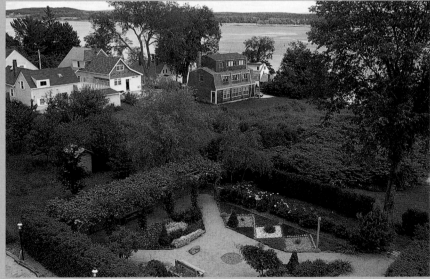

Arborvine, Blue Hill (374-2119)
Arrows, Ogunquit (361-1100)
Blue Hill Inn, Blue Hill (374-2844)
Burning Tree restaurant, Otter Creek,
 Mt. Desert Island (288-9331)
Castine Inn, Castine (326-4365)
Chase's Daily, Belfast (338-0555)
Harraseeket Inn, Freeport (865-9377)
Islesford Dock, Cranberry Isles
 (244-7494)
Kitchen Garden Restaurant, Steuben
 (546-2708)
Le Domaine, Hancock (422-3395)
Maine Diner, Wells (646-4441)

Pilgrim's Inn, Deer Isle (348-6615)
Primo, Rockland (596-0770)
Squire Tarbox Inn, Westport Island,
 Wiscasset (882-7693)

Waterford Inne, Waterford
 (583-4037)
White Barn Inn, Kennebunkport
 (967-2321)

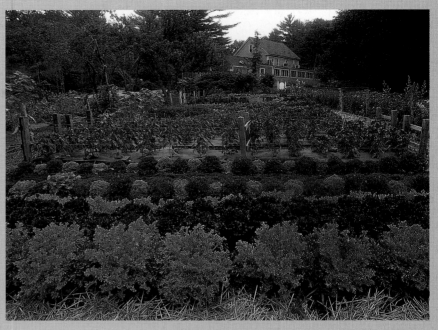

Opposite top: On Deer Isle at the Pilgrim's Inn, salad greens and floral garnishes are harvested from the inn's own garden. Built in 1793, the inn is listed on the National Register of Historic Places.

Opposite bottom: A neat-as-a-pin parterre at the Castine Inn makes use of oyster and mussel shells, plentiful by-products of dinners served at the inn. Purple creeping thyme and green lemon thyme fill out the geometric design. Owners Amy and Tom Gutow design the inn's menus around fresh local fare.

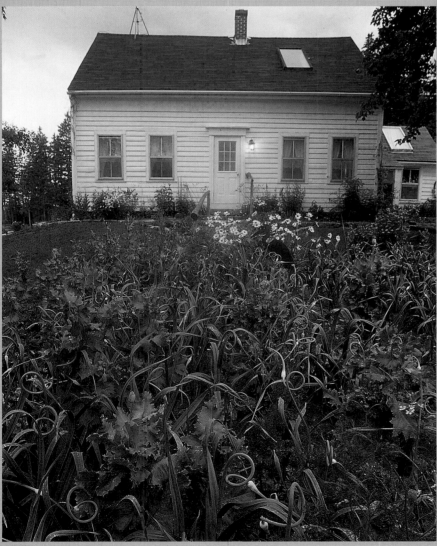

Above: Spectacular flower, herb, and vegetable beds draw visitors to Arrows, in Ogunquit. Owners Clark Frasier and Mark Gaier experiment with unusual varieties of salad greens and other crops. Marcia MacDonald keeps the vegetable garden looking splendid; Thomas Lovejoy maintains the restaurant's flower gardens.

Left: In Steuben, east of Ellsworth, the Kitchen Garden Restaurant serves fresh organic produce, free-range chicken, and other local ingredients. Owners Alva Lowe and Jessie King invite patrons to arrive early and wander through the herb, vegetable, and flower gardens.

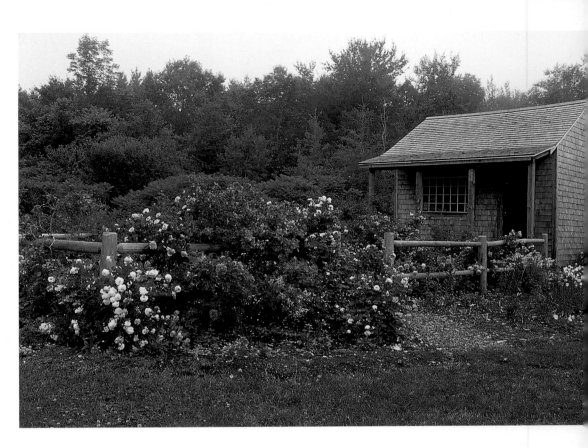

Hybrid perpetuals, floribundas, climbers, ramblers, and heirloom roses peak the first week in July at Camden's Merryspring Horticultural Nature Park, which also features a children's garden and rock garden.

Merryspring Horticultural Nature Park, Conway Road (off Route 1), Camden (telephone: 207-236-2239). Open every day from dawn to dusk. Perennials and annuals, a rose garden (featuring species and types that thrive in Zone 5), an herb garden, an arboretum, and a nature preserve fill this sixty-six-acre park. The nonprofit organization that maintains Merryspring strives to "acquaint, stimulate, and educate the community in all matters of horticulture, and to exercise and advocate sound principles of wildlife ecology and conservation in order to protect our natural environment." Workshops, lectures, plant sales, and a spring garden show are other reasons to visit.

Norlands Living History Center, 290 Norlands Road, Livermore (telephone: 207-897-4366). Open July 1 through Labor Day, weekends only Labor Day through Columbus Day. (Always call ahead for hours and daily schedule of events. Tours daily, 10 to 4; last tour departs at 2:30 p.m.) This nineteenth-century homestead, complete with Victorian mansion, several farm buildings, and all their contents, was donated intact in 1973 to the Washburn-Norlands Foundation. Today the property, with many original plantings, operates as a living history center for the educational use of the general public. Visitors enjoy an in-depth look at daily life 150 years ago and are encouraged to participate in agricultural activities. Special activities are announced on the center's website: norlands@ctel.net

Pine State Arboretum, 153 Hospital Street, Augusta (telephone 207-621-0031). Open daily year-round, dawn to dusk. More than three hundred species of trees and shrubs on 224 acres show the range of hardwoods and evergreens at home in Maine. A rock garden and miles of groomed trails lure walkers, joggers, and cross-country skiers.

University of Southern Maine Stone House Gardens, Wolf Neck Road, Freeport (telephone: 207-865-3428). Open daily year-round, from dawn to dusk. Hundreds of heathers, as well as daylilies, azaleas, peonies, and iris serve as a living index to plants that thrive on Maine's southern coast. A rhododendron display garden with more than forty species and hybrids is maintained by the Maine Chapter of the American Rhododendron Society.

The Wild Gardens of Acadia, Sieur de Monts Spring, Acadia National Park, Mount Desert Island (telephone: 207-288-3338). Open daily, mid-May through October. A superb assortment of wildflowers fills the twelve habitat gardens that make up this educational resource at the foot of Dorr Mountain. Highlights include a wide variety of ferns, with many plants clearly labeled.

Noteworthy Nurseries

Nurseries and garden centers stocked with unusual plants suited to difficult conditions make Maine a plant hunter's paradise. The businesses below represent just a sampling of what is available. (For an inclusive list of nurseries and garden centers throughout the state, visit *People, Places, and Plants* magazine's website: www.ppplants.com.)

The nurseries profiled here tend to be specialists, and some are located off the beaten path but are well worth seeking out. Most maintain exquisite display gardens, of which they are justifiably proud, and many hybridize and propagate their own varieties. They may not be open at all times or in all seasons, so it's wise to call ahead.

Barth Daylilies, 71 Nelson Road, Alna (telephone: 207-586-6455). Renowned hybridizer Nick Barth sells his daylily introductions direct from their beds (peak bloom: July 15 to August 15), as well as by mail. On view are more than four hundred named varieties, including fifty Barth originals acclaimed for their excellent substance and high bud count. Call ahead.

Blackrock Farm, 293 Goose Rocks Road, Kennebunkport (telephone: 207-967-5783). Near Goose Rocks Beach lies this southern-Maine mecca for unusual annuals, perennials, herbs, and organic vegetables. Especially noteworthy are owner Helene Lewand's salvias, passionflowers, and ivies, which get their start in two greenhouses on the eighty-acre farm. Open daily 9 to 5, May through September.

Eartheart Gardens, 1709 Harpswell Neck Road, Harpswell (telephone: 207-833-6327). Gardeners rely on this small nursery, owned and managed by Sharon Hayes Whitney, for Dr. Currier McEwen's latest iris introductions. Acclaimed as the hybridizer of the world's first yellow Siberian iris, Dr. McEwen has worked for years with Ms. Whitney. Open the third Sunday in June and the second Sunday in July, or by appointment.

Fernwood Nursery & Gardens, RR 3, Box 928, Cross Road, Swanville (telephone: 207-338-4100). Gardeners who complain of "too much shade" leave Fernwood newly confident that a shortage of direct sunlight is no impediment to a good garden. Rick and Gail Sawyer offer shade-tolerant woodland plants on view in the nursery's tranquil demonstration gardens. Included are rare trilliums, toad lilies, ligularia, astilbes, meadow rue, and hundreds of hostas, many hybridized at Fernwood. Nursery-propagated wildflowers and such unusual ground covers as native ornamental grasses, ferns, barren strawberry, wintergreen, and bunchberry offer lovely alternatives to traditional turf grasses. Open daily May and June, 9 to 5. Open Tuesday through Sunday July through September from 9 to 5.

In late May, hostas hybridized at Fernwood, in Swanville, join woodland phlox in a richly textured shade garden.

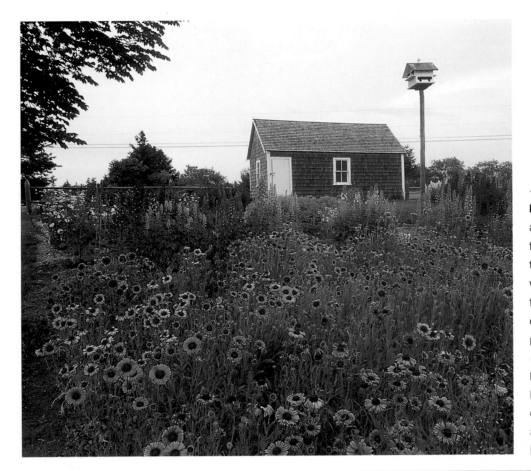

Fieldstone Gardens, 620 Quaker Lane, Vassalboro (telephone: 207-923-3836). Stone walls banked in ferns, hostas, and peonies show the way to nurseryman Steve Jones's spectacular display gardens, part of a 220-acre family perennial and tree farm. A sumptuous assortment of ornamental plants—Oriental poppies, iris (including some of Dr. Currier McEwen's tetraploid Siberians), ground covers, and phlox, in particular—tempts gardeners to try something new. Open 9 to 5 April to mid-November; closed Sundays and Mondays.

Friendship Garden, 117 Bradford Point Road, Friendship (telephone: 207-832-7905). On a six-and-a-half-acre saltwater farm with views of Friendship Harbor, entrepreneur Debbie Deal raises seemingly endless rows of giant delphiniums, blanket flowers, bellflowers, lavender, foxgloves, daisies, Canterbury bells, and other "cottage" perennials. Patrons can snip their favorites and pay by the bunch, or request that plants be dug and potted. Open late May through Labor Day, Tuesday through Saturday from 10 to 4.

Left: Suzy Verrier and Kai Jacob, proprietors of North Creek Farm, in Phippsburg, sell organic produce and hard-to-find heirloom roses.

Below: Flourishing in North Creek's display gardens in early July is apricot-hued 'Ghislaine de Feligonde', a multiflora rambler in circulation since 1916.

Fox Hill Nursery, 347 Lunt Road, Freeport (telephone: 207-729-1511). Roses grown on their own roots (not grafted) and field-grown lilacs flourish at this twenty-eight-acre specialty nursery. An astonishing range of lilacs includes varieties from Russia, Asia, Germany, and France, in addition to America's own favorite cultivars, such as 'President Lincoln' and 'Wonderblue'. Purists will appreciate Eric Welzel's nursery as a source for "old farm lilacs" *(Syringa vulgaris),* the naturalized species that has been gracing houses in Maine for more than two hundred years. Open daily 9 to 5 from April 1 to November 15.

Gingerbread Farm, RR 1, 3590 Old Winthrop Road, Wayne (telephone: 207-685-4050). More than a thousand different perennials, either raised in the nursery's former cornfield or brought in from select growers, tempt gardeners from May 1 through Labor Day. Hostas, daylilies, peonies, roses, and variegated brunnera surround an 1820s cottage festooned with gingerbread trim. Custom-planted containers are another specialty of the house: Bring your own pot or basket, and the staff will fill it with a potted garden to suit. Open daily 9 to 6, May through Labor Day, or by appointment.

Hidden Gardens, 96 Seekins Road, Searsport (telephone: 207-548-2864). Tough plants for northern climates are the specialty of Carla Brown's nursery, about four miles from downtown Searsport. Gardeners flock here for hostas, primroses (tested on-site for the past twenty-two years), daylilies, phlox, cimicifugas, monkshood, and gentians. More than fourteen hundred hardy varieties include a nearly indestructible cobalt blue delphinium that once grew in the Caribou garden of the owner's grandfather. Open from the last week of April through mid-September, daily 8 to 5.

North Creek Farm, 24 Sebasco Road (Route 217), Phippsburg (telephone: 207-389-1341). Unusual roses (Scotch brier, Siberian, Gallicas, and polyanthas among them) and perennials now carpet

this saltwater farm that dates to 1850. Owners Suzy Verrier (the noted rosarian) and Kai Jacob open their ornamental garden to visitors for six months of the year. More than three hundred varieties of roses peak at the end of June and provide eloquent proof that the genus does indeed thrive in Maine. North Creek is also a working farm, offering a wide range of organically grown vegetables and cut flowers, as well as seeds and garden tools. Open daily from 9 to 5, May through October.

Perennials Preferred, 906 Feylers Corner Road, Waldoboro (telephone: 207-832-5282; call ahead). Hardy perennials are the lifework of owner Jean Moss, whose small Zone 4 nursery features giant sea kale, stately verbascum, lungwort, cranesbill, nepeta, primroses, and much more, most in multiple varieties. Open mid-May through the end of August, Tuesday through Saturday 10 to 4, other times by appointment. (No mail order.)

The Roseraie at Bayfields, P.O. Box R, Waldoboro (telephone: 207-933-4508). Hardy landscape and garden roses are the specialty of Lloyd Brace's small nursery. More than three

hundred varieties—rugosas, gallicas, and heirlooms among them—can be seen on-site or ordered by mail; brochure available. Website: www.roseraie .com. Open from the next-to-last Friday in April until October freeze-up (call for exact dates), Monday to Saturday 10 to 5, Sunday 8:30 to noon; closed Sundays in August, Sundays and Mondays thereafter.

Snug Harbor Farm, 87 Western Avenue, Kennebunk (telephone: 207-967-2414). This is a nursery with a twist. Owner Tony Elliott admires animals almost as much as plants, accounting for the doves, chickens, horses, and dogs that share the property with unusual or hard-to-find annuals, perennials, and herbs. Greenhouses filled with topiary fascinate children and adults almost as much as the miniature horses that live on the grounds. Open April through late October, Monday through Saturday 9 to 5, Sunday 10 to 3.

Stone Soup Farm, Red Barn Road, Monroe (telephone: 207-525-4463). Extensive display gardens feature herbs, lilies (all types), perennials, and flowers for drying. Owner and garden designer Kate

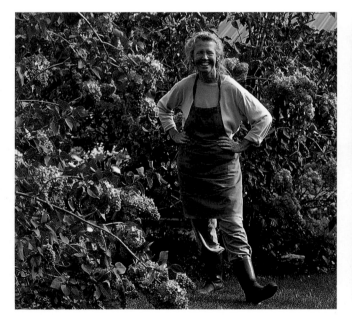

In Monroe, Kate NaDeau greets visitors to Stone Soup Farm, a nursery noted for its innovative display gardens. An all-white garden **(right)** designed by Ms. NaDeau features white lilacs *(Syringa vulgaris 'Alba'), Spirea x vanhouttei,* and candytuft *(Iberis).*

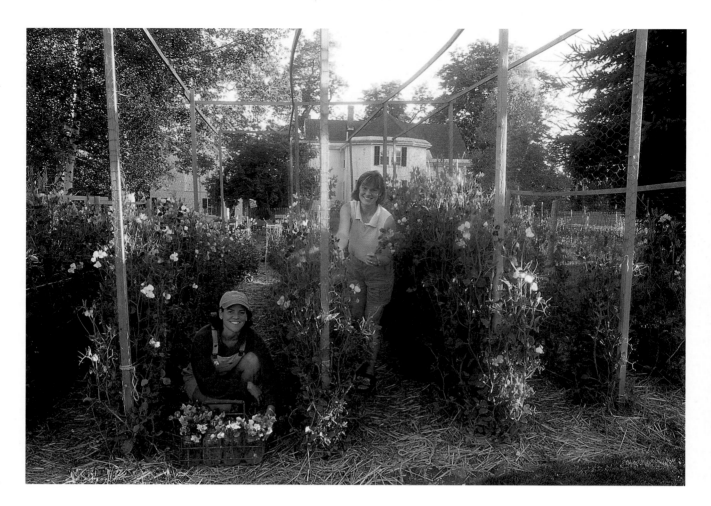

NaDeau has turned twenty-six acres of stony, sloping earth into a showplace for her considerable talents. Over the course of a decade she has assembled a broad selection of plants that stand up to below-zero temperatures. A well-stocked shop and classes in garden crafts are additional reasons to seek out this rural haven. Open May through July, daily 10 to 4, other times by appointment.

Sweet Pea Gardens & Greenhouses, Route 172, Surry (telephone: 207-667-6751). Everyone has a weakness. Sue Keating has one for sweet peas, the specialty of the six-thousand-square-foot garden she maintains with her husband, Pat, and her daughter, Maggie. In spring, twenty-five varieties of sweet-pea seedlings in every known color (and bicolor) crowd display racks, alongside thirty varieties of sweet-pea seeds. Also available: perennials, shrubs, and climbers—and bouquets of cut sweet peas, of course. Open May through July 4, Monday through Saturday 9 to 5. In August: open Monday, Wednesday, Friday, and Saturday 9 to 5.

Sue Keating (on right) and assistant Jackie Nunez grow twenty-five varieties of sweet peas at the Keatings' farm in Surry. Among the varieties is blue-purple 'Cupani' **(below)**, dating back three hundred years.

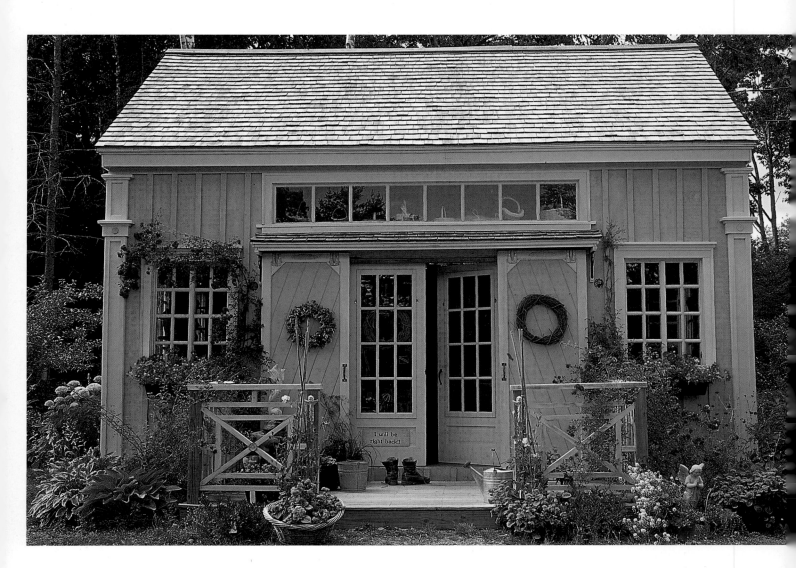

In Walpole, Windsong Herbs and Gardens is a certified-organic grower of herbs both common and unusual. Herbal products await inspection inside this converted farm building.

Windsong Herbs and Gardens, 26 Windsong Way (off Harrington Road), Walpole (telephone: 207-677-3770). Owners Elizabeth and Jeff Kellett offer certified-organic herbs and specialty produce raised on-site, as well as potted plants, seedlings, and honey. Visitors can pick their own herbs and flowers, then move on to the gift shop to inspect the wreaths, herbal vinegars and oils, and other herbal items for sale. Open May through Columbus Day, daily 9 to 5.

Windswept Gardens, 1709 Broadway, Bangor (telephone: 207-941-9898). Roses well suited to northern climates fill display gardens purposely sited on a slight hill exposed to cold north winds. All bushes are planted in permanent garden situations. Owner and rosarian Robert Bangs guarantees all the nursery's roses, which are offered after trial plantings in Windswept's gardens. Also available: a wide variety of perennials and shrubs. Open May through September, Monday through Saturday from 9 to 5, Sunday from 10 to 4.

Meet Me at the Fair

Common Ground Fair, Common Ground Fairgrounds, Unity, third weekend in September. Maine's colorful and wholesome harvest festival features food vendors who grow their own ingredients or purchase them from certified organic growers. About a thousand exhibitors sell produce and demonstrate everything from weaving to composting. Since 1976, this has been the fair to attend to learn how to dry herbs, raise bees, and graft fruit trees. Sponsored by the Maine Organic Farmers and Gardeners Association. Information: 207-623-5115.

Machias Wild Blueberry Festival, Centre Street Congregational Church, Machias, third weekend in August. A pie contest, five-mile blueberry walk, children's parade, and performances by the Machias Community Band highlight this celebration of Maine's signature fruit. The town is duly proud of its position at the epicenter of Washington County, home to 90 percent of America's wild blueberries. Information: Blueberry Festival Committee, P.O. Box 265, Machias ME 04654.

Herb Fest, Common Ground Fairgrounds, Unity, first weekend in June. Maine herbalists and gardeners offer instruction in herbal medicine and herb garden design, starting herbs from seed, herbal skin care, and cooking with herbs. Vendors showcase the products of Maine's herb growers. Information: 207-639-2005.

Opening day at the annual Common Ground Fair, in Unity, includes a children's parade, with young marchers dressed as vegetables.

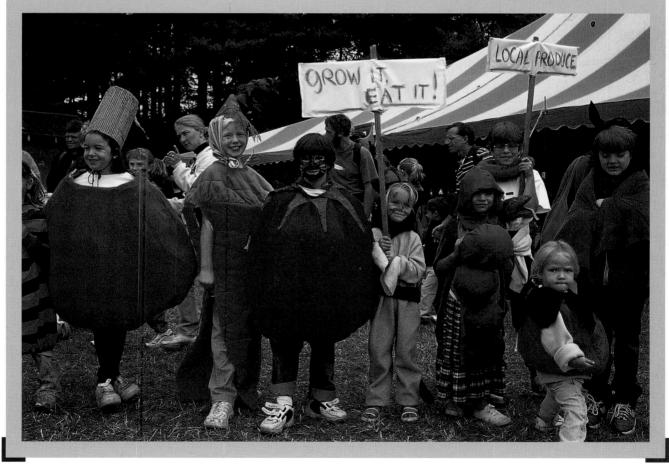

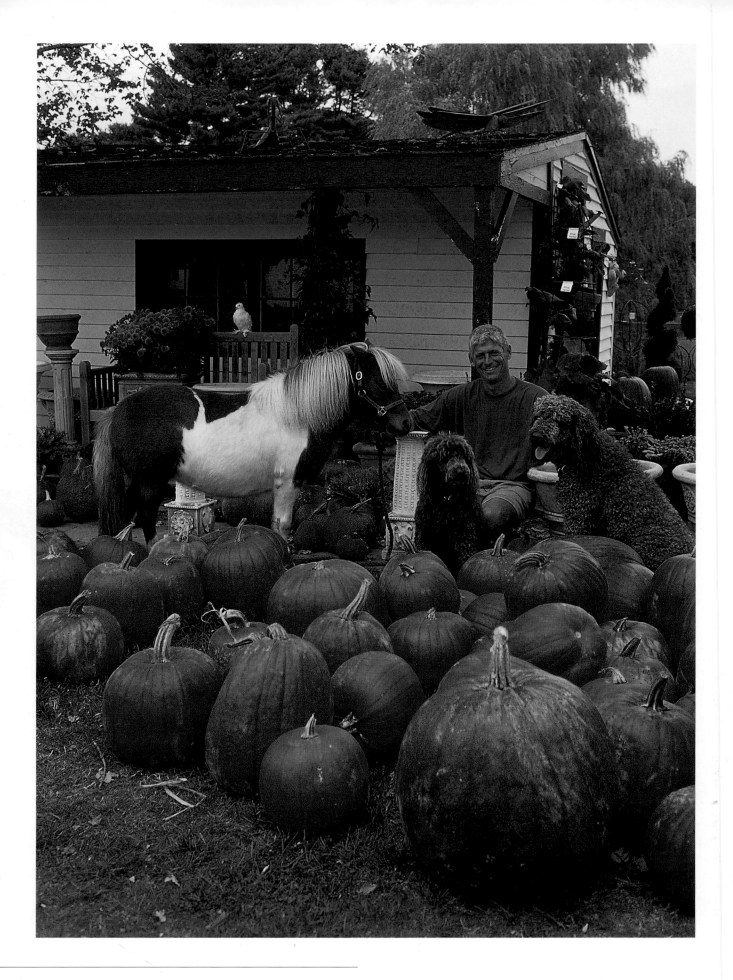

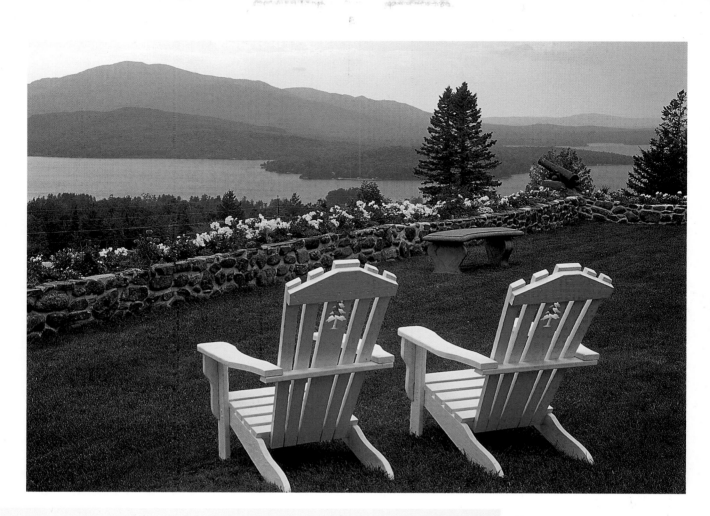

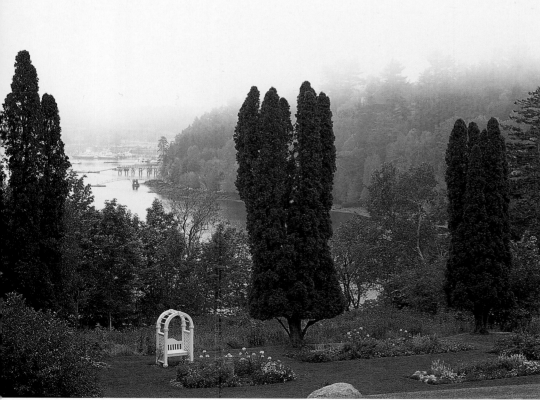

Above: At the Blair Hill Inn, in Greenville (207-695-0224), a nine-hundred-foot-long granite wall built in 1891 sports a depression in its top designed specifically to hold summer annuals. Moosehead Lake dominates the landscape below.

Left: In Northeast Harbor, the Asticou Inn (207-276-3344) looks out over gardens and on to the harbor.

Opposite: Tony Elliot's twin passions are animals and plants. At his Snug Harbor Farm, in Kennebunk, the plants are for sale, as well as pumpkins in autumn. He is also known for his topiary offerings.

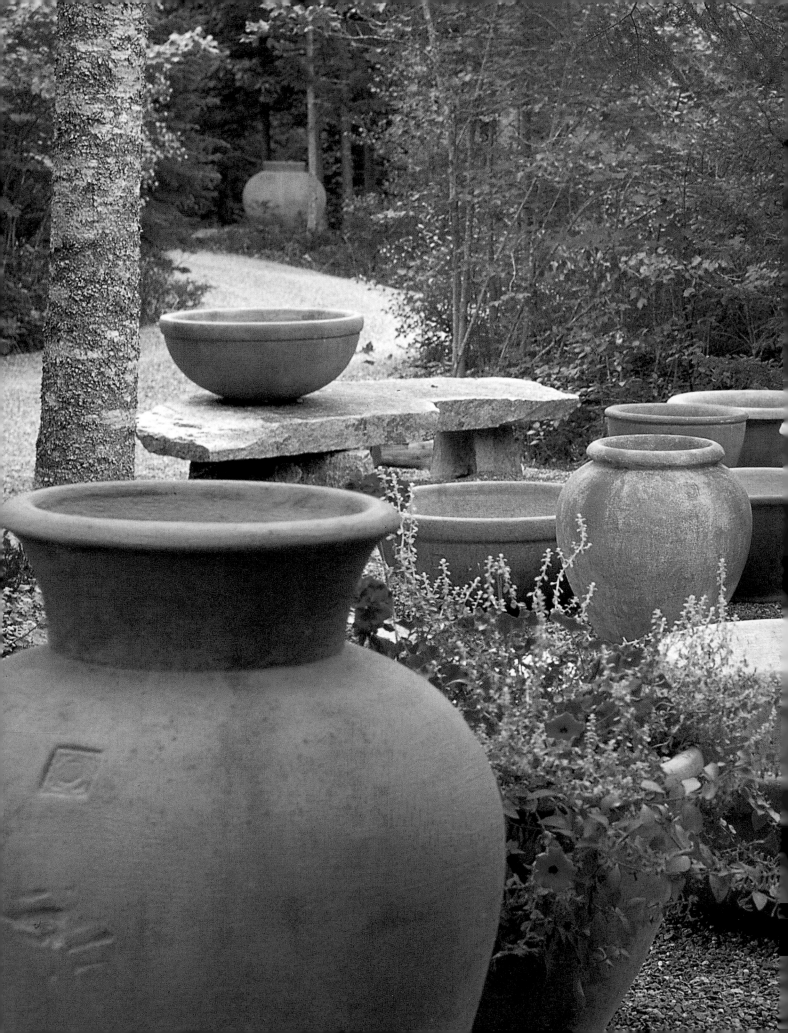

Garden Treasure

Maine gardeners in search of a classic pot, a charming birdhouse, or an offbeat outdoor sculpture needn't travel very far. They can find just about anything they desire (as well as things they weren't aware they *did* desire) without leaving the state. Although the days of barns loaded with underpriced period furniture and art ended long ago, antiques shops filled to the rafters with reasonably priced relics still dot the roadways.

Not all the back-road booty is old, however. Maine is also home to talented craftspeople who are happy to sacrifice larger city markets for the tranquillity of a rural studio. At their Lunaform Studio in West Sullivan, for example, Phid Lawless and Dan Farrenkopf create garden pots that lend ancient grace to contemporary landscapes. (See listing on p. 159.) Stately urns, gracefully proportioned planters, and generous bowls evoke the styles of Greek

— **Previous page:** On display at Lunaform, in West Sullivan, are pots, urns, and garden bowls that never fracture, even when freezing temperatures are followed by a rapid thaw.

— **Above:** All pots bear the Lunaform chop, or hallmark— a quarter moon set within a square frame.

— **Right:** Potters Phid Lawless (left) and Dan Farrenkopf take a break after completing a four-foot-tall "Borghese" urn finished in Tuscan red.

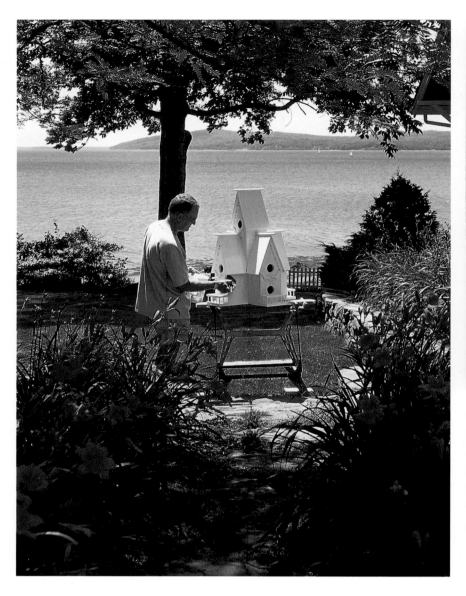

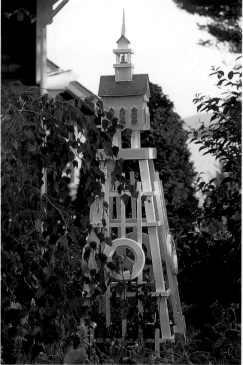

Barry Porter creates bird-houses fit for a phoenix. Some are mounted on obelisks, which become trellises for sweet peas and morning glories.

amphorae and Roman olive jars. What makes each piece exceptional is its durability: Phid and Dan have perfected a method for constructing oversize pots that withstand extended periods of freezing temperatures. Each seamless, hand-turned vessel is like an onion, its multiple layers consisting of concrete reinforced by nylon mesh and galvanized steel wire. Their planters can sit permanently outdoors, needing no special care if kept filled with soil to within an inch of the rim. Lunaform's potters consciously follow in the footsteps of Eric Ellis Soderholtz (1867–1959), the Maine photographer turned sculptor whose classically styled concrete pots—the "must-haves" of their day—still grace gardens eighty years after they were made. In fact, Lunaform's "Reef Point" pot is named for a similar Soderholtz

urn designed at the request of Beatrix Farrand for her famed (and, sadly, gone) Bar Harbor garden.

Farther up Route 1, in Belfast, lives another Maine original. Barry Porter makes birdhouses. His wife, Cindy, and their daughter, Courtney, paint them. (See listing on p. 158.) No ordinary domiciles, Barry's avian retreats include churches, elegant mansions, and charming cottages. A veterinarian by day, Barry spends evenings and weekends embellishing his diminutive dwellings with finials, front porches, and roofs of copper or recycled ceiling tin. No one can say for sure whether the songsters who take up residence give a fig about their fancy digs, but indisputably the houses are occupied year after year. The Potters advise that dwellings be carefully positioned in a protected area out of the wind, and

Opposite and left: Wreath-maker Andy Pratt prepares to create another winterberry masterpiece.

Above: Formed into an ethereal open circle, yellow-orange bittersweet hangs on a weathered shed door.

in partial shade so that the interior does not become too hot. Outside the Porters' own house, known as Daylily Cottage, birdsong fills the air as sparrows, finches, and chickadees try out the model homes that Barry and Cindy display throughout their garden. Prospective customers who call ahead can tour the grounds and select a model to be custom crafted for their own garden.

In Woolwich, across the Kennebec River from Bath, more fine craftsmanship comes from the studio of Andy Pratt, wreathmaker (see listing on p. 158). Retired from the navy and now an operating-room nurse, Andy spends his days in the hospital. After hours, though, he can be found in the mead-ows surrounding the decommissioned Maine Yankee nuclear power plant, in Wiscasset. There, with the blessing of landowners, he gathers bittersweet, winterberry, and serviceberry canes to transform into wreaths. What sets Andy's wreaths apart is their exuberant, full form and emphasis on natural materials. Autumn visitors are apt to take home and display Andy's creations as symbols of Maine's bounty and reminders of delightful days spent touring the state's rural roads. (Andy's wreaths can be seen at a number of retail shops, including Marston House, in Wiscasset; Brambles, in Damariscotta; and Mason Street Mercantile, in Bath.)

Throughout Maine, garden treasure can be

Top: Antique sprinklers add charm to a garden wall.

Above: Fitted with vintage gardening forks, an old tool rack doubles as garden sculpture.

Right: Increasingly collectible (and expensive), vintage watering cans lend their pleasingly diverse forms to a garden bench.

found in some unlikely places. Gas stations turned into shops, old barns, even roadside tables set up on a whim by eager entrepreneurs may yield just the right plant container, flower vase, or garden focal point. For those who thrill to the hunt, a favorite sport is "junking." These gardener-collectors (also known as junkers) prowl rural shops in search of secondhand finds that don't quite qualify as antiques. With well-trained eyes, they ferret out useful treasure from shelves of dusty odds and ends. Lidless coffeepots, salt-glazed crocks, dented watering cans, and bottles bearing interesting labels or

Pots unearthed in the dark recesses of Maine's antiques shops include classically elegant concrete urns and unusual terra-cotta models with rolled rims.

Reborn Containers

Using everything from old washtubs to coffee cans, gardeners anywhere can enjoy a broad range of plants. Key decisions, from location to growing medium to species, can be arrived at with local conditions in mind, making container gardening one of the most versatile forms of horticulture. Plants are grouped in separate containers according to individual requirements for soil composition, fertilizer (or lack of it), and water. These days, what puts some container gardens in a class by themselves is the originality of the vessels that cradle them. Just about anything that holds soil will

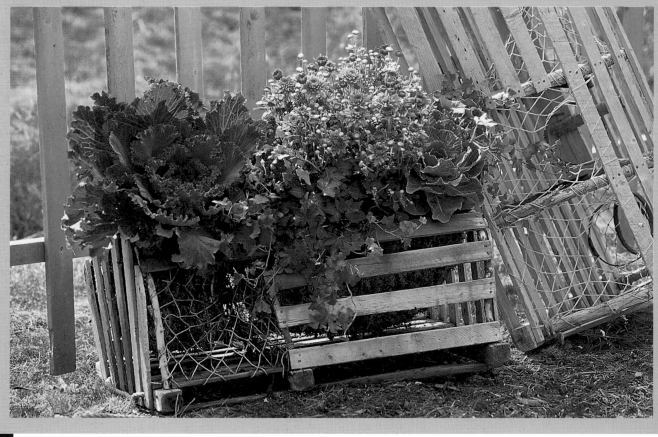

do, as long as drainage is adequate. To prevent soggy roots that lead to rot, use a pickax to punch holes in the bottom of large metal containers such as troughs (those without antique value), and a hammer and nail for smaller vessels such as buckets. Making holes in tough items, such as brass bowls, may require an electric drill. Wooden crates can be lined with a black plastic garbage bag (black is less apt to be noticed than white); punch holes in the plastic liner beforehand, insert the liner in the crate, then fill it with planting medium. To plant a lobster trap, line the trap with sphagnum moss, then top with a plastic liner. Spread a second layer of moss over the liner and then add planting medium.

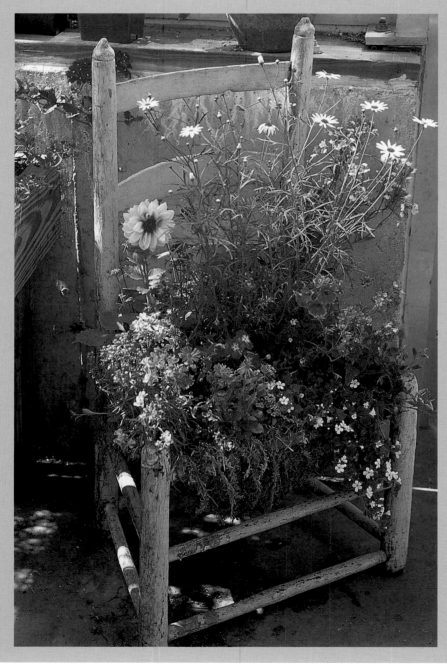

Above: A rusty can with a colorful label becomes a stylish vase when fitted with a small glass jar inside.

Left: A flower-cushioned chair at Allen, Sterling & Lothrop, a Falmouth garden center, has a new "seat" constructed of chicken wire, sphagnum moss, and potting soil.

Opposite top: Pansies sprout from a galvanized trough once used for animal feed.

Opposite bottom: At Allen, Sterling & Lothrop old wooden lobster traps are turned into homes for bright bloomers.

inscriptions are possible booty from a successful "junket." These and similar vintage treasures make winsome vases for colorful bouquets (or "fresh-cuts," as florists sometimes call them). Larger items, including galvanized washtubs, graniteware breadboxes, and wooden fruit and vegetable crates, become eye-catching container gardens. Even a lobster trap (lined with chicken wire and sphagnum moss, then filled with potting soil) can nurture

inexpensive seedlings purchased in six-packs.

Indeed, many of Maine's best sources for garden treasure don't call themselves antiques stores at all. Elmer's Barn, in Coopers Mills; Fifi's Finally I Found It, near Augusta; and the Cornish Trading Company, in Cornish, near the New Hampshire border, are just three examples. The owners of these dusty emporiums knowingly cater to collectors whose imaginations are sometimes bigger than their wallets, those who can see beyond the obvious: a rusty funnel, for example, may easily become a flowerpot with built-in drainage system. Junkers know that wheelbarrows past their prime can yet serve as portable container gardens, ideal for transporting posies from sun to shade as conditions require. Tired sprinklers, trowels, garden forks, and other vintage tools clearly are not trash, sensitive plantsmen and -women know; they're artifacts worthy of display on porch shelf or potting-shed wall, where they become charming reminders of gardens, and gardeners, gone by.

Above: Graniteware coffee-pots await transformation into rustic vases. Fitted with glass jars as liners, each will become a home for bouquets of fresh flowers.

Right: In Jill Hoy's Stonington garden, a decommissioned wheelbarrow provides handsome support for cascading roses.

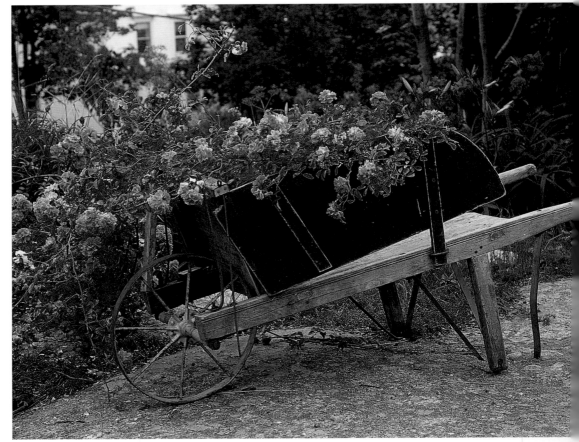

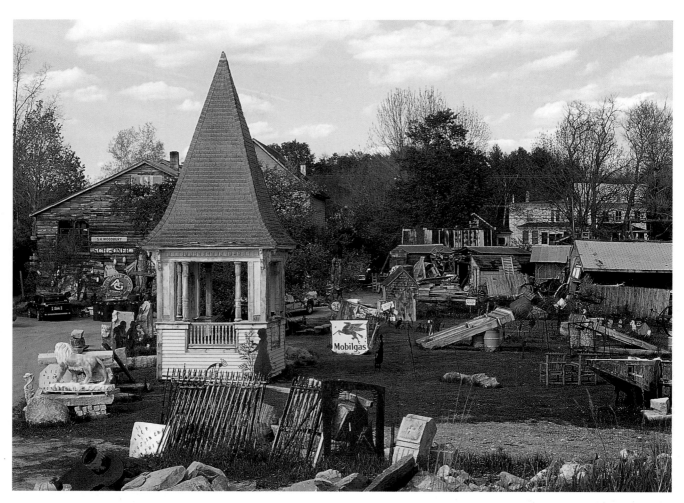

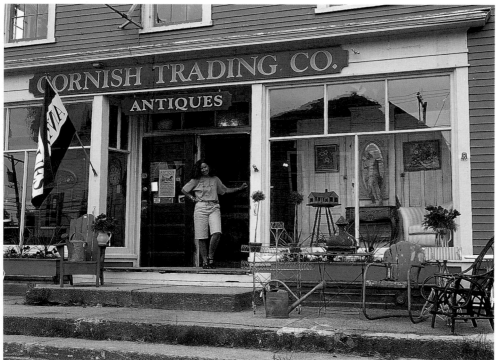

Above: Elmer's Barn, in Coopers Mills

Left: Owner Francine O'Donnell greets collectors outside the Cornish Trading Company, in Cornish.

Antiques & More

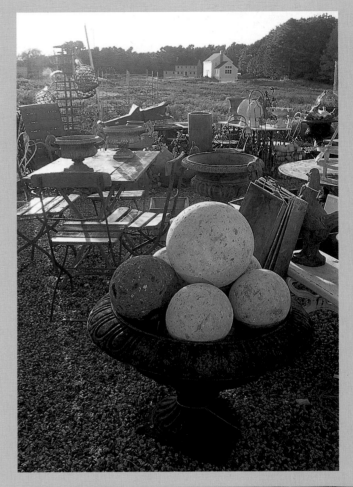

Below is a sampling of the many Maine emporiums that regularly include garden furnishings among their wares.

For an annually updated directory of antiques dealers statewide, send $3 to Edward M. Welsh, Jr., RR 3, Box 1290, Winslow, ME 04901. The directory also appears (free) online at edwelch@metiques.com.

Area code for all telephone numbers is 207.

Andy Pratt Wreaths, 1206 Old Stage Road, Woolwich (882-9641)

Antique Revival, Route 301, Naples (683-6550)

Antiques on Nine, 75 Western Avenue, Kennebunk (967-0626)

Back to Earth Gardenworks, 605 Lewiston Road, Topsham (865-9459)

Barry Porter Garden Art, RR 5, P.O. Box 5286, Belfast (338-3352)

Belcher's Antiques, Reach Road, Deer Isle (348-9938)

Bob Withington Antiques, 611A Route 1, York (363-1155)

Brambles, Main Street, Damariscotta (563-2800)

Cornish Trading Company, Main Street, Cornish (625-8387)

Country Collection, Route 11, Limington (637-2580)

Elmer's Barn, Route 17, Coopers Mills (549-7671)

Fifi's Finally I Found It, Route 3, Augusta (623-0434)

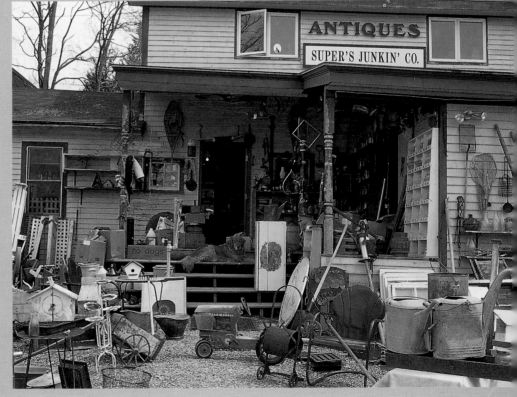

Opposite top: Items on display at Antiques on Nine, one of many antiques shops in the Kennebunk region.

Opposite bottom: Super's Junkin' Company, in Town Hill, near Bar Harbor.

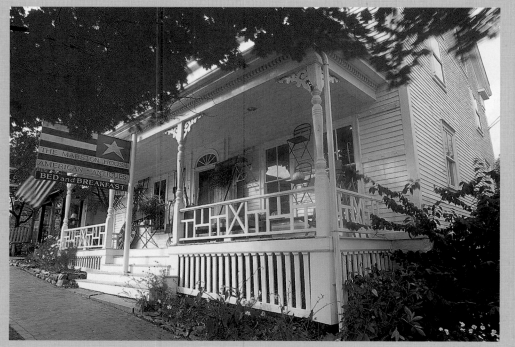

Above and left: At Marston House Antiques, in Wiscasset, a metal chair becomes a hanging showcase for a white 'Valenciano' pumpkin.

Fiona's Porch, 7 York Street (Route 1A), York (363-6270)

The Foxglove, Pritham Avenue, Greenville Junction (695-3895)

Garden Cottage, 52 Main Street, Belfast (338-0165)

Hall's, Route 1, Belfast (338-1170)

Hidden Brook Antiques, Route 302, Bridgton (647-5241)

Landmark Architectural Antiques, 108 Main Street, Belfast (338-9901)

Lily's, Main Street, Cornish (625-2366)

Lovejoy's Antiques, 122 Water Street, Hallowell (622-5527)

Lunaform, Cedar Lane, West Sullivan (422-0923)

Lydia Gutch Antiques, 170 Front Street, Bath (443-4551)

Maine Camp, South Paris (743-2040; call for information)

Marston House Antiques, 101 Main Street, Wiscasset (882-6010)

Mason Street Mercantile, 50 Front Street, Bath (442-7018)

Mollyockett Marketplace, 255 Bethel Road, West Paris (674-3939)

Off the Wall Antiques, 500 Ocean House Road, Route 77, Cape Elizabeth (767-2222)

Polly Peters, 26 Brackett Street, Portland (774-6981)

Portland Architectural Salvage, 919 Congress Street, Portland (780-0634)

Queen Anne's Lace, Wells Union Antiques, Route 1, Wells (646-8609)

Scottish Lion Blacksmith, Route 32, Round Pond (529-6605)

Secret Garden, 296 Sanford Road (Route 109), Wells (646-5603)

Smith-Zukas Antiques, Wells Union Antiques, Route 1, Wells (646-6996)

Super's Junkin' Company, Route 102, Town Hill, Mount Desert Island (288-5740)

The Weede Shoppe, 395 Falmouth Road, Windham (892-2093)

Wells Union Antiques, Route 1, Wells. A group of 10 dealers, open 10 to 5, May through November.